TWIN CITIES
MINNEAPOLIS-ST. PAUL
A Photographic Journey

TEXT AND CAPTIONS: **Bill Harris**

PHOTOGRAPHY: **Frozen Images, Inc., Minneapolis**
Peter Beck, Ed Bock, Robert Friedman, Will Goddard,
Annie Griffiths Belt, Richard Hamilton Smith,
Everett C. Johnson, Kurt Mitchell, Tom Nelson,
Chuck Peflev, Thomas Rumreich, Steve Schneider,
Rob Sheppard, Brady Willette

DESIGN: **Teddy Hartshorn**

DIRECTOR OF PRODUCTION: **Gerald Hughes**

CLB 3365
© 1993 CLB Publishing, Godalming, Surrey, England.
All rights reserved.
This 1993 edition published by Crescent Books,
distributed by Outlet Book Company, Inc., a Random House Company,
40 Engelhard Avenue, Avenel, New Jersey 07001.
Random House
New York • Toronto • London • Sydney • Auckland
Printed and bound in Malaysia.
ISBN: 0 517 10057 6
8 7 6 5 4 3 2 1

TWIN CITIES
MINNEAPOLIS-ST. PAUL

A Photographic Journey

Text by
BILL HARRIS

CRESCENT BOOKS
NEW YORK • AVENEL, NEW JERSEY

When he wrote the *Song of Hiawatha*, Henry Wadsworth Longfellow added a glossary to guide his readers through the maze of Indian words he used to tell the tale. Among them was Minnehaha, which he defined as "... a waterfall on a stream running into the Mississippi between Fort Snelling and the Falls of St. Anthony." If writing now he might say that Minnehaha is in Minneapolis, or even that it is in the Twin Cities. But in 1855, when he wrote his epic poem, there was no such place as Minneapolis, and its twin, St. Paul, would probably have been identified by the decidedly unpoetic name of Pig's Eye.

The Twin Cities region has come a long way since 1855, but Minnehaha Falls still lives up to its name, which means "Laughing Water." Indeed, although there have been dry seasons when there was no water at all, the Parks and Recreation Department has installed pumps to give the waterfall a boost when one is needed. Neither Hiawatha nor Mr. Longfellow could have predicted such a triumph over nature, and they would have been amazed to learn that, by the summer of 1992, the Twin Cities boasted not one Minnehaha Falls, but two, and that the new one doesn't freeze solid in the winter. The poet would probably prefer the original in its dazzling winter white, and the great Indian chief surely would because it was there that he met the love of his life. The new version not only doesn't drape the nearby trees with frost and icicles, but anyone crossing the bridge in front of it is much more likely to run into a dog named Snoopy than an Indian maiden. Yes, Snoopy; Charlie Brown's best friend. The laughing water of the nineties is one of the attractions at Camp Snoopy, an indoor theme park which is itself one of the attractions of Mall America, which has risen from the ruins of Met Stadium, the former home of the baseball team, the Minnesota Twins, in suburban Bloomington. That Snoopy is the star of the show is entirely appropriate. Charles M. Schulz, creator of the "Peanuts" comic strip, was born in St. Paul. He learned cartooning at a school in Minneapolis before developing his famous characters, known in the beginning as "Li'l Folks," who appeared exclusively in the *St. Paul Pioneer Press* for nearly three years before going national.

Mall America is a "state of the art" shopping center. The biggest in the country, it has four department stores and hundreds of specialty shops. It has more than forty places to

grab a snack or sit down to a meal, and it also has nightclubs and a choice of more than a dozen different movies to see. It has an eighteen-hole miniature golf course in a mountain setting, and a fantasyland created from large Lego blocks, each weighing 750 pounds. For those who like to keep in touch with the outside world, customers can rent cellular telephones at any Mall entrance, none of which, its builders boast, is more than 300 feet from any of the 13,000 parking spaces. And for those who want to keep in contact with Minnesota's past, Camp Snoopy is landscaped to give a North Woods feeling, and includes thirty log structures which its promoters proudly note were "built by Minnesota crafts-people." Among its sixteen rides is Paul Bunyan's Log Chute, a flume ride that takes kids back to the very beginning of Minnesota's modern history and past a 19-foot animated replica of the legendary logger Paul Bunyan and a 13-foot moving model of his blue ox, Babe. Naturally, they are the biggest such figures ever created.

It takes big, bold images to conjure up the history of Minneapolis and St. Paul and the towns around them that are officially designated the Twin Cities Metro Area, but it's hard to know where to begin. In the early nineteen hundreds a farmer named Olof Ohman made a discovery that many said proved Minnesota was visited by Europeans 130 years before Columbus arrived. What Ohman found under the roots of a poplar tree was a stone inscribed with words that were foreign to him, although he had been born in Sweden. It was later translated and identified as a Viking runestone bearing the message that eight Swedes and twenty-two Norwegians had wandered westward from Vinland and made camp near what is now the town of Kensington, in the middle of Minnesota. The year, according to the inscription, was 1362. The stone has been alternately hailed as a major archeological discovery and derided as a fake, and nearly a century after it was found it is still a good starting point for a heated argument. But whether Vikings found their way to Minnesota in the fourteenth century or not, there is no other evidence of their presence, and the recorded history of the area doesn't begin until more than three centuries later.

When the French first arrived along the St. Lawrence River in 1536 they were content to concentrate on fishing, but after they began trading with Indians for furs they realized the new land was filled with treasures and began pushing inland in search of more. It also presented them with an opportunity to search for the Holy Grail of the explorers of the day, a Northwest Passage connecting the Atlantic and Pacific oceans. The prime mover in the French effort was Samuel de Champlain, who discovered Lakes Huron and Ontario and thought that they were the first link of the fabled waterway, a theory he believed was confirmed with the discovery of Lake Superior. He became convinced that the link was within his grasp when Indians told him of another great inland sea to the south and west of Huron. However, Champlain was an old man by then and he sent Jean Nicolet to find it for him. He was so sure that his explorers would reach the land of Cathay that he gave Nicolet a damask robe to present to the Great Kahn; but instead of the Chinese emperor, the Frenchman met the chief of the Winnebago Indians near what is now Green Bay, Wisconsin, on the shores of Lake Michigan. The trip wasn't a total loss, however. In addition to adding a fourth Great Lake to the empire of New France, Nicolet's 1634 excursion also brought him in contact with Indians who told him of a stream that led from the lake to another great water that flowed south.

It was obviously an exciting prospect, but Champlain died soon after Nicolet returned to Quebec to make his report, and the great trading company he had built fell into anarchy. His dream of finding the Northwest Passage died with him, and the search for furs fell to freelance adventurers, of whom two of the most successful were Pierre Esprit Radisson and Médart Chouart, the Sieur de Groseillers. It was they who made the first contact with the Sioux Indians in 1660, and in the process also apparently became the first white men – apart from the Vikings, of course – to set foot in Minnesota. It was a heady experience, and they returned to Canada loaded with valuable furs and bright hopes for the future. But Radisson and Groseillers, whatever they might have accomplished, weren't company men, and when they arrived in Montreal they were relieved of their furs and arrested. They ultimately got their revenge by emigrating to England, where they became founding members of the Hudson's Bay Company, a juggernaut that gave the French a run for their money in the New World.

In the meantime, King Louis XIV of France took a hand in the fortunes of the North American fur traders, funding a party of explorers headed by Louis Jolliet and Father Jacques Marquette to pick up where Nicolet had left off. In 1673, they reached the Mississippi by way of the Fox and Wisconsin rivers, and followed it south until they reached the Arkansas River, at which point they decided that if they kept going they'd reach the Gulf of Mexico and not the Pacific. They turned back in disappointment, but their voyage had taken them past the Missouri River, and on the return trip they found a shortcut to Lake Michigan by way of the Chicago and Illinois rivers. All things considered, the king of France got good value for his money. But he still didn't have control of the Northwest Passage, if there was such a thing.

Thanks to the efforts of Daniel Greysolon, Sieur Duluth, the territory that is now northern Wisconsin and Minnesota was claimed for France through an agreement with the Sioux in 1679. The Sioux, who called themselves *Dakotah*, which means "friend" in their language, but were known to the French by the Chippewa word *Nadouessioux*, "little viper," were pleased to cast their lot with the white men because the Chippewa, forced into the west by the Iroquois, were pushing them further west from their own ancestral lands. The Sioux had every reason to act as friends, but within a year of signing the treaty they created an international incident by capturing three white explorers and transporting them up the Mississippi. The captives were rescued and the affair might have been forgotten except that one of them, Father Louis Hennepin, wrote detailed descriptions of everything he saw, including the waterfall on the Mississippi which he named for his patron saint, Anthony of Padua.

After returning to France, Father Hennepin published his diaries in a book he called *A Description of Louisiana*. It became a bestseller and set romantics to dreaming of the day when they themselves might see such wonders as the Falls of St. Anthony. It started wheels turning in the heads of more practical dreamers who translated a powerful waterfall on a great navigable river into a perfect site for a city. But it wasn't until 122 years later, in 1805, that anyone made any move to turn that dream into reality.

French claims to Minnesota came to an end in 1763, when they were defeated by the British at Quebec, but the territory's accent was overwhelmingly Gallic for years afterward. But it

was from those thirteen colonies on the East Coast, the Americans, that the strongest challenge came. At the end of the Revolutionary War, after a tough round of negotiations, the borders of the new country were fixed at the Mississippi River in the West and the St. Lawrence River to Lake of the Woods in the North. Their maps were flawed, and they didn't know that Lake of the Woods was west of the Mississippi. They also had no idea how far north the river extended above the Falls of St. Anthony, but both the river and the lake were too far off for anyone to care. When the time came to begin caring, Thomas Jefferson was in the White House, and he was planning to change everything by buying Louisiana from Napoleon. Once the purchase was complete, Jefferson sent a party led by Zebulon M. Pike to find the source of the Mississippi and to locate sites for army posts along the river north from St. Louis. When they reached the mouth of the Minnesota River in late September, 1805, Pike made a deal with the Sioux chief, Little Crow, to buy the Falls of St. Anthony and nine square miles of land around it, which is today most of the area within the city limits of Minneapolis and St. Paul.

Pike estimated that the land he was buying was worth about $200,000, but he secured the deal with a down payment of $200 and 60 gallons of whiskey, leaving it to Congress to come up with the rest. The conferees spent the next dozen years discussing the value of land in Minnesota before finally authorizing a payment of $2,000. It wasn't until two years later that they found any use for the land. In 1819, Lieutenant Colonel Henry Leavenworth arrived with orders to build a fort. He made the mistake of building it on low ground on the banks of the Minnesota River, however, and half his men fell victim to the legendary Minnesota winter. He moved across the river to higher ground in the spring, but by then his replacement, Colonel Josiah Snelling, was already on his way.

Snelling was clearly the man for the job. His fort was going to be something much stronger and far more impressive than the wooden stockades that passed for defensive positions along the rest of the frontier. He ordered limestone cut from the bluffs and logs floated down the Rum River, and he used them to build a fortress in a diamond shape with towers at its corners. It had all the earmarks of a medieval castle in Europe, and it stood as a symbol of American power in a land that had never seen such a permanent-looking structure. Though it was designed to withstand an attack from any direction, Fort Snelling never was attacked, but it became as important to the history of the country as any military establishment that ever withstood the pounding of hostile fire. Before the creation of the village that would become St. Paul, the fort stood as the symbol of civilized life in Minnesota, and it was the site of the first church services in the old Northwest, as well as the first school, the first hospital, and the first library. It was also, significantly for the future of the Twin Cities, where the first wheat was planted and the first flour mill established. Snelling became a popular tourist destination in the early nineteenth century as well-heeled Europeans and Americans toured the Mississippi in steamboats, with St. Anthony Falls, as the head of navigation, the logical destination.

But the earliest settlers, who began arriving in the 1820s, didn't come from the East or the South. They had originally come from Scotland, Switzerland, and Germany with the help of Thomas Douglas, the earl of Selkirk, who had promised them a better life in Canada in a colony he created near present-day

Winnipeg. In spite of Douglas's good intentions, the so-called Selkirkers didn't find their new life at all as promised. When they weren't being harassed by fur traders who resented their presence, they had to contend with hostile Indians who resented them even more. They found the Canadian winters hostile, too, and finally began moving south in search of friendlier surroundings. They wound up at Fort Snelling, where they stayed although they didn't find a warm welcome. In the eyes of the military they were squatters on federal land, and they were evicted, often by force. But they stayed in the area and bided their time. They especially represented a thorn in the side of Major Joseph Plympton, the man in charge at Fort Snelling, who complained that they were cutting down too many trees and allowing their horses and cattle to graze unchecked, not to mention that they drank too much. When an 1838 treaty with the Chippewa opened more land for settlement, Plympton forced the squatters out of the fort's shadow, and most moved a short distance down the river, where they established a town of their own.

One of the men who moved with them was a former trapper, Pierre "Pig's Eye" Parrant, as earthy a character as ever lived on the wild frontier. Even people who turned a blind eye to ugly men had to admit that Pig's Eye was beyond the pale. He was "low browed," they said, as well as "coarse and ill-looking." He had lost an eye in an earlier adventure, and the grayish-white remains of it was the source of his nickname because, as one of the milder descriptions of the man explained, it gave him "a kind of piggish expression." In spite of his appearance, Parrant was one of the leading citizens of the little town as he owned the tavern there, and because of it, the settlement was eventually named for him. The honor came from a patron who used the name Pig's Eye as his address and never failed to get his mail delivered. The name stuck until a priest named Lucian Galtier arrived to establish a church in the vicinity of the tavern. He picked a spot on the banks of the river where he expected one day there would be a steamboat landing, and built his little chapel which he named for St. Paul. A half dozen years later the name was given to the whole community around it, and Pig's Eye passed quietly into history. Parrant himself left town.

Father Galtier was quite right in believing that his chapel would soon be surrounded by steamboat landings. Before long, the boats stopped calling at Fort Snelling in favor of the better berths across the river at St. Paul, and the port became the most important city on the upper Mississippi, eventually becoming the territorial capital. But it wasn't the only center of activity.

When Major Plympton was fuming against the squatters in his midst, he had something more in mind than the loss of trees and trampled grass. Almost from the day he arrived he had hopes of eventually owning the Falls of St. Anthony, and he knew it was only a matter of time before Indian treaties would make its waterpower available for development. The time came in 1838, but Plympton wasn't fast enough. When word came that the treaties had become official, the Major ordered his men to stake a claim for him, but by the time they arrived on the scene, Franklin Steele, the storekeeper from Fort Snelling, had built a shack next to the falls and was busily planting potatoes. He also planted the seeds of the town of St. Anthony a short time later when he built a sawmill and a store.

It was the sawmill that made all the difference. The forests of Minnesota weren't an inexhaustible resource, but it seemed

as though there were enough trees to last several lifetimes, and men flocked to the upper Mississippi to cash in on the bonanza. As St. Anthony began bursting at the seams on the east bank of the river, another settlement, known as All Saints, was growing just as fast on the west side, the growth coming from the logs that choked the rivers from the north and were sawed into lumber that made nearly everyone rich. The Twin Cities at the time were really lusty triplets, a state of affairs that changed with the merging of All Saints and St. Anthony in 1872 and the emergence of a new city named Minneapolis. The name had actually been coined twenty years earlier by a schoolteacher, who suggested it would be appropriate to combine the Indian word *minne*, which means water, to the Greek word *polis*, signifying a city. The two roots were connected with the letter "a" to make the name fall off the tongue more easily. All other suggestions, of which there were dozens, were forgotten. Many of the contenders were the names of the lumber barons who had put the place on the map, but the man whose name eventually became synonymous with the industry didn't move to the Twin Cities until 1891, not long before the nearby pine forests virtually disappeared.

Frederick Weyerhauser was already rich and successful when he built his home on fashionable Summit Avenue in St. Paul. An immigrant from Germany, he began his career in the lumber business working in a sawmill at Rock Island, Illinois, but his job was cutting wood, not selling it. One day when his boss was out to lunch, young Weyerhauser sold a load of lumber for sixty dollars in gold and realized for the first time that trees were worth big money. Not long afterward, he and his brother-in-law pooled their resources and bought a bankrupt sawmill. Most of their customers paid them in butter and eggs and livestock, but they found merchants willing to convert the produce into cash, and within their first nine months of operation they earned $3,000. Within a year or two they earned enough to buy the biggest lumber yard in Rock Island, as well as four other businesses, and Weyerhauser himself had enough capital left over to invest in eighteen other concerns. Frederick Weyerhauser knew how to handle money, and he had an even greater talent: he knew how to handle men, and how to pick the best of them as partners. He had a genius for merging companies, a novel idea in his day, and in 1871 he brought fourteen of them together to form the Mississippi River Logging Company, with himself as its president. Less than ten years later he brought even more entrepreneurs under his umbrella and formed the biggest timber company in America, employing more than fifteen hundred men.

Weyerhauser himself was the antithesis of flamboyance, a man of few words who worshipped his family and was in turn worshipped by them. But he owed his success, as did the city of Minneapolis itself, to some of the most colorful, rowdy characters America has ever seen. The lumberjacks who carved up the forests of the old Northwest came from New England, Scandinavia, Canada, and Ireland, but wherever they spent their boyhood, they found their manhood in the forest, and it turned them into a breed apart. Each of them had a specialty, and each knew that his life as well as his livelihood depended on his skill. First on the scene in a logging operation were the cruisers who marked the trees that would be cut. They were followed by choppers who knocked the trees down, and then by sawyers who cut them into logs. In the meantime, swampers were busy clearing underbrush and cutting roadways to the nearest river, and they were followed in turn by loaders who

wrestled the logs onto ox-drawn sledges. Other workers, known as landing men, rolled the logs onto the riverbank for the eventual trip to the mill after pounding their company's brand into the ends of the logs for identification at the final destination.

The logs were stored over the winter and as soon as the ice began breaking up in the spring, everyone lent a hand rolling them into the river. Crews of men lined the banks for miles to keep the flow moving, but quite often a log or two would turn sideways and bottle up hundreds behind them, creating a dangerous job for the jam crew whose job it was to get the whole thing moving again. And the movement, inexorably, was in the direction of the Twin Cities, and both Minneapolis and St. Paul thrived on the bounty. It was a heady, but short-lived experience. By the turn of the century the virgin forests of Minnesota had all been floated down the rivers, and the loggers moved on in the direction of Montana, Idaho, and the Pacific Northwest.

Some parts of the United States are full of ghost towns, abandoned when the local gold mine or silver mine played out, but Minneapolis and St. Paul were spared such a fate when the loggers moved away. This was partly because of their location, but it was people who made the real difference. One of the most celebrated of them, James J. Hill, is still a legend among the giants in St. Paul's history, although he arrived in the Twin Cities as a tourist and had no intention of staying. Hill had come from Ontario, and as a teenager he set out in the direction of New York to seek his fortune. His search took him to Philadelphia and then to Baltimore, to Charleston and Savannah, and then back to New York by way of Pittsburgh. There were fortunes to be made in all those places in the early 1850s, but nothing quite measured up to Hill's dream and he decided to head for the Orient. The first stop in his new odyssey was St. Paul, where he expected to join up with mountain men who would guide him to the Pacific, where he could find a ship that would take him the rest of the way. But, by a strange twist of fate, the trappers had moved out in the direction of the mountains just a few days before he arrived and the path to the West was effectively shut down for the winter. So Hill did what any ambitious young man would do, he got himself a job. In a reassuring letter to his grandmother, he wrote that, "... I like this country very well and I think I shall like it better the longer I live here. I am in the commission and shipping business. My salary is twice as much as I could get in Canada and the work is easy, all done in an office. I have from six o'clock every evening to walk around and enjoy myself." But young Jim Hill wasn't the sort to waste time idly walking around and his idea of enjoying himself was to search for new opportunities.

There was plenty of opportunity in St. Paul. In 1857, a year after Hill arrived, Harriet Bishop, the founder of Minnesota's first school, wrote that, "St. Paul is comparatively an infant city with a population of probably ten thousand souls, but here 'every man counts.' Here men are picked not from the fossilized haunts of old fogyism, but from the swiftest blood of the nation. Every man here, to use a Western expression, is 'a steamboat,' and is determined to make his mark on the history of Minnesota ... It is a strange medley, indeed, that which you meet aboard a Mississippi steamer. An Australian gold hunter, a professor in an Eastern university going out to invest in Minnesota, a South Carolina boy with a thousand dollars and a

knowledge of double-entry bookkeeping...." She might also have mentioned a Canadian with an itch to succeed, like James J. Hill. His job in St. Paul's shipping and commission business was as a clerk in the office of a steamboat company, and he became captivated by the idea of the future of transportation, the lack of which had stopped him dead in his tracks on his way across the country.

The company he worked for was thriving, shipping flour and wheat down the river and bringing back freight to satisfy the needs of a growing city. He also saw passengers arriving at the steamboat landings with no intention of ever going back where they came from, and little by little he began to realize that this town he had regarded as a temporary winter quarters represented the opportunity he had been dreaming of, and that the key was in transportation. Very soon after he took the job with the steamboat company he was promoted and given the responsibility of negotiating freight rates. He discovered that by charging less he could fill the boats faster and still keep profits respectable. It was a lesson he'd never forget. Eventually he branched out as a partner in a freight-forwarding company and then made a deal to supply the fuel that powered the trains of the St. Paul and Pacific Railroad. In spite of its high-sounding name, the line only extended for ten miles between St. Anthony and St. Paul, but it was growing, and by the early 1870s it had extended westward into the Red River Valley. It was still a long way from the Pacific, but it had nearly 300 miles of track and it was the only railroad in Minnesota.

The St. Paul and Pacific had expanded, like many railroads of the day, with free land grants, but it still lost money. Hill's enterprise, meanwhile, did not. Railroad locomotives, like the steamboats, burned wood back then, but Hill had a better idea. Coal was much more efficient and a good deal more economical, and Hill, as the railroad's fuel source, found suppliers down the river willing to sell him all the coal he needed and in the process he became the only supplier of coal, not only for the railroad but also for the furnaces of the Twin Cities area itself, a monopoly of bonanza proportions in a place where the average winter temperature hovers around 27°F. But Jim Hill wasn't finished yet.

He had gone into partnership with Norman Kittson to carry freight and passengers between Canada and St. Paul by steamboat with the Red River Transportation Company. However, he believed that railroads were a better way, and when the St. Paul and Pacific finally went bankrupt in 1878, he and Kittson interested Canadian investors in helping them buy it. Although he estimated it was worth more than five times what they had paid for it, the line was in sorry shape and it took most of their resources to get it up and running. But, ever the optimist, Hill, who had been named the railroad's president and general manager, pushed an extension of its right-of-way up to the Canadian border, where it could connect with the Canadian Pacific. With that, he changed its name to the St. Paul, Minneapolis and Manitoba Railroad, but although he dropped "Pacific" from the name, it was still very much in his mind.

In pushing northward, he had been able to take advantage of land grants offered by the Minnesota Legislature, and while he was out personally supervising construction he was also casting a critical eye on the potential for farming the land his company now owned. Luck was with him again, because farmers in the area were bringing in unusually large harvests that year,

which not only made them prosperous, but increased the value of the land the railroad planned to sell. Hill ran ads in European newspapers and the response was overwhelming. They produced a flood of buyers for his land and, even more important, they provided new customers for his railroad, and Hill and his partners became millionaires. It was then that Jim Hill decided the time had come to go back to his original dream of seeking his fortune in the Orient.

By then it was territory between the Twin Cities and the coast that intrigued him most, however. He believed that the wheat fields of the Dakotas and Montana, and the forests on the other side of the Rockies were destined to be the nucleus of a new empire, but that it would all be worthless until an empire builder provided the transportation to bring the bounty to market. When he announced that he would be that empire builder, he was almost alone in believing he could possibly pull it off. For one thing, there were already two transcontinental railroads, both built with heavy government subsidies, and it was obvious that Washington wasn't interested in investing in any more railroad ventures. Hill had secured land grants in Minnesota, but none of the other territories he had to cross in the direction of Puget Sound offered any such largesse and none were prepared to. Ordinarily, that would have put an end to any railroader's dream, but Jim Hill had already proven he was no ordinary man.

His Great Northern Railroad was the only cross-country line built without government help, and because of it the Empire of the Northwest that Hill had predicted became a reality. It created prosperous towns across the northern prairies, in Montana and Idaho and all the way to the Pacific coast, but the cities that prospered most were Minneapolis and St. Paul. Because of the new railroad, the farmers of Minnesota were able to ship their produce profitably, the iron ore from the North could be moved economically, and the cattle brought in from the West turned St. Paul into a major meat packing center. The line's biggest profit maker lay in transporting grain and lumber from the West through the Twin Cities on the way to Chicago and the East, but the freight cars were making the return trip relatively empty, and Jim Hill's answer to the problem finally brought his original dream full circle. An empty freight car is a railroad man's nightmare, and the Empire Builder eased the pain by sending salesmen to China and Japan to open new markets for American products, especially cotton, which he could bring up the Mississippi in his steamboats. The idea worked, and before long the man whose career had begun with boats on the Mississippi had two steamships, the *Minnesota* and the *Dakota*, making regular runs across the Pacific from Seattle to the Orient. He himself never made the trip, even though it was preparing for such a trip that took him to St. Paul in the first place. Apart from the fact that he probably didn't have the time, his years in the Upper Midwest had turned Jim Hill into a railroad man, and ocean voyages had lost their glamor. When he retired in 1912, Hill wrote a lengthy farewell to his employees and associates in which he noted, "... most men who have really lived have had, in some shape, their great adventure. This railway is mine." He went on to say, "... I feel that a labor and service so called into being, touching at so many points the lives of so many millions with its ability to serve the country, and firmly established credit and reputation, will be the best evidence of

its permanent value and that it no longer depends upon the life or labor of any single individual." While Hill may have been right, the achievements of a few individuals in the Twin Cities of the mid-nineteenth century are the stuff of American legends. At first glance, John S. Pillsbury doesn't seem to fit this mold.

It wasn't that John didn't believe in honesty and hard work, or that he didn't have good business sense, but he didn't seem to have much in the way of good luck. He moved to St. Anthony in 1855 because he believed the town would grow and that he would prosper with it. But two years after he opened a hardware store there, a financial downturn they called a panic back then, but we call a recession today, nearly put him out of business. He hung on, though, and just as the economy began to turn around, his store burned to the ground and he was not only out of business but deep in debt. He was able to get a job, but for the next six years, nearly every penny he earned went to pay off his creditors. It made life a bit hard for him and his wife, but it worked wonders for his credit rating, and a few years later he talked his nephew, Charles, into moving to Minneapolis to join him and his brother, George, and together the three men invested all they had in a run-down flour mill. Charles managed the operation for a salary of a thousand dollars a year plus one-sixth of the profits. He earned $6,000 the first year, and at the end of the second he had earned enough to form his own business: C.A. Pillsbury and Company. His Uncle John went on to become governor of Minnesota, and Uncle George the mayor of Minneapolis. John also established the University of Minnesota, and then went back East to recruit its first students. In 1890 Charles sold the company to British investors, and not long after the three founders died, C.A. Pillsbury and Company went bankrupt. Eventually, Charles's two sons were able to rebuild it, and by 1923 it was an all-American company again and the name Pillsbury a household word, not only in America but all over the world.

Minneapolis and St. Paul were already well known as one of the country's biggest producers of flour when Pillsbury's Best appeared on the scene. Farmers who began arriving in the area in the 1850s discovered that the only practical crop for the tough prairie soil was wheat. And through trial and error they discovered that the only practical type of wheat to grow in the Minnesota climate was spring wheat, which could be planted in April and harvested in mid-summer. Ironically, the Minnesota winter is too harsh for growing winter wheat. The local market was big enough to absorb their output and while there were more than a dozen flour mills in Minneapolis when the Civil War ended, there were several other Minnesota towns with more of them. Once again, it was a man with an idea who gave the Twin Cities the edge and revolutionized an industry. Cadwallader Washburn had migrated into Wisconsin from New England, and after making a fortune as a lumberman and serving as the new state's governor, he moved on to Minneapolis to try his hand at something different. He had decided that the combination of transportation, water power, and the increasing output of local farms made possible by new machinery would make Minneapolis a flour-milling center, and he arrived with the money and the business sense to make it happen. But there was a problem he hadn't anticipated. The spring wheat that was Minnesota's only crop produced harder grains, and that made it more expensive to grind into flour than the winter wheat that was grown in most other parts of the country.

Unless something could be done to improve the process there was no hope of selling Minnesota flour anywhere except in the local market.

The Twin Cities had also faced another roadblock to becoming the state's most important flour-milling center. They were competing with their own success in the lumber business. By 1860 there was no space left on either side of the river to squeeze in new mills of any kind, and most of the power of the St. Anthony Falls was being used to turn saws rather than grindstones. In 1865, William Eastman bought Nicollet Island (named not for Jean Nicolet, the discoverer of Lake Michigan, but for Joseph Nicollet, who explored and mapped the Minnesota Territory). It was his intention to put mills there, but the rights to water power weren't included in the sale, and he decided to improve on nature by digging a tunnel to divert the river water and create a new power source. The idea looked easy on paper, but he had assumed that the limestone at the edge of the falls extended deep underground and, as it turned out, it didn't. His workmen hit a layer of sandstone below the surface, and eventually the tunnel they dug through it collapsed and the Falls of St. Anthony began disappearing down into a whirlpool. The rushing water washed away quite a few riverside mills as well as tons of stone and wood tossed into the hole by townspeople who realized that without the falls, their cities would be out of business. They managed to choke the flow until engineers arrived and built a dike across the river and filled the underwater hole. Within two years a pair of dams were built and the power of the falls was harnessed so that there was plenty of power to go around. It seemed that as the forests were disappearing the future lay in wheat.

But Cadwallader Washburn and others like him had pinned their hopes on shipping their flour around the country. It was the only way to build a profitable business, and they went to work to make their product better. When the hard grains of spring wheat were ground, the brittle, outer bran layer left behind brown residue that made the flour look unappetizing. Worse, the gluten layer, which gives flour its food value and is the element that causes rising in baked goods, also refused to blend with the flour and, because it didn't, the product tended to spoil faster. On the plus side spring wheat is unusually rich in gluten, and the Minneapolis millers knew if they could figure out how to change the process they'd have the best flour made. Among the men who wrestled with the problem was Edmund La Croix, who had come from France with an experimental purifier. When George Christian, Washburn's partner, heard of it, he hired La Croix to experiment in their mill. Eventually, La Croix and Christian perfected a machine that used compressed air to blow away the bran coating as the grains were cracked, and then ground them into fine white flour. What Washburn advertised as "New Process" flour was an overnight sensation. Thanks to the extra gluten, it was much higher in food value than flour produced from winter wheat, and better still, a baker could turn out more bread with less flour than ever before. Needless to say, the world beat a path to Washburn's door – and to Minneapolis.

Before long, all the Minneapolis millers were using La Croix's machine and all of them prospered. But although the purifier solved their major problem, it created a new one. Because each grain of wheat was ground twice, the millstones wore out twice as fast, and replacing them was expensive. The solution seemed

obvious: use rollers instead of stones, as many European millers were already doing. But there were still unanswered questions. No one knew what the rollers should be made of, or how they should be lined up to crack and grind the hard spring wheat.

When they heard that millers in Hungary had some answers, Washburn and his new partner, John Crosby, sent an engineer to Budapest on a fact-finding mission. When the Hungarians found out why he was there, they locked their doors and curtained their windows, but he finally managed to get after-hours access to one of the mills and in a few nights he mastered its secrets. Washburn and Crosby got much more than they had hoped for. The steel rollers used in what they called "The Hungarian Method" lasted longer than stones and it took less power to turn them. Best of all, the spacing and placement the Budapest millers had developed by trial and error allowed them to increase their yield and to produce flour in a dozen different grades of fineness.

The Twin Cities were now the country's major source of flour, but there was still more to be done. Fortunately, former lumber barons like Washburn had capital to invest, and they unstintingly put it into railroads. Washburn himself pushed for a line to Sault St. Marie, Michigan, which allowed Twin Cities' millers to bypass Chicago when they shipped their flour eastward. Others invested in lines extending westward to cut their costs in bringing wheat from the distant prairies, and by the last decade of the nineteenth century the Twin Cities were rivaling Chicago as the country's most important railroad center. The millers also invested heavily in banks so they could have more control over the money supply, especially at harvest time when they needed huge amounts of cash to pay the farmers who supplied them with wheat. In the process, the Twin Cities became one of the country's most important financial centers.

Naturally, there was a spirit of fierce competition in the air, but the giants, Pillsbury on the east side of the river and General Mills, the successor to the Washburn Crosby operation, on the west, were generally content to keep their rivalry friendly. There was plenty of business to go around, after all. By the mid-1920s, Minneapolis was shipping ninety-five thousand barrels of flour a day, and the real competition wasn't from each other but from other cities, notably Buffalo and Kansas City. Eventually, both were shipping more flour than Minneapolis, but the companies that produced it were, by and large, Twin Cities based. The key was innovation, a Twin Cities tradition, and promotion, which the millers of Minneapolis turned into an American art form. As James Ford Bell, who formed General Mills in 1928, put it: "There is no limit to the possibilities before us. The door is wide open."

As far as Bell was concerned, the key to that door was diversification. Among the problems already faced a generation earlier, was the realization that the Minnesota wheat lands were becoming exhausted after years of supporting a single crop. The overall prosperity of the area had also increased land values and its corollary, property taxes, and farmers had been forced to diversify. Many switched to dairy farming, bringing another important industry to the region, but this wasn't what the millers had had in mind. They felt something new was called for, and one of the first major new ideas came to them by accident.

One day a hospital dietician was making a gruel of wheat bran for his patients and spilled some of it onto a hot stove. The drops fried into little wafers, which he found quite tasty, and he took some samples to General Mills to see what they thought

of it. They not only thought they liked it, but they hired him to develop a recipe for the stuff, and late in 1924 they were ready to take it to market. No one knew what to call this new, ready-to-eat breakfast food, and the company held a contest among its employees to name its prize baby. The winner was Jane Bausman in the New York office, who came up with the simple nickname, "Wheaties," that everyone agreed was a flash of inspiration. An equally simple radio jingle asked listeners "Have you tried Wheaties?" and noted that it was "the best breakfast food in the land." Those who did try it agreed, and before long the Breakfast of Champions was the best selling breakfast food in the land. But General Mills was still a major producer of flour, and to help housewives learn new uses for it the company created Betty Crocker to do the job.

Even the most enthusiastic merchandiser would be hard-pressed to glamorize a product like a bag of flour, and General Mills knew better than to try. Their spokesperson was ordinary to a fault, the kind of woman most Americans would like to have as a next door neighbor. She was trustworthy and loyal to family values, she was generous with her time, willing to share her experience and her knowledge and, most of all, she was friendly. Once the concept was determined, the character herself had to be established. The first step was an employee contest to find a woman with just the right hands to use in photographs of step-by-step recipes, and the second was to come up with a perfect name for this composite housewife. The surname Crocker was borrowed from a former Washburn Crosby executive and "Betty" was chosen as a typical all-American name. Next came her physical appearance, which was carefully crafted to combine Scandinavian, Irish, and other facial features to augment the all-American look. In the decades since, Betty's appearance has changed to keep up with the times, but her influence hasn't changed a bit in more than seventy years. Although she could be a modern housewife's great grandmother, she's still very much the woman next door, still trusted, and still one of the best-known fictional heroines ever created.

Over the years, General Mills has followed Bell's lead into diversification and today it is a leading producer of everything from fabrics and children's games to electronic components, but it is still a food company, and with such products as Wheaties and Bisquick, it is still a huge factor at every super-market checkout line. One reason is that in addition to creating innovative products, the company has a knack for selling them. Consider the story of Cheerios. When the research people developed the breakfast food made from cooked oats pressed through a die and puffed up with air, the marketing people followed up with the creation of a cartoon character capable of performing superhuman feats of strength. The captions on the cartoons read "He's feeling his Cheerios," and kids all over America wanted to get the feeling themselves. Until then, the only way to get big and strong was by following Popeye's lead and eating more spinach. With that as competition, there was no contest. The company also promoted the product through one of the most successful children's programs in the history of radio, "The Lone Ranger," and in the early 1940s General Mills was able to boast that it was the world's largest distributor of airplanes when it began inserting models into cereal boxes to introduce yet another reason for a child to want to feel his Cheerios.

While the millers of Minneapolis and St. Paul were diversifying, other local businessmen were doing the same. A company known

as Minneapolis-Honeywell started out in business making a thermostatically-controlled damper for hand-fired coal furnaces and eventually became an electronics giant of global proportions, with plants all over North America and Europe producing thousands of products that control airplanes and space shuttles, as well as switches that allow computers – many of which are made by St. Paul's Remington Rand Univac – to do their work. And the company that, possibly more than any other, has changed the way we all live and work began in St. Paul at the turn of the century as a manufacturer of sandpaper. The Minnesota Mining and Manufacturing Company, now known as 3M, has given the world Scotch Tape, Scotchguard, and Scotchlite. It has been a leader in the development of audio and video tapes, and hardly a man now alive remembers those dark days and years when we didn't have Post-It Notes to help us communicate.

All the activity in the Twin Cities business community obviously had a good effect on the local economy, but visitors to St. Paul and Minneapolis are usually pleasantly surprised to find that, while they are bustling places, the quality of life is more what one would expect in a small town than a center of so much industrial activity. And the real surprise is that it keeps getting better. Back in 1938, when the Federal Writers' Project created its guide to Minnesota, it noted that Minneapolis had one acre of city parkland for every ninety-two of its citizens. In the nineties, the ratio has changed to an acre for every forty-three Minneapolitans. Not many other American cities can make such a claim, unless it is St. Paul. Minneapolis's twin has seventy parks and no less than eighty-three lakes inside its city limits. Although outdoor activity is part of the joy of life in the Twin Cities, it is possible to avoid it almost completely. St. Paul's nearly five miles of enclosed skyway, a pedestrian path high above the streets, connects Galtier Plaza with Carriage Hill Plaza, and includes the four-block shopping area known as Town Square, which itself includes what is billed as the world's largest enclosed park. The giant greenhouse is filled with greenery and waterfalls and encompasses the newly-restored, antique Cafesjian's Carousel, whose sixty-eight horses were the stars of the Minnesota State Fair for seventy-five years before coming indoors to give year-round pleasure. Minneapolis has a system of forty-six skyways that allows pedestrians to wander nearly as far in climate-controlled comfort through forty downtown blocks, and the length of the walkways is slowly growing. Such amenities were obviously created to serve local businesses, but there is a great deal of altruism in the Twin Cities business community, and there has been from the earliest days. In the late 1960s a group of the area's business leaders banded together in what they called the Five Percent Club, with a pledge to give five percent of their pre-tax income to civic improvement, and the results are obvious in every corner of the Twin Cities. But if the business community of the two cities is combined, it isn't very likely that Minneapolis and St. Paul themselves will ever merge. Old rivalries, once quite pronounced, have long since disappeared, and in some places the boundaries between the two are hard to define, but Minneapolis and St. Paul have never been identical twins and for now, at least, marriage seems quite out of the question. But few other pairs of cities anywhere in the world with as much in common as Minneapolis and St. Paul have ever survived as separate entities, a fact especially remarkable considering that both were created in the same era

and grew at the same rate. The simple fact is that, while Twin Citians are well-aware of their common destiny, and are willing to join forces for their common interests, they like their separate identities and that gives the metro area a variety that goes beyond its fascinating ethnic mix.

The most often-heard comparison is that Minneapolis is a city representing the West and that St. Paul is very much an Eastern city, even though at this point in America's development there is very little difference in the basic fabric of the country's cities. St. Paul has a kind of Victorian charm and a New England-style sense of aristocratic reserve. Minneapolis prides itself on the trappings of progress and is as thoroughly modern as cities much younger. The people themselves, although as homogenized as the populations of any other cities in the country, don't share quite the same roots. The immigrants who settled in St. Paul were mostly Irish and German, and those who dominated early Minneapolis were from the Scandinavian countries. In terms of religion, St. Paul is traditionally Catholic and Minneapolis Lutheran. But apart from those differences, which most Twin Citians consider insignificant, not much else separates them. For instance, they all share a passion for music that goes back to the first settlers and makes the Twin Cities one of the top two or three centers of musical life in America. Both the Scandinavians and the Germans have a passion for singing, and choral music from the Twin Cities has been considered the country's best for generations. As far back as 1903, when only six American cities supported their own symphony orchestras, Minneapolis, which ranked eighteenth in size, formed one of its own and has watched it grow over the years, with such great conductors as Eugene Ormandy and Dimitri Metropolous, into the Minnesota Orchestra, one of the greatest musical organizations in the world. The Twin Cities also supports the Minnesota Opera, the St. Paul Chamber Orchestra, the hundred-year-old Schubert Club and a host of other musical organizations, all of which rank among the best America has to offer. Taking the tradition a step further these days is a local boy who made good as a rock star calling himself Prince, and the well-known Paisley Park recording studio. Local producers have been responsible for some of *Billboard Magazine's* top recordings, and the modern musical world's all time champ for sales of single records was Janet Jackson's "Rhythm Nation," which resulted in six tracks that made the grade as top-five singles. The trend prompted *Rolling Stone Magazine* to coin the phrase "Minneapolis Sound."

But the entertainment possibilities offered by the Twin Cities goes well beyond music. There are more live theaters here than in any area of the country except New York, and the crown jewel is the Guthrie Theater, which ranks among the most respected theatrical institutions in the world. It was founded in 1959 by the Irish director, Sir Tyrone Guthrie, who arrived in Minneapolis with a dream of bringing serious theater to a country where producers seemed to him more concerned with box-office receipts than art. He obviously had gone to the right place. Land was donated and the business community pledged money, but the most impressive effort was made by volunteers, twelve hundred of them, who knocked on doors to raise the two million dollars that was still needed to begin construction. In the years since, the Guthrie has given them back impressive productions of major theatrical classics as well as a chance to explore contemporary and experimental drama. It has given

them the kind of pride rare in other cities, but Twin Citians never really lacked civic pride in the first place.

They find pride in their championship baseball team, the Twins, and in the Metrodome, where their team won the World Series in 1982 and again in 1991, and where Super Bowl XXVI shared center stage with the St. Paul Winter Carnival in 1993. The Winter Carnival is the oldest cold weather festival in America, dating back to 1886. With King Boreas and the Queen of the Snows in residence in their ice palace, the twelve-day celebration includes more than a hundred special events, including a snowmobile race, ice-carving contests, ski jumping, even golf and softball and sometimes, if the ice isn't too thick on the lakes, water skiing. Its counterpart, the Minneapolis Aquatennial, which lasts for ten days in mid-July, makes the local lakes and rivers the star of a show that includes more than 250 different events. Those activities include boat races, of course, but there are also two parades and lots of fireworks, and Twin Citians warm up for it with the annual Fourth of July Taste of Minnesota Festival on the lawn of the State Capitol in St. Paul. There is also an annual golf tournament on ice-covered Lake Minnetonka in February, and the St. Patrick's Day parade a month later marks the first sign of spring, even though the temperature usually doesn't cooperate. In April, nearly every ethnic group in the area gets together at the St. Paul Civic Center for one of the biggest such festivals in the world. In late June, the Swedish community celebrates Svenskarnes Dag in Minnehaha Park, and in July the Minnesota Orchestra goes outdoors for a series of summer concerts. The State Fair, one of America's biggest as well as oldest, comes to St. Paul in late August, and a few weeks later, in nearby New Prague, the Czechs celebrate Dozinky, the traditional Czechoslovakian harvest festival. Naturally, the Germans have a patent on October, with the popular Octoberfest.

The people of the Twin Cities are obviously proud of their roots, and for generations their celebrations have not only added spice to their life in Minneapolis and St. Paul, but while the rest of the country regarded itself as a melting pot, they have always been aware of the advantages of creating a mosaic. It is quite appropriate. The view of the Twin Cities from the air is itself a mosaic. There is hardly any way to tell where Minneapolis ends and St. Paul begins, and the cityscape is dotted with lakes and parks and tree-lined streets, with the curving Mississippi River catching flashes of the sun. Minneapolis has taller buildings, but St. Paul isn't without its share of glass and concrete, and both have an unusual blend of commerce and simple beauty. It was not for nothing that the Urban Institute ranked the Twin Cities number one in the country for quality of life, or that *Working Woman Magazine* told its readers that they are the best place to live for mothers with careers, echoing a report by *Savvy Magazine* that the area is tops in the country for raising children. *Fortune Magazine* said that the Twin Cities is the second best place in America for doing business, and *Forbes* reported that they are home to more than two hundred of the best small companies in America. Arthur Frommer, the travel writer ranked the Twin Cities as one of the top ten vacation destinations, not just in the United States, but in the world, and *Newsweek* rated them as one of the country's ten "hot" cities. When *Better Homes and Gardens Magazine* said that St. Paul is "one of America's most surprising cities," no one who lives there was at all surprised. So, they are quick to add, is its lusty twin.

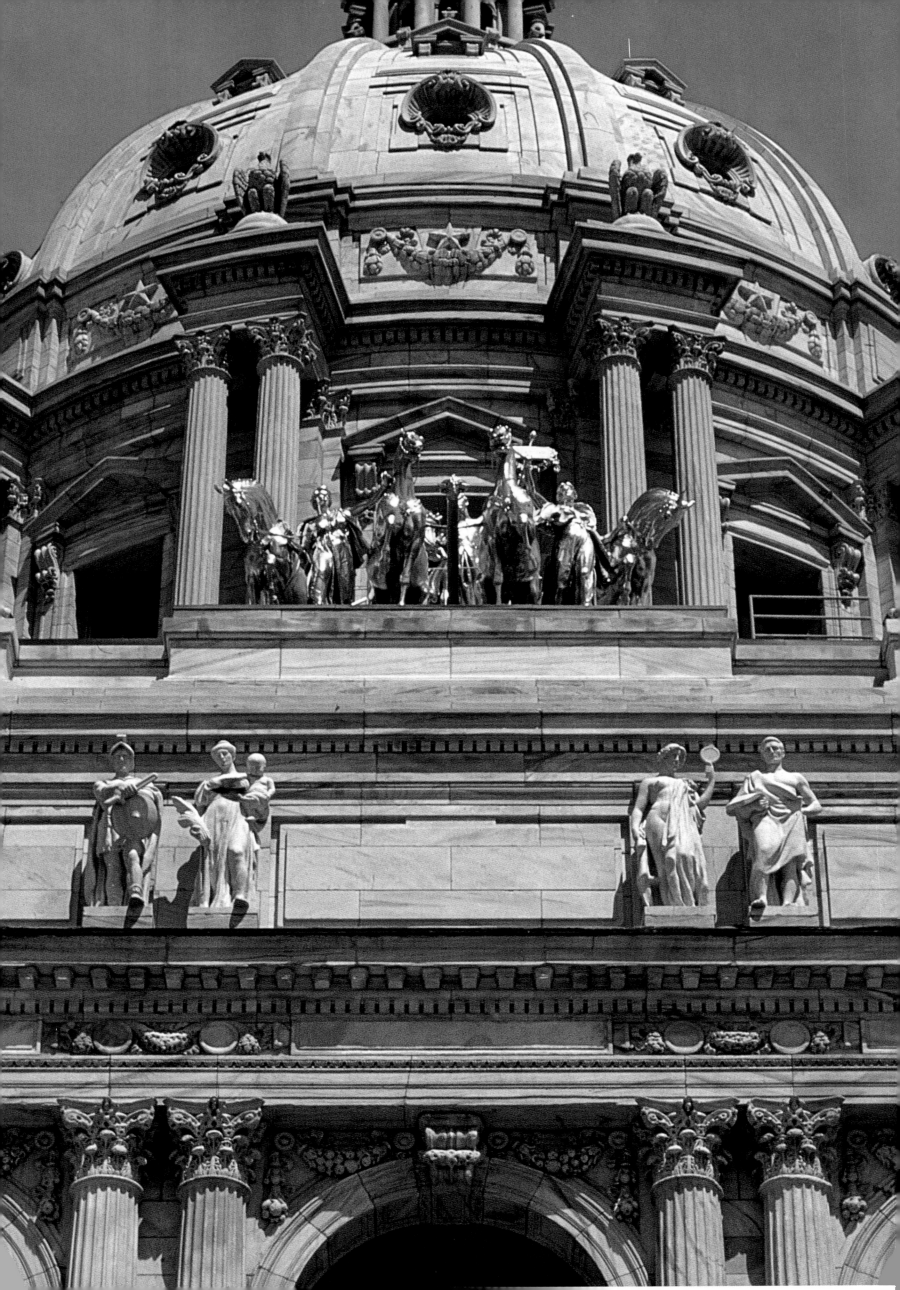

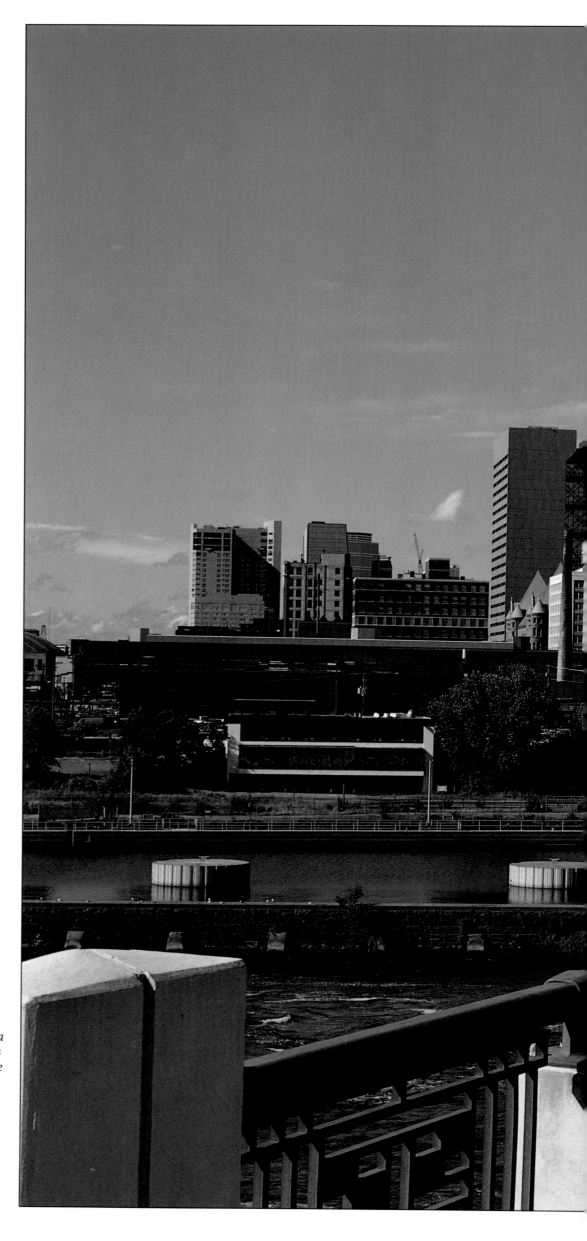

Minnesota's State Capitol (previous page), on a hill overlooking St. Paul, was designed by Cass Gilbert, and is crowned by an enormous marble dome. Right: Third Avenue Bridge, over the upper lock of St. Anthony Falls, frames the Minneapolis skyline.

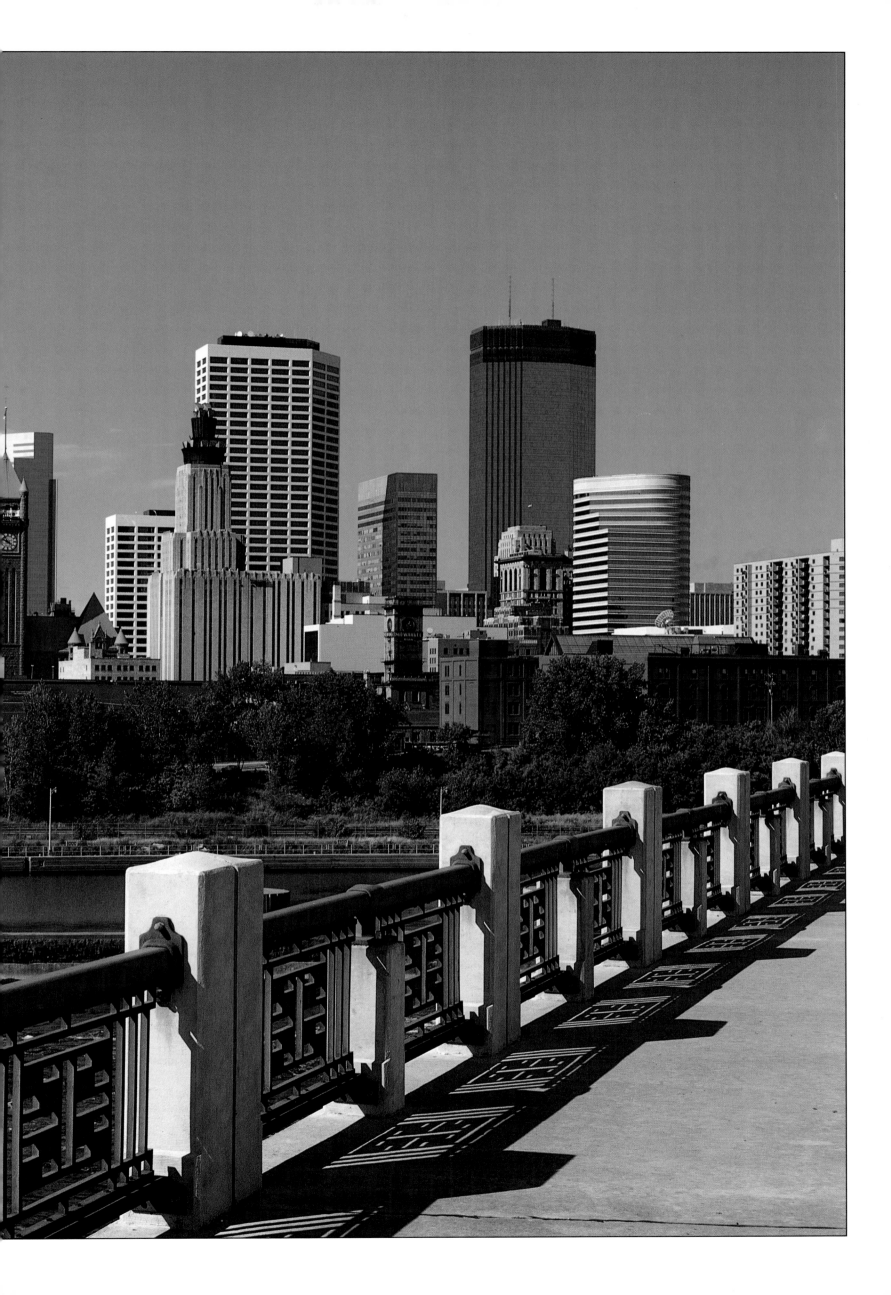

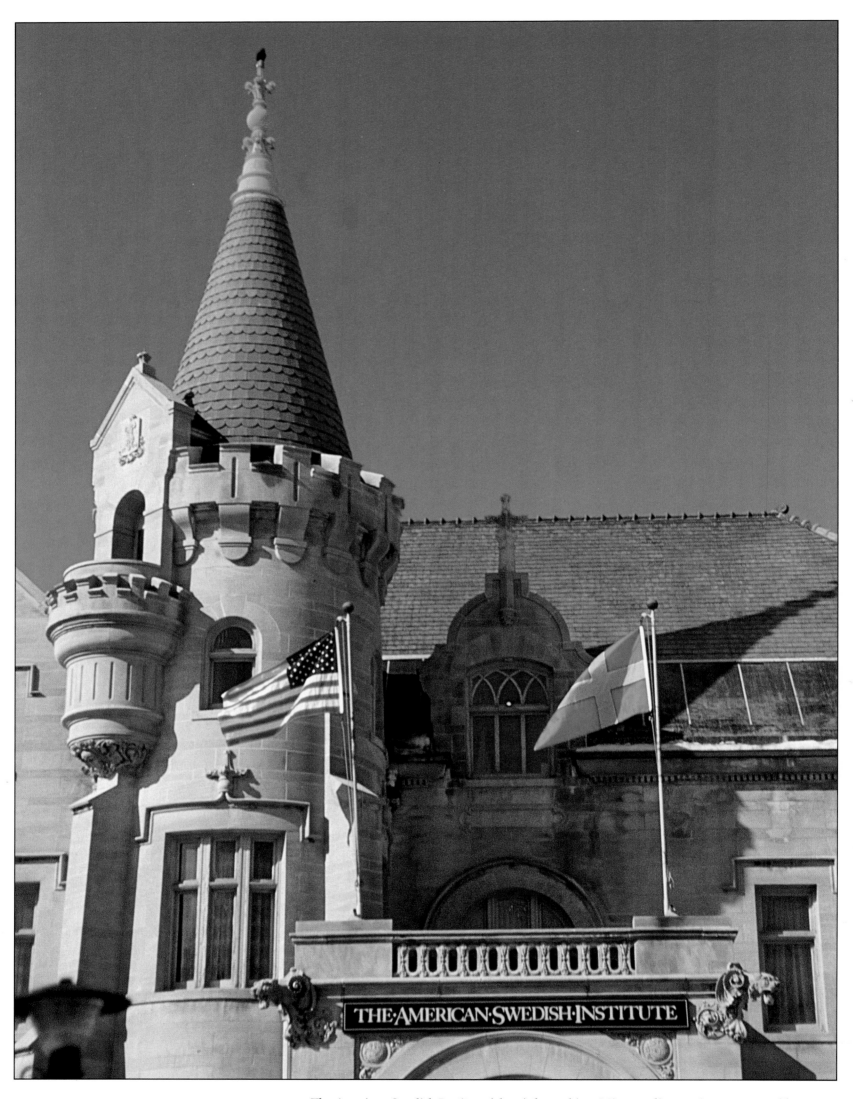

The American Swedish Institute (above), housed in a Minneapolis mansion once owned by immigrant publisher Swan J. Turnblad, preserves the Swedish experience in the United States. The pride of St. Paul is the massive Landmark Center (facing page), a restoration of a former Federal Court and Post Office. Overleaf: the Minneapolis skyline from Loring Park and the west.

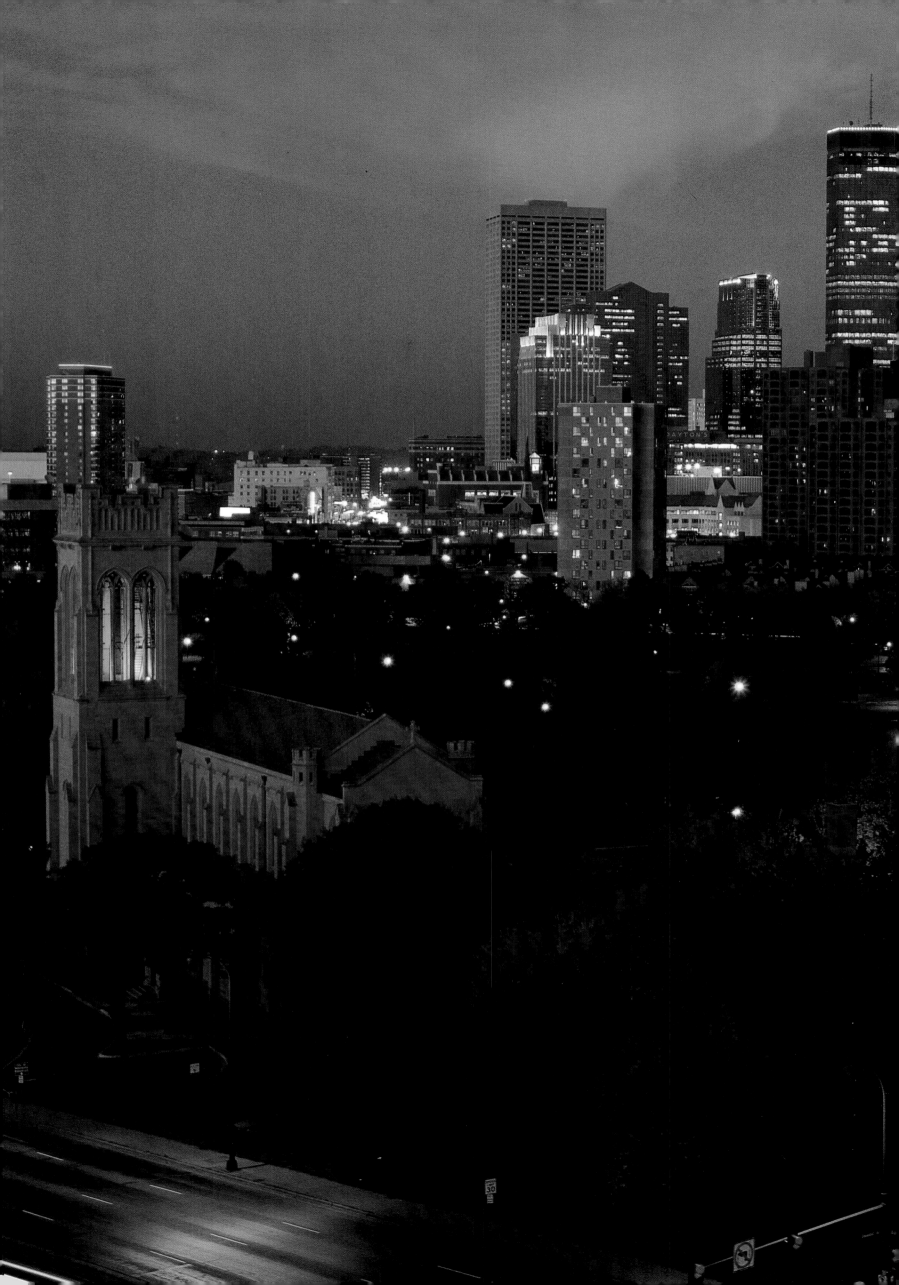

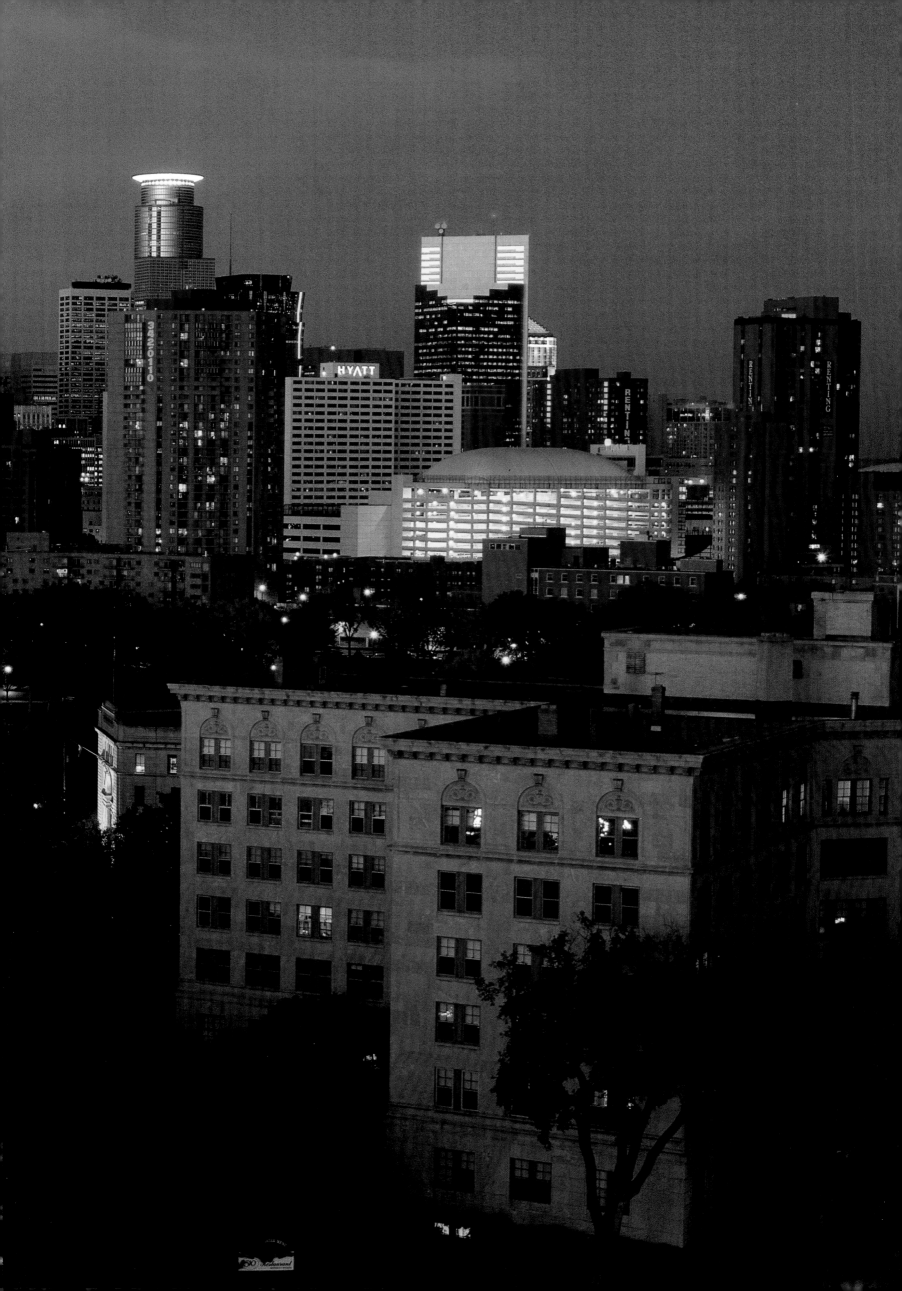

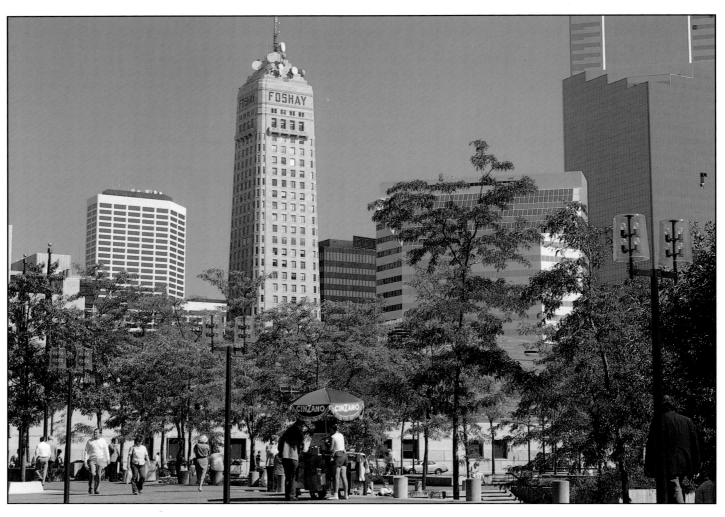

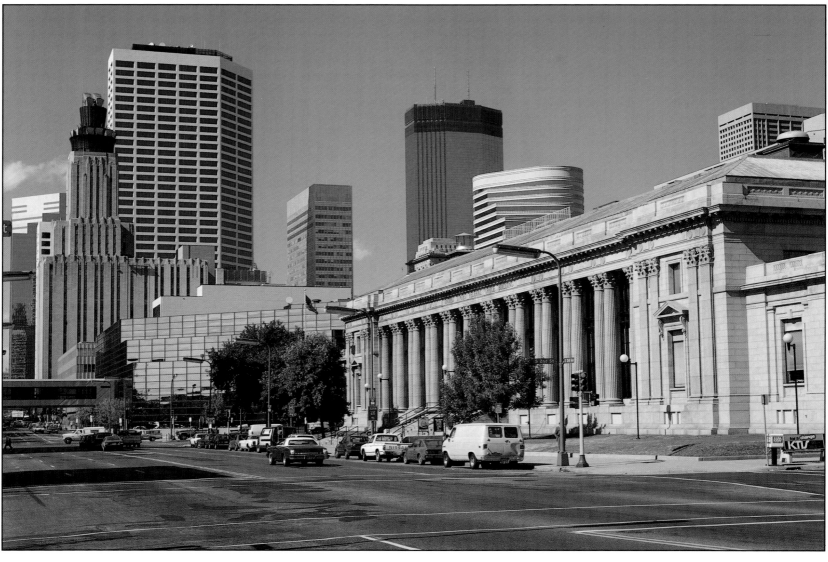

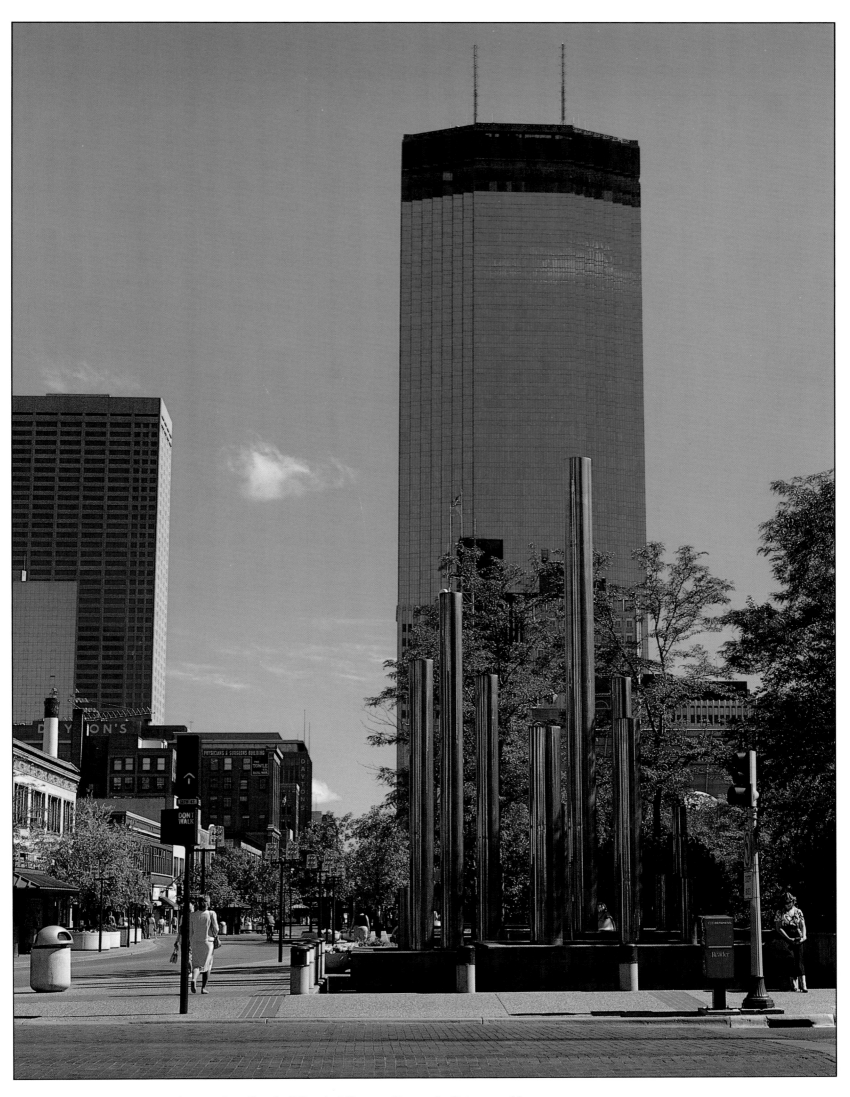

Foshay Tower (facing page top), once the tallest building in Minneapolis, was built to resemble the Washington Monument. But Washington's influence is officially represented by the Federal Office Building (facing page bottom). Above: the fifty-one-story IDS Tower looming over Peavey Plaza, considered the best work of architect Philip Johnson.

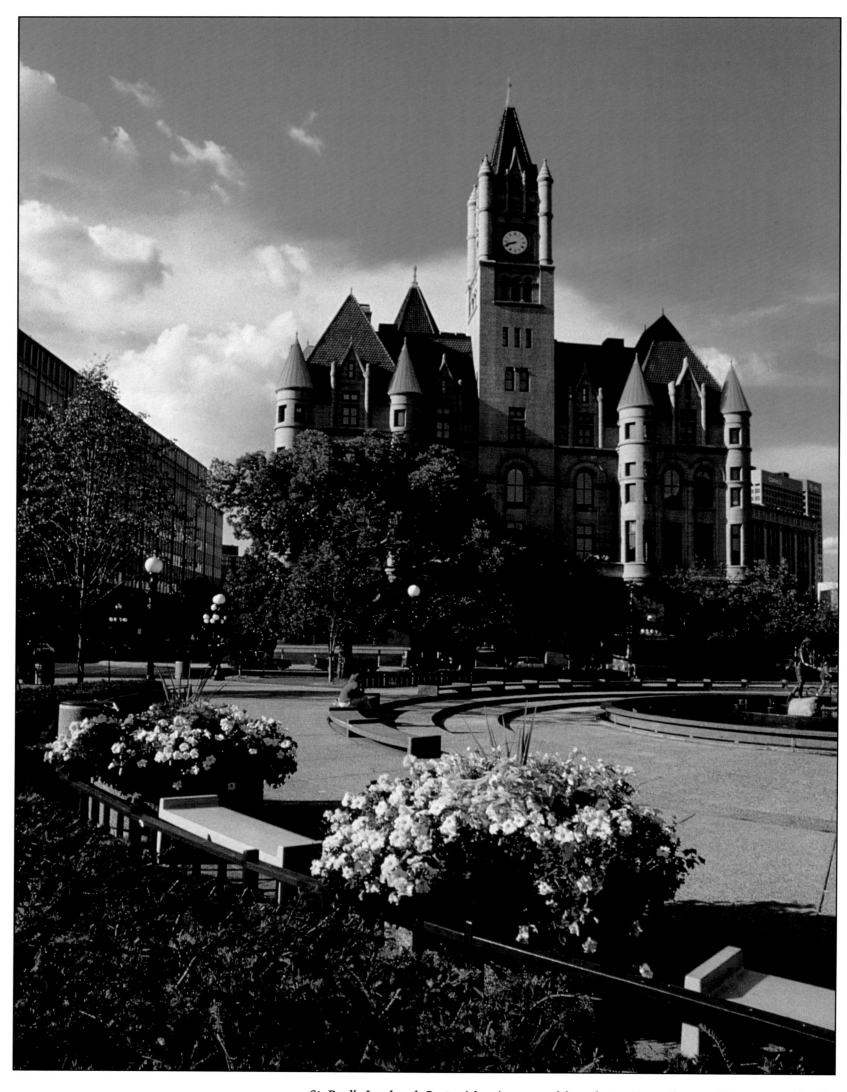

St. Paul's Landmark Center (above) was saved from destruction and restored by concerned local citizens. Rice Park and the Ordway Music Theater (facing page top) are on a site that has been an urban oasis for a century and a half, while the Minnesota State Capitol (facing page bottom), once surrounded by buildings, was given breathing space in one of America's earliest renewal projects. Overleaf: the St. Paul skyline, at its most dramatic looking across the Mississippi River at sunset.

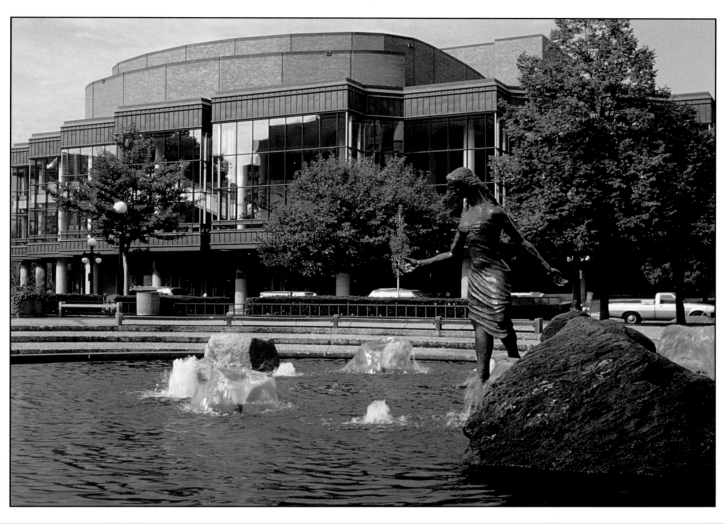

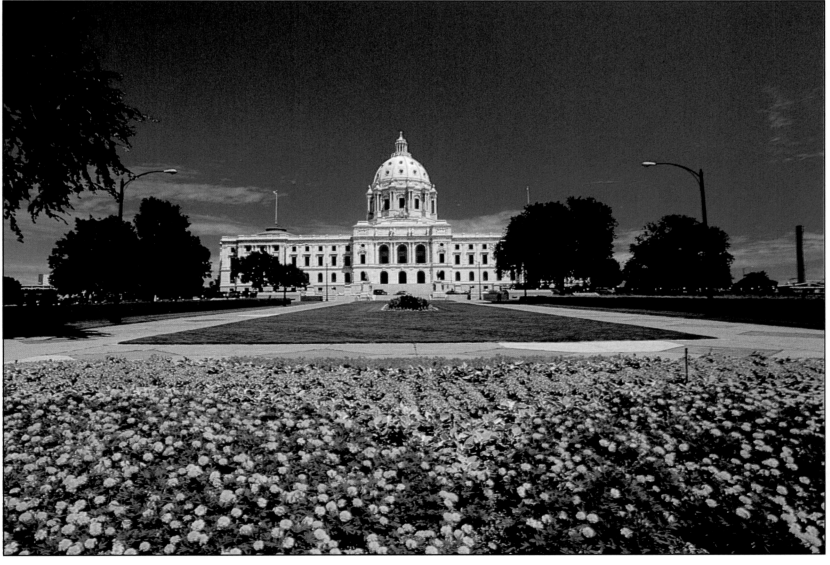

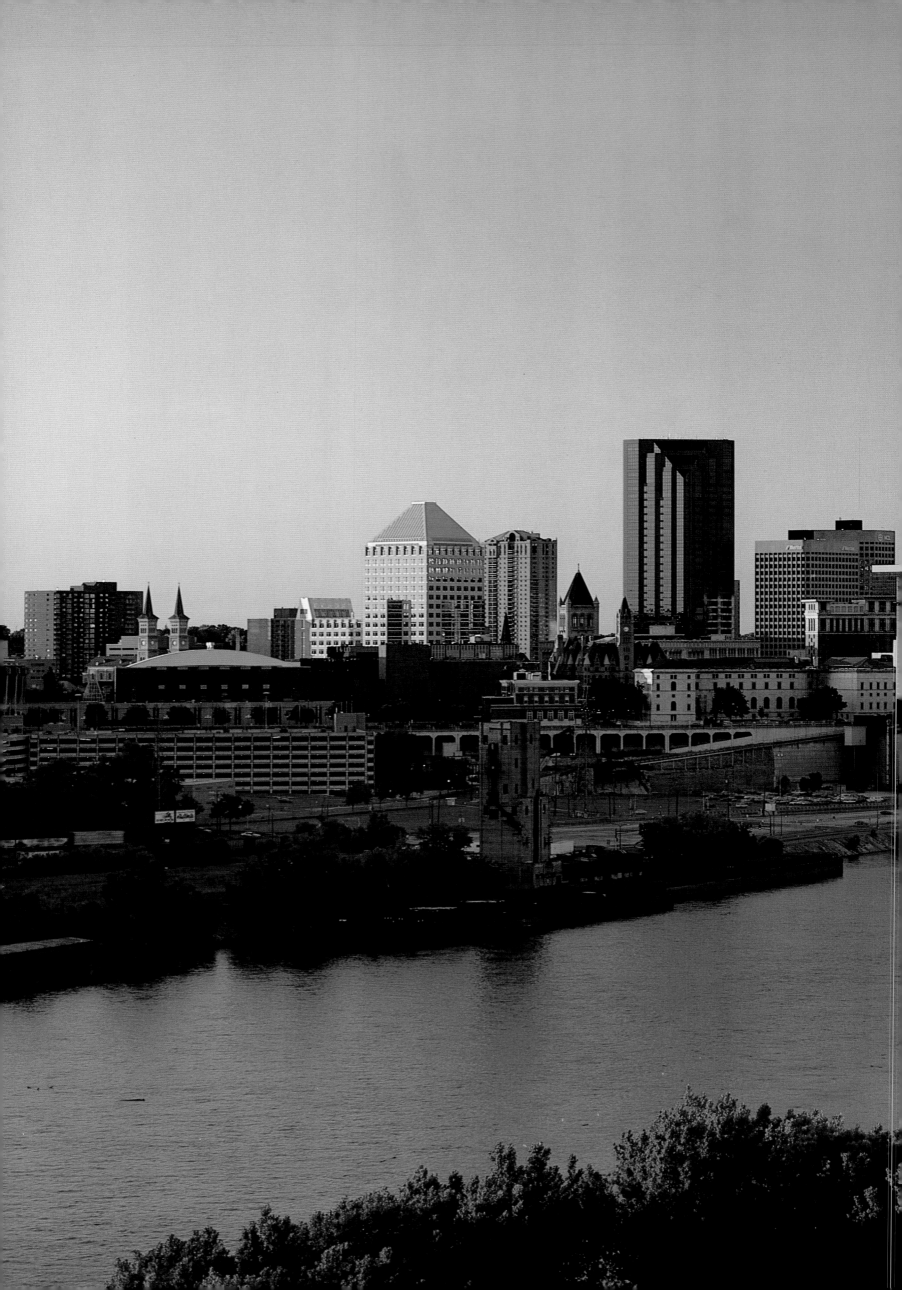

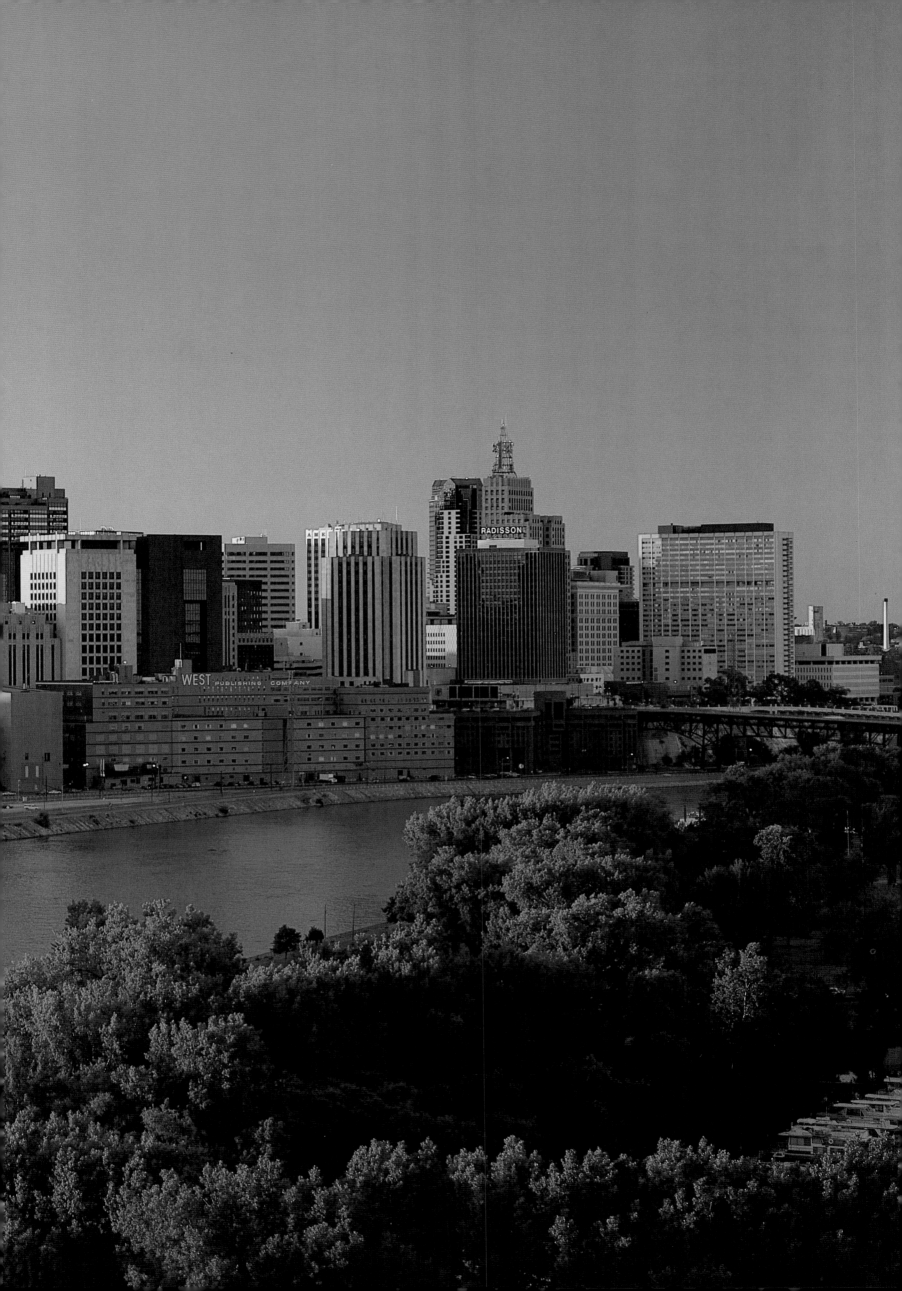

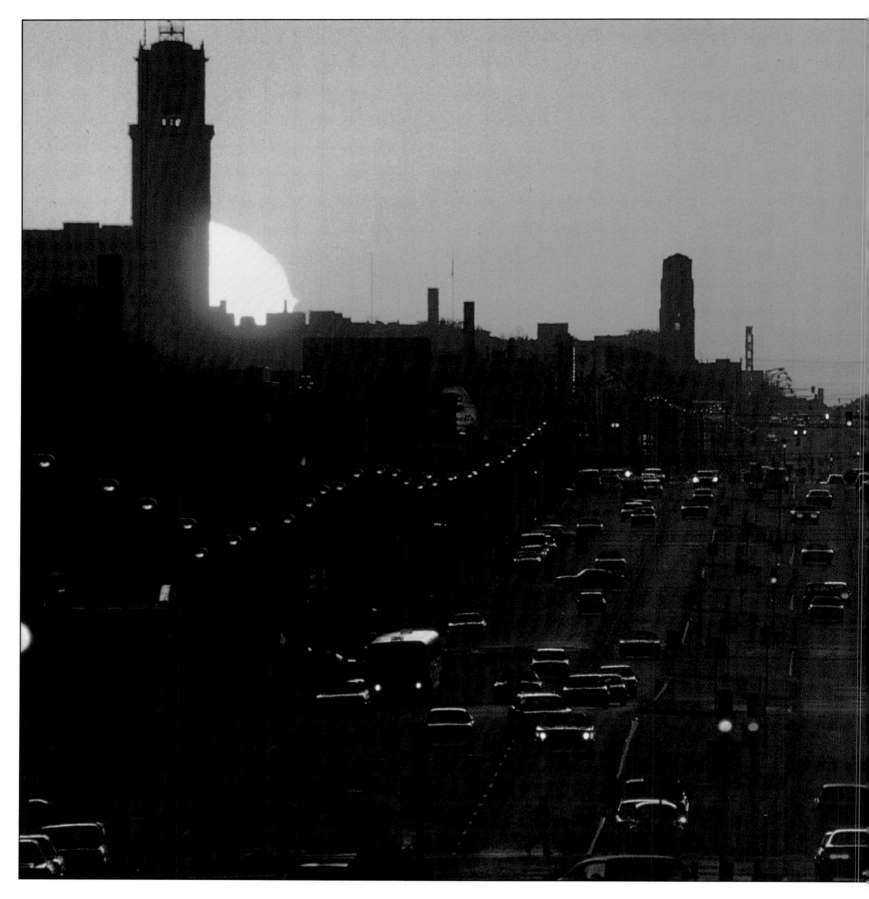

St. Paul's University Avenue (above) is one of the main links between the Twin Cities, although interstates connect Minneapolis (right) with the rest of Minnesota and the country. Perhaps the most recognizable structure in downtown Minneapolis is the Hubert H. Humphrey Metrodome Stadium (overleaf), home of the Minnesota Twins.

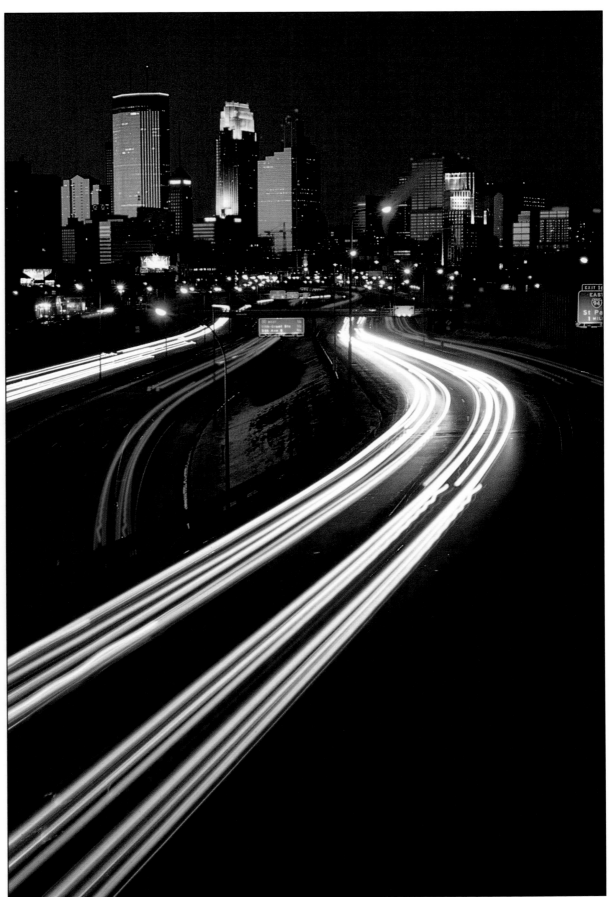

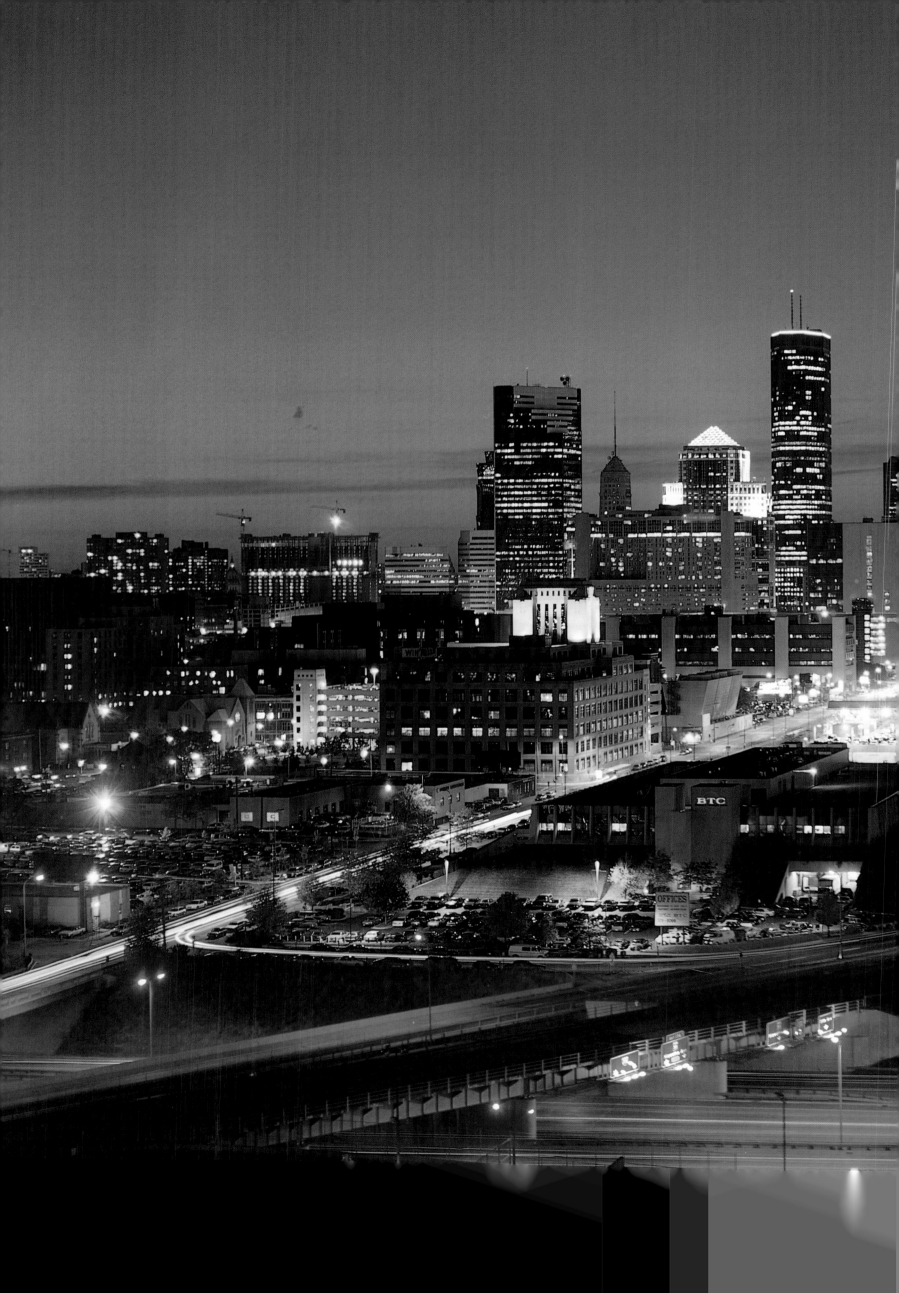

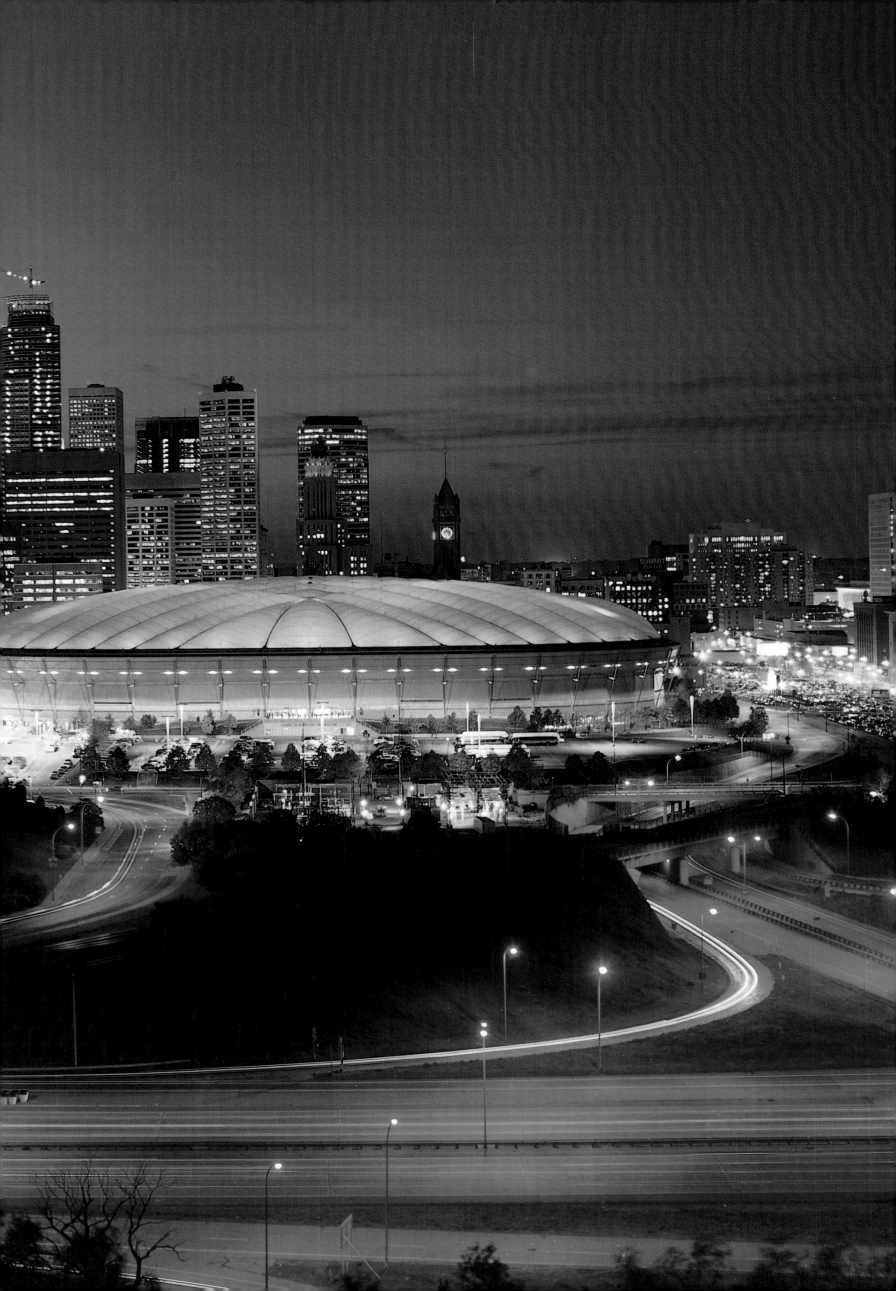

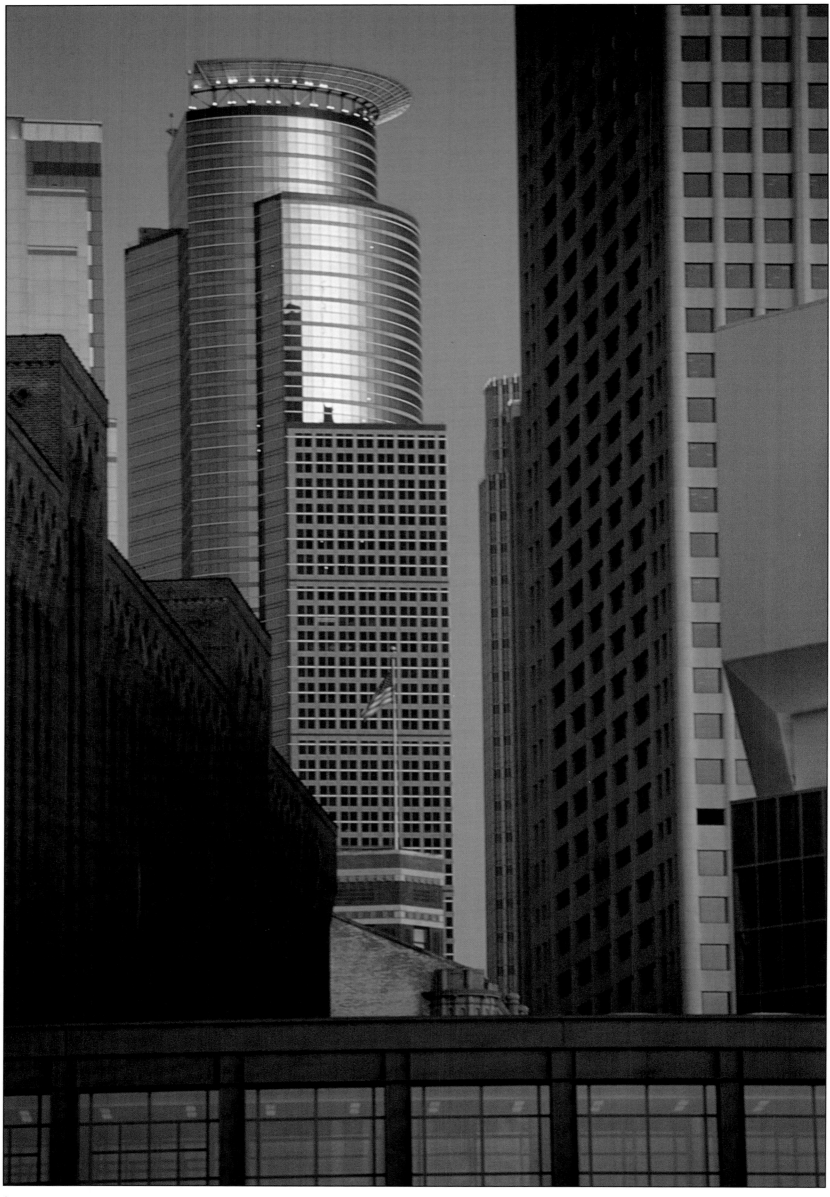

The modern landmark of Minneapolis' Target Center (facing page and overleaf), home of the Minnesota Timberwolves basketball team, is one of the Twin Cities' newest attractions, and Galtier Plaza (above) is part of the "new" St. Paul.

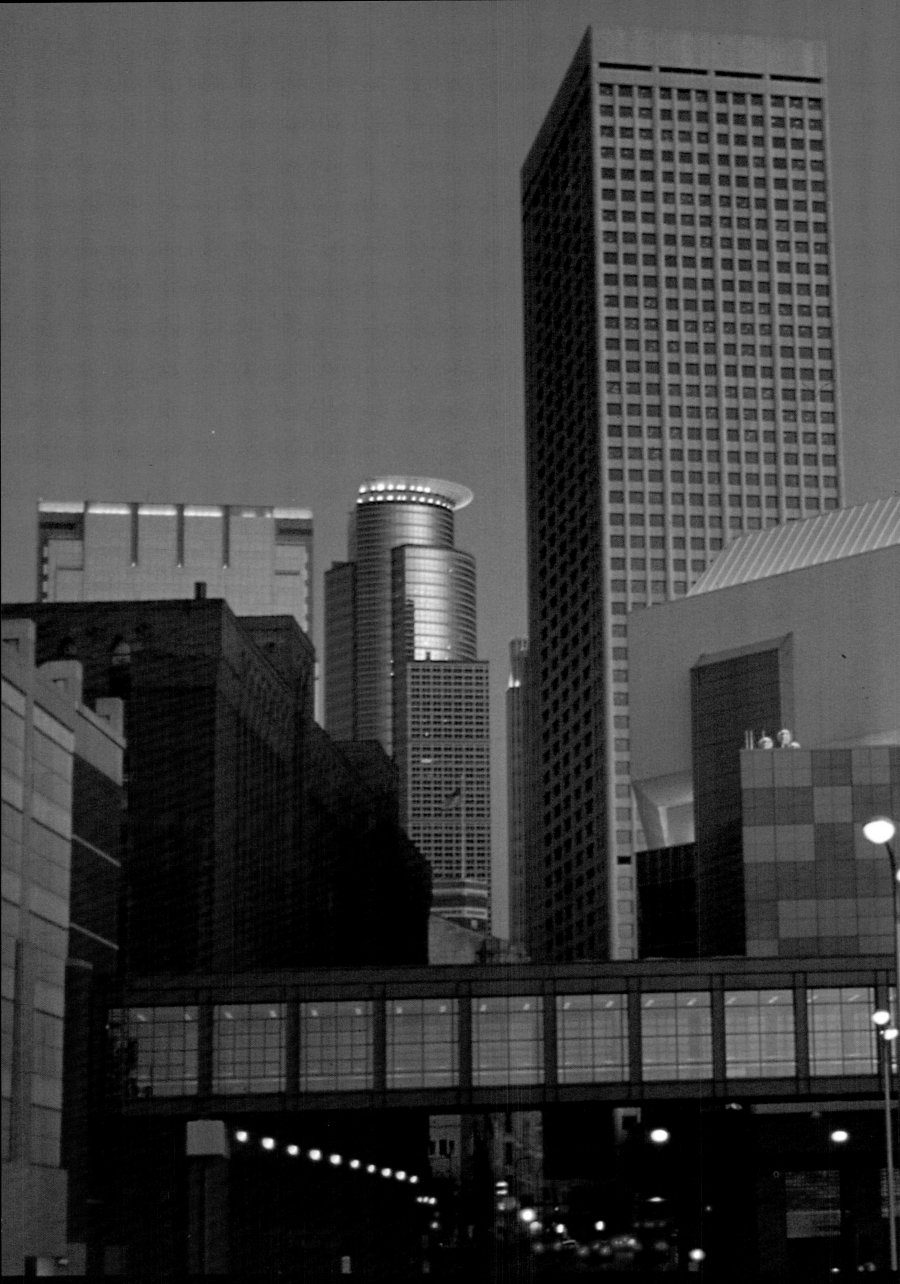

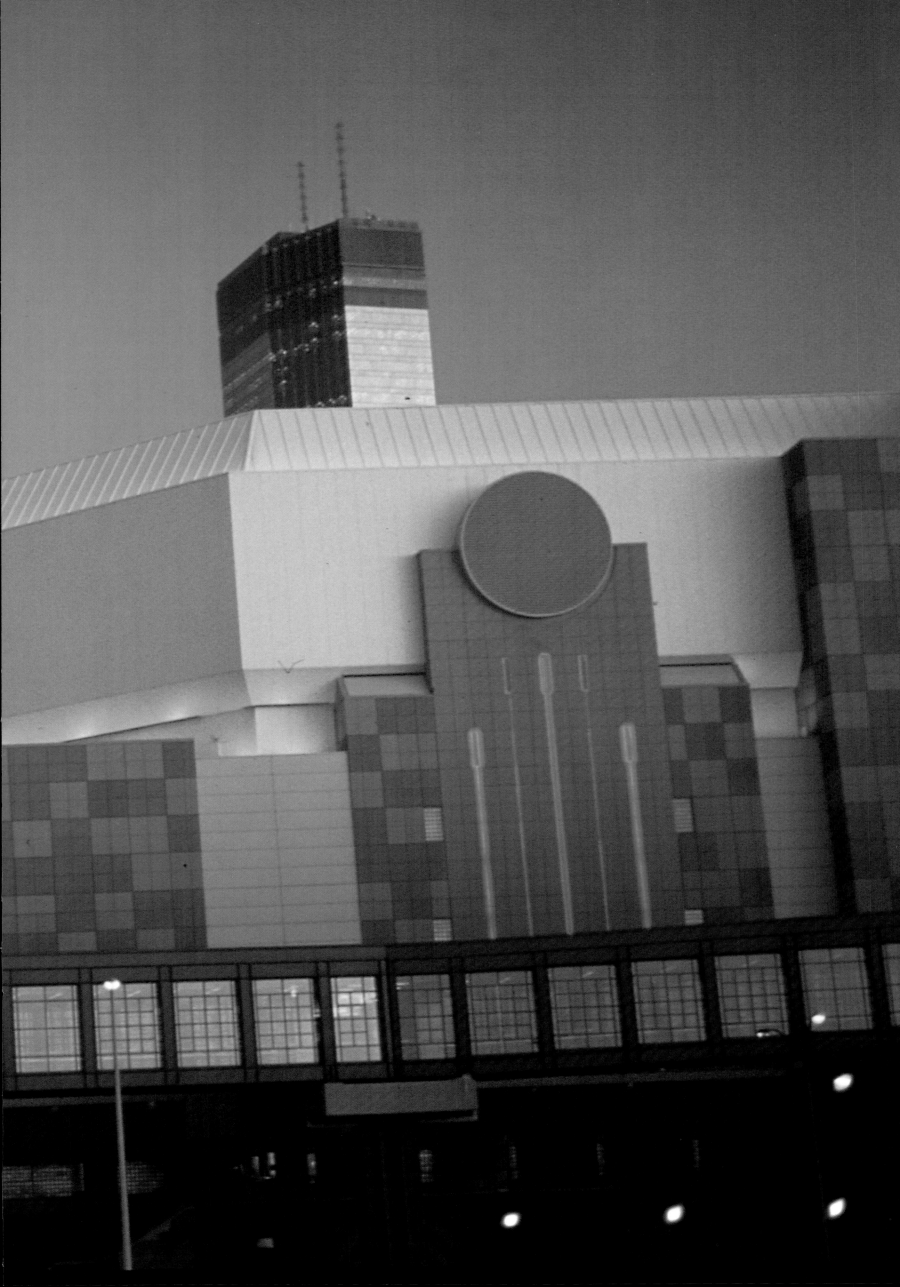

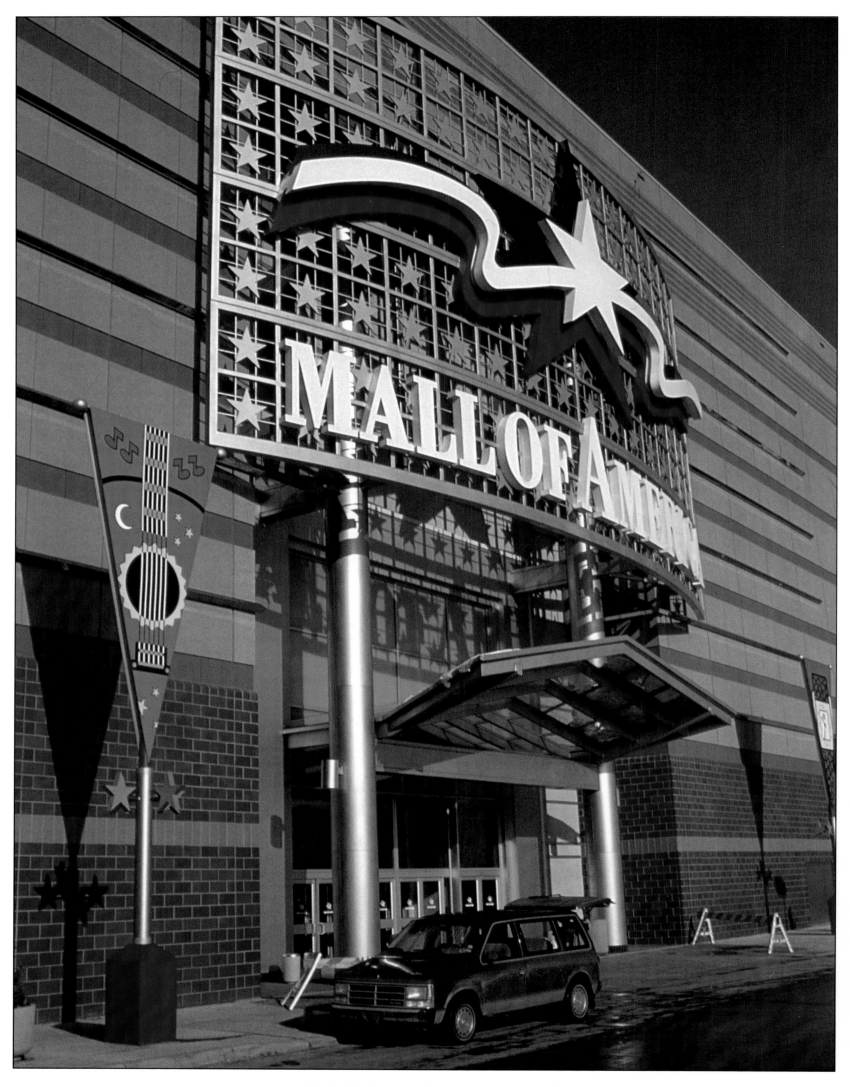

The Mall of America (these pages and overleaf), in Bloomington, is a year-round wonderland of greenery, entertainment and, of course, abundant shopping opportunities. The biggest shopping mall in the country, it is filled with such excitements as Camp Snoopy (facing page top) and Legoland (facing page bottom).

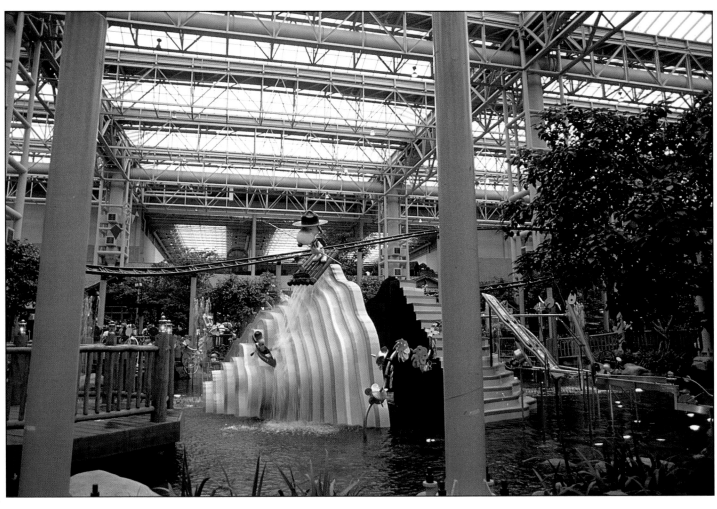

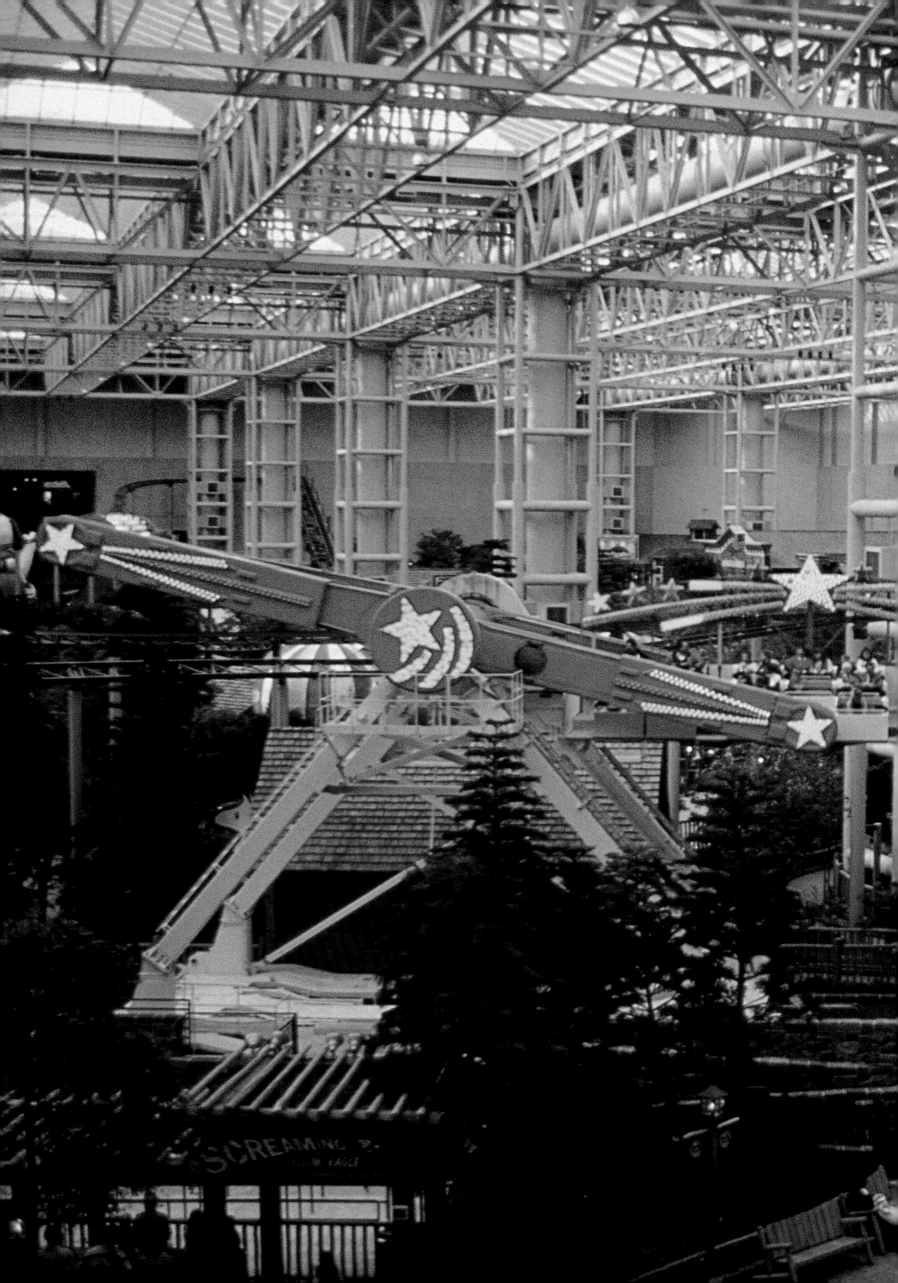

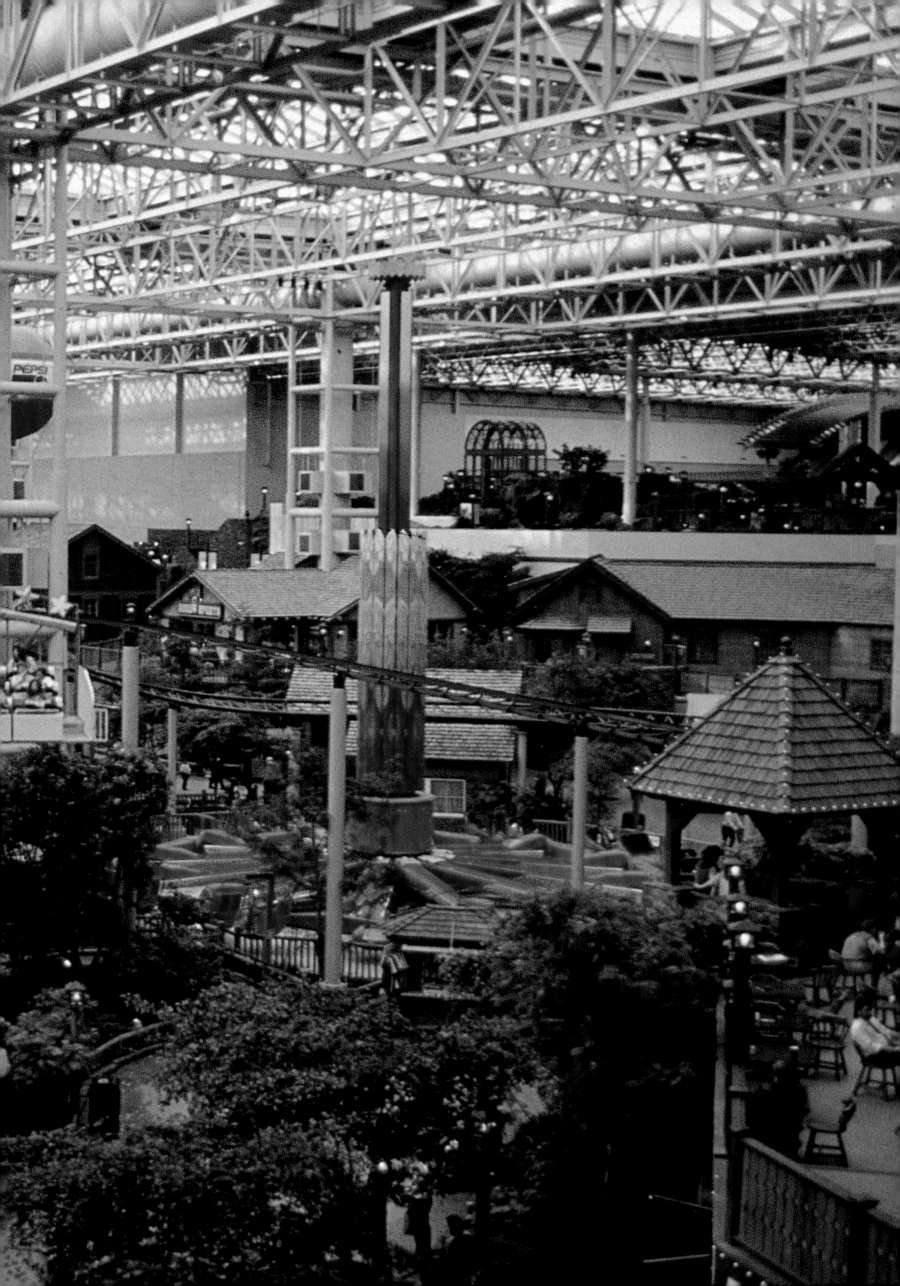

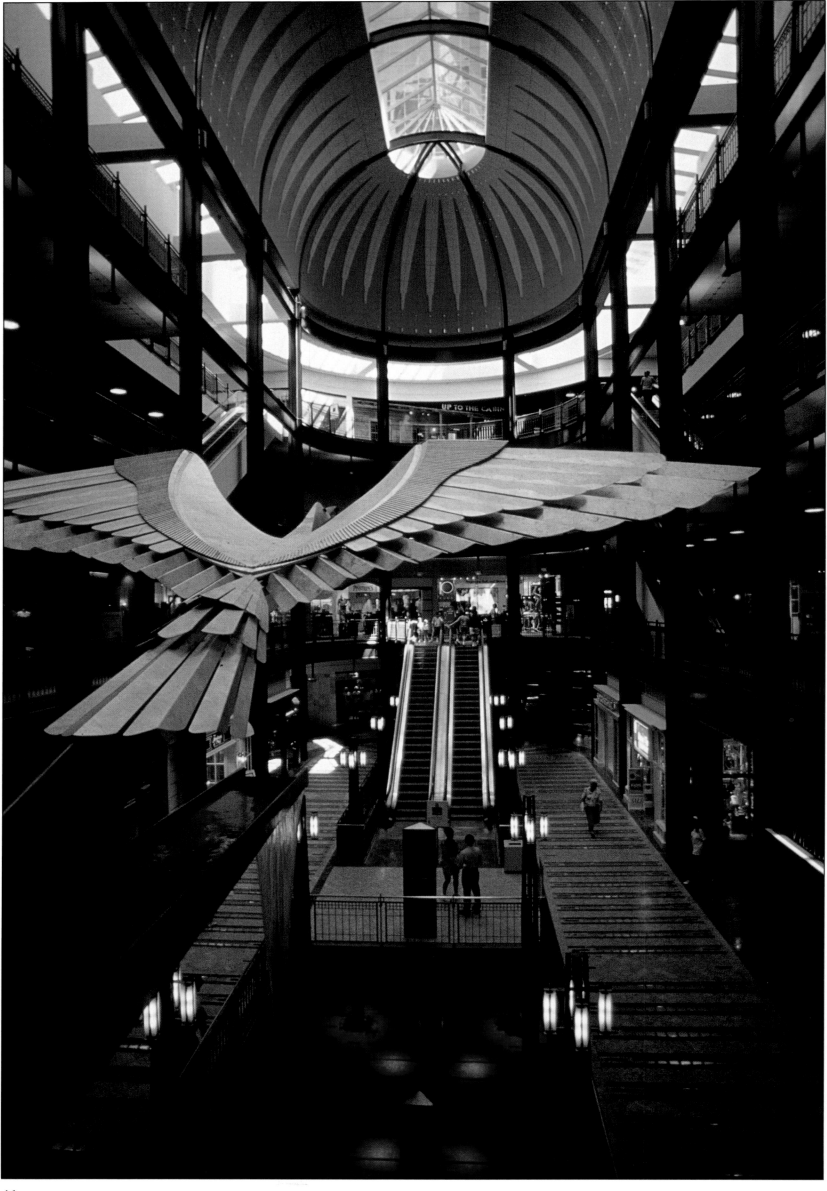

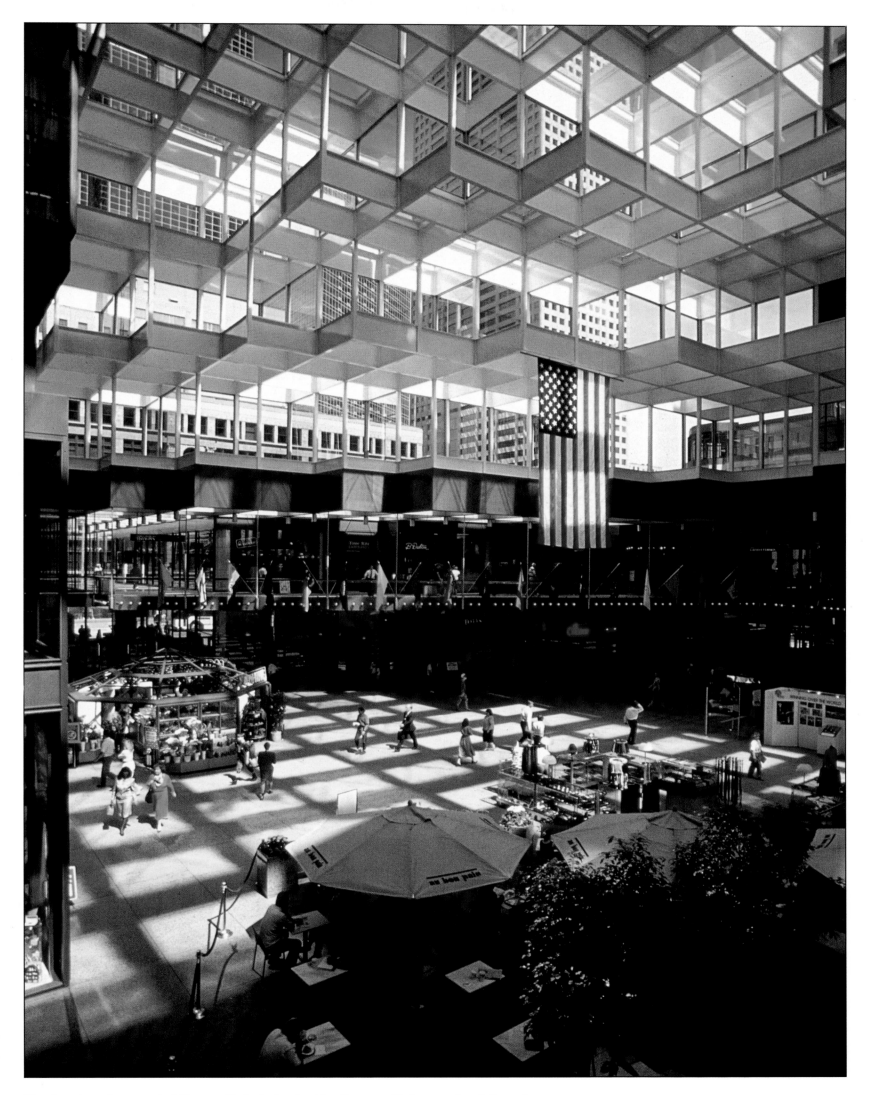

The shopping adventure in Minneapolis includes Gavidae Common (facing page) and Crystal Court (above), the focal point of the city's skyway system. Christmas shopping in the Twin Cities is made easier by such climate-controlled shopping spaces as the Conservatory at Nicollet Mall (overleaf), which is connected to other shopping areas by skyway and the underground "serpentine."

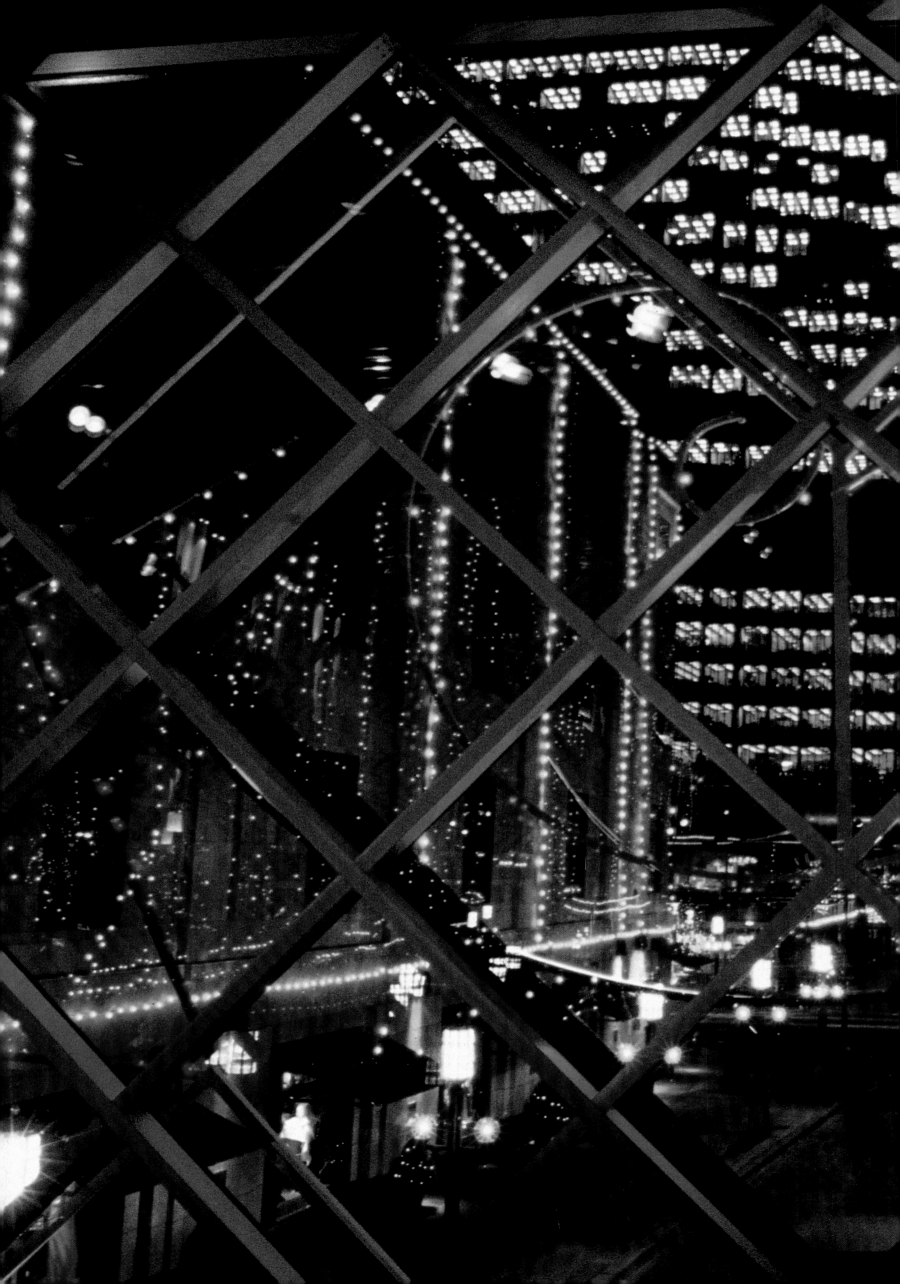

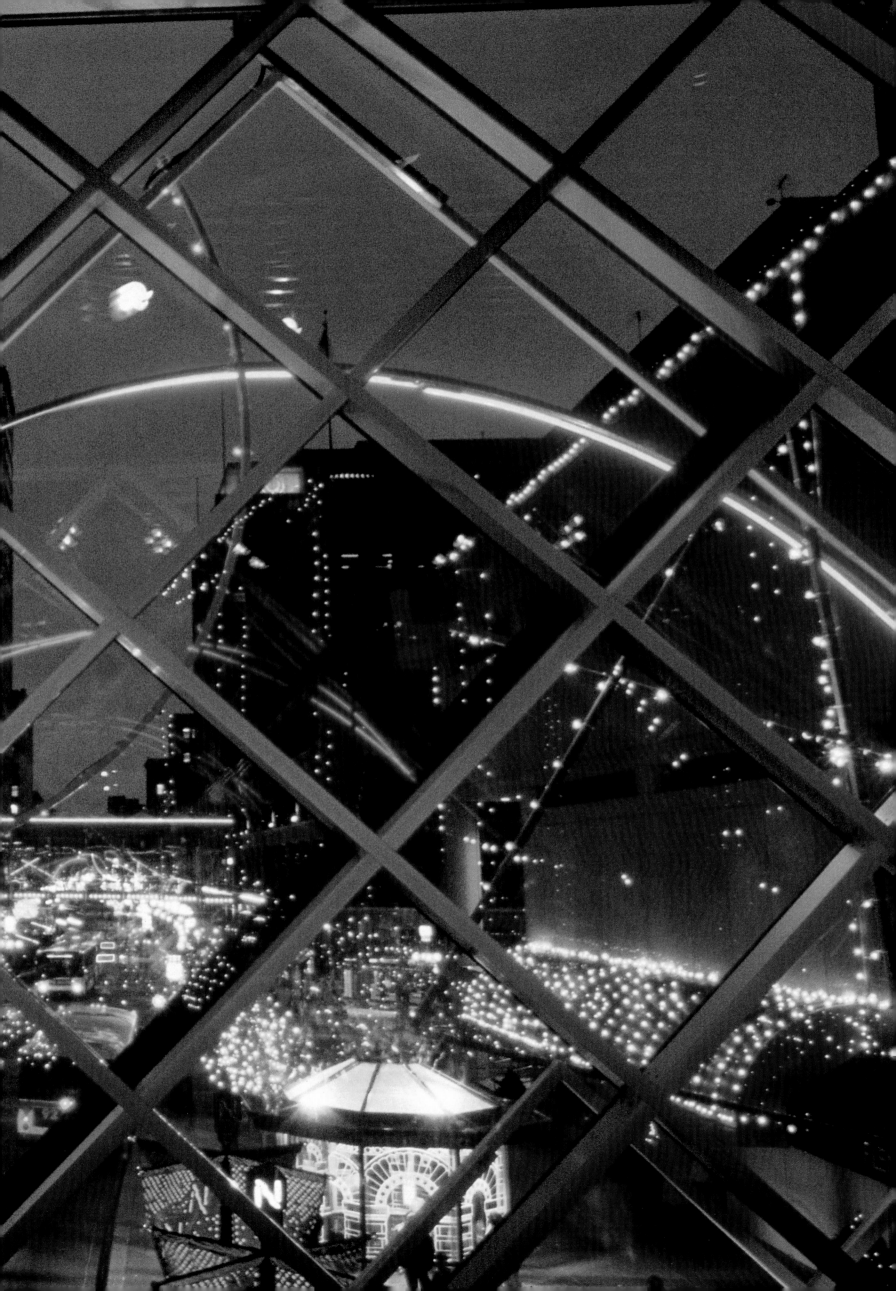

They take winter in their stride in the Twin Cities, where a White Christmas (these pages) is a foregone conclusion. Some say that Minnehaha Falls (overleaf), a spectacular natural feature in Minnehaha Falls Park, is even more beautiful when surrounded by ice and snow.

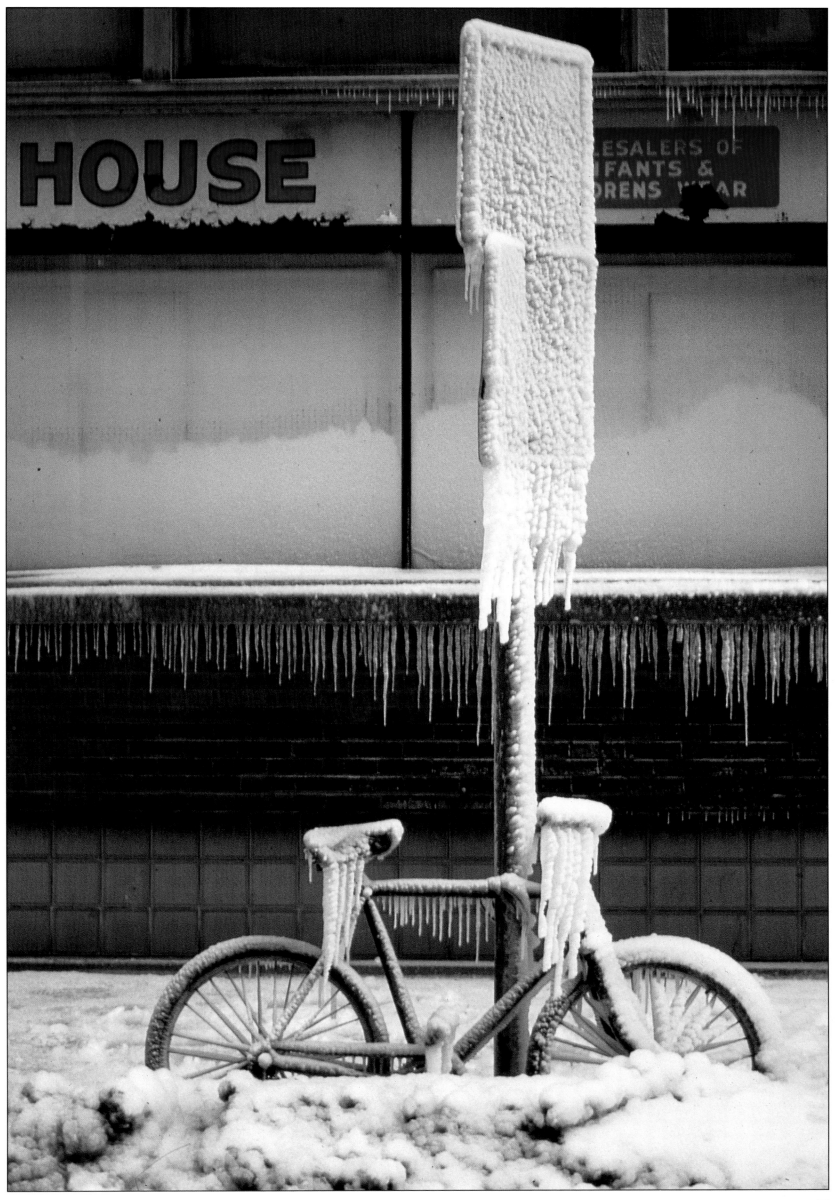

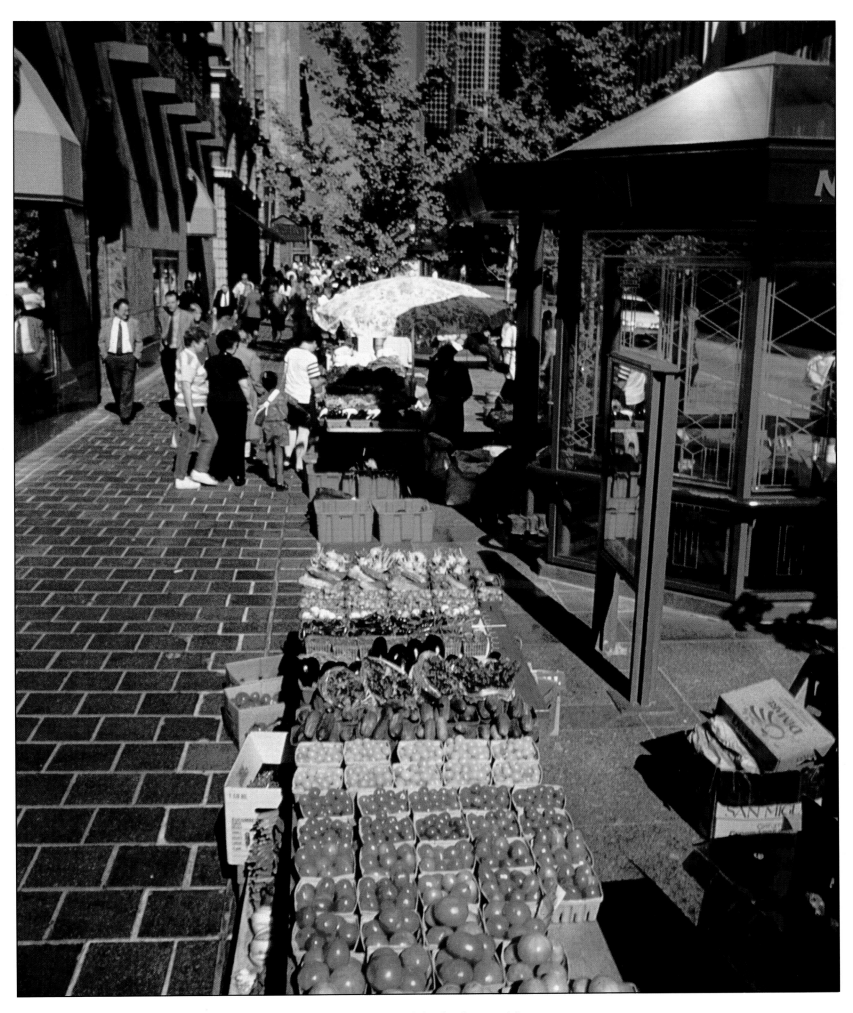

Minneapolis Farmers' Market (these pages), in Nicollet Mall, is a colorful, lively place to visit where midwest farmers and plant growers bring their produce and buyers and sellers converge in the early hours of the morning. At weekends arts and crafts are added to the goods available.

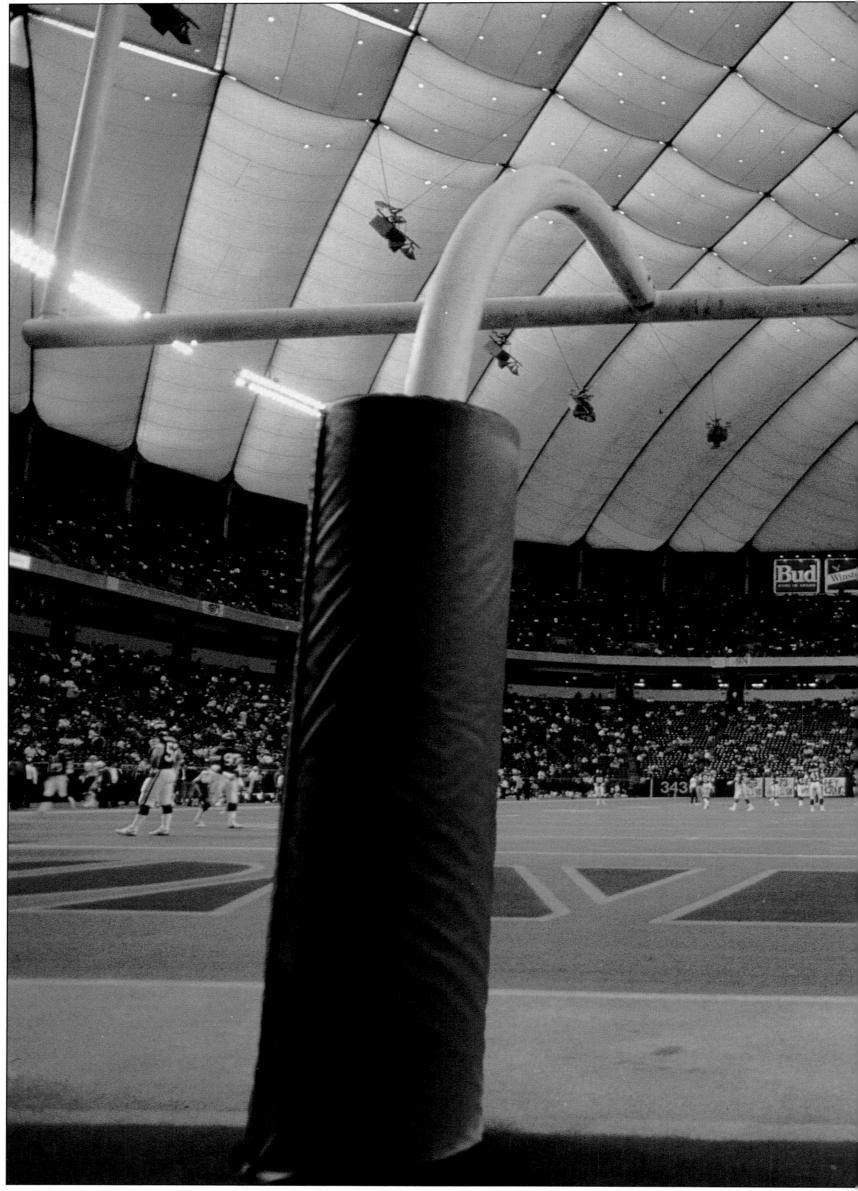

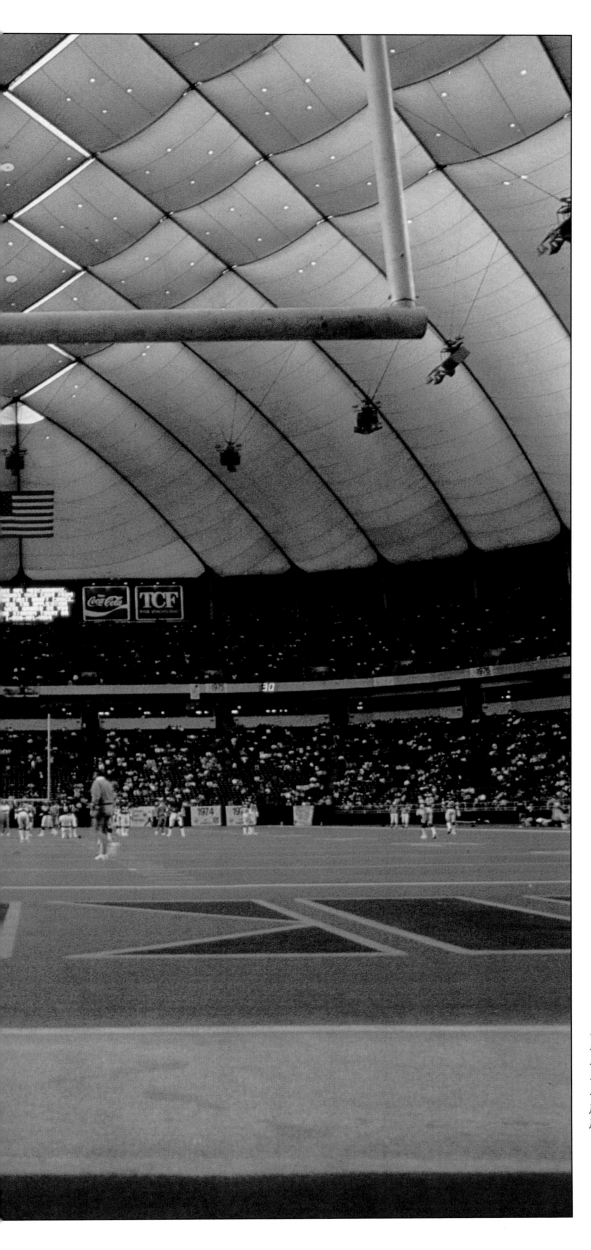

Left and overleaf: the Hubert H. Humphrey Metrodome, Minneapolis home to the Minnesota Vikings of the National Football League and the Minnesota Twins of baseball's American League, has a capacity of 62,212 for football and 55,883 for a baseball game. It is frequently filled to capacity!

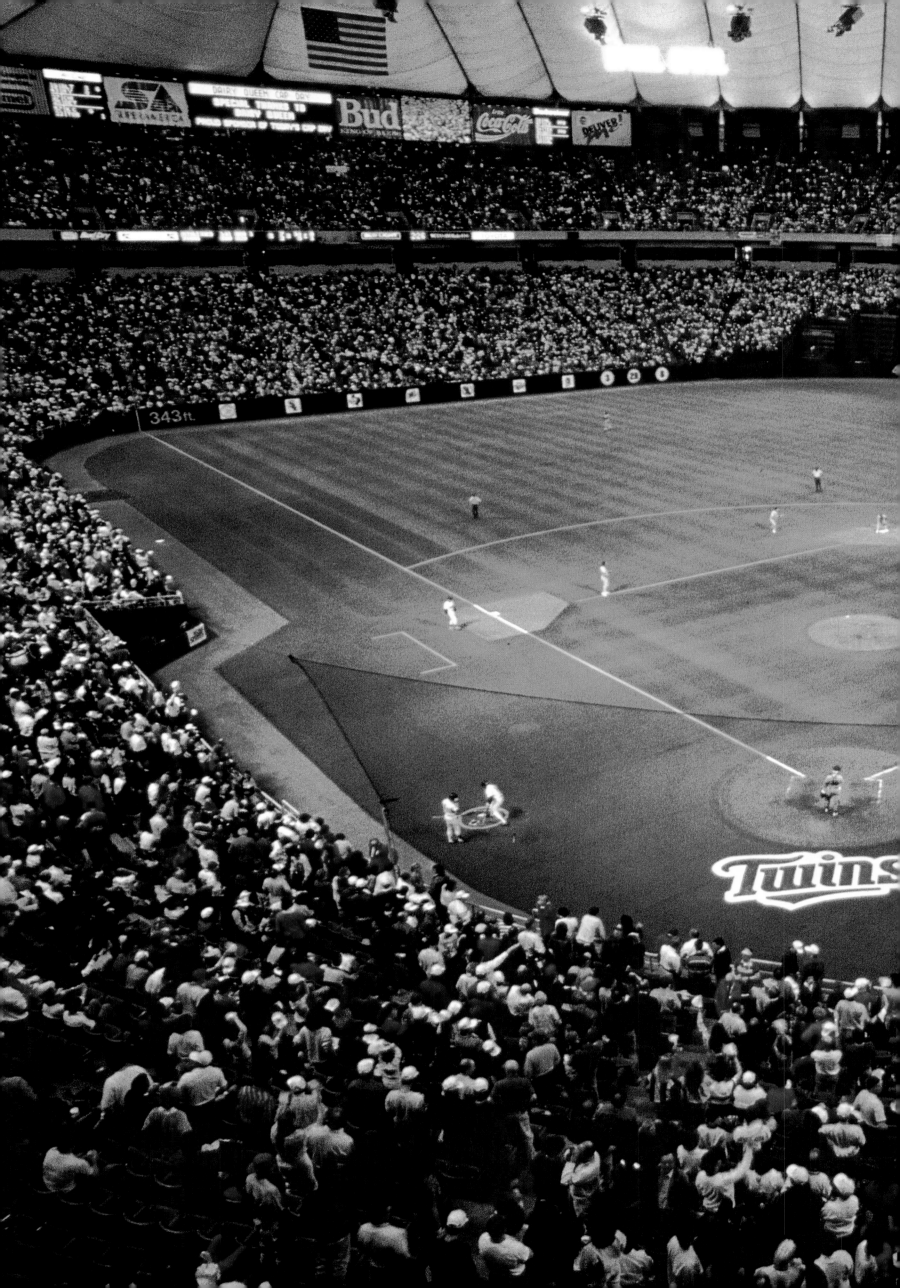

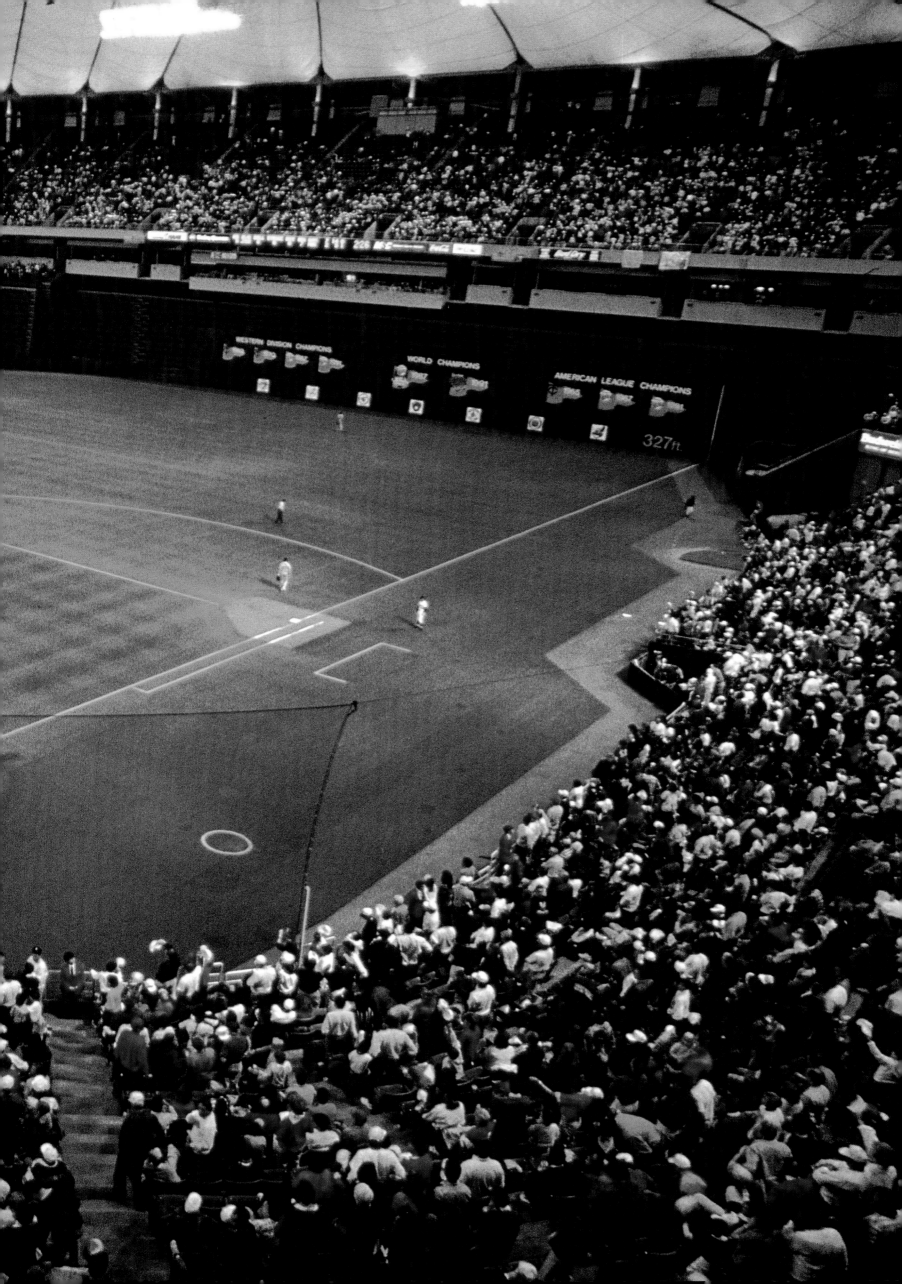

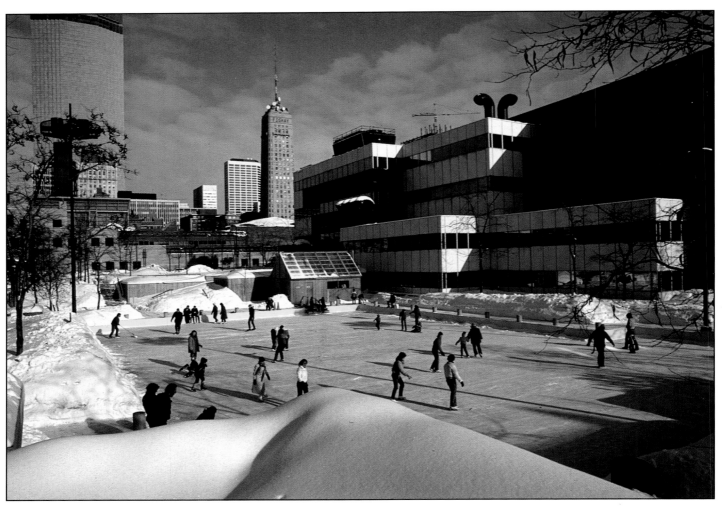

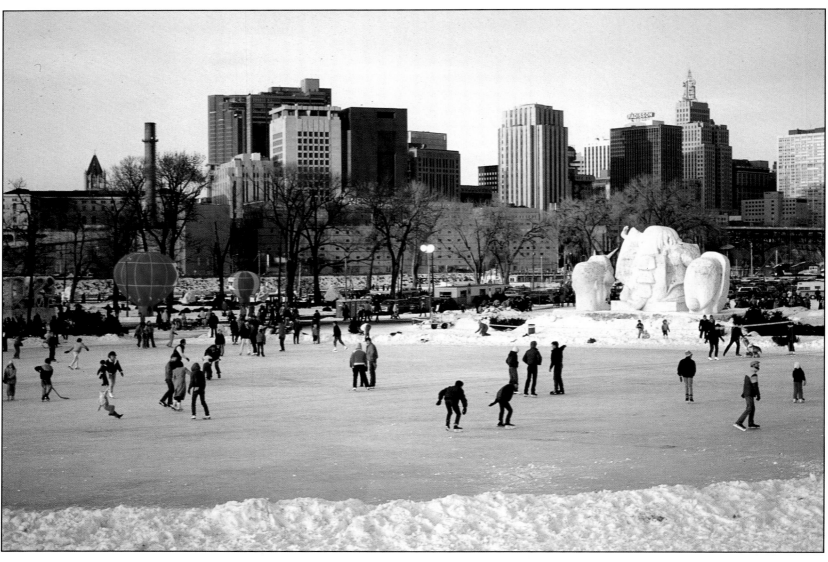

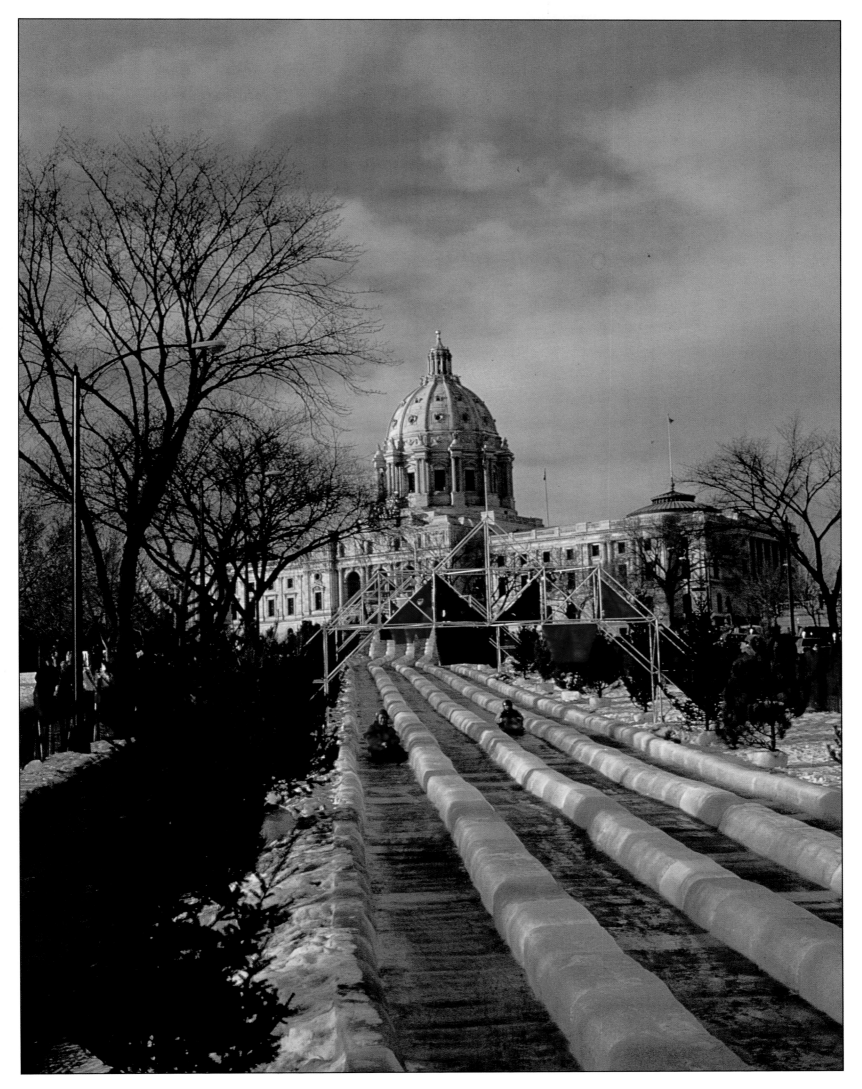

The St. Paul Winter Carnival (above and facing page bottom) is the country's largest cold-weather celebration, involving everything imaginable to turn snow and ice into pure pleasure. Another winter attraction is the ice skating rink at Peavey Plaza in Minneapolis (facing page top), an area converted to an outdoor restaurant during summer.

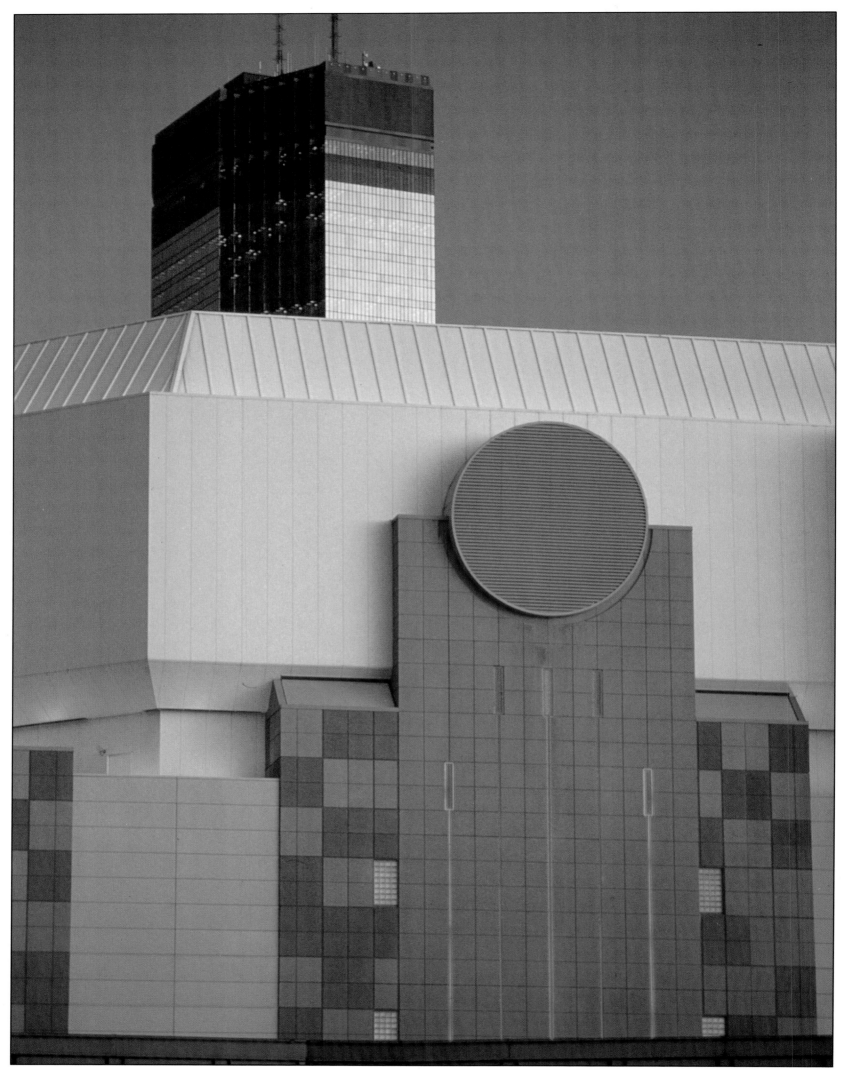

Minneapolis streetscapes are made even more fascinating by the designs on such building facades as the Target Center (above), the Valspar Building (facing page top and overleaf) and the revitalized Warehouse District (facing page bottom).

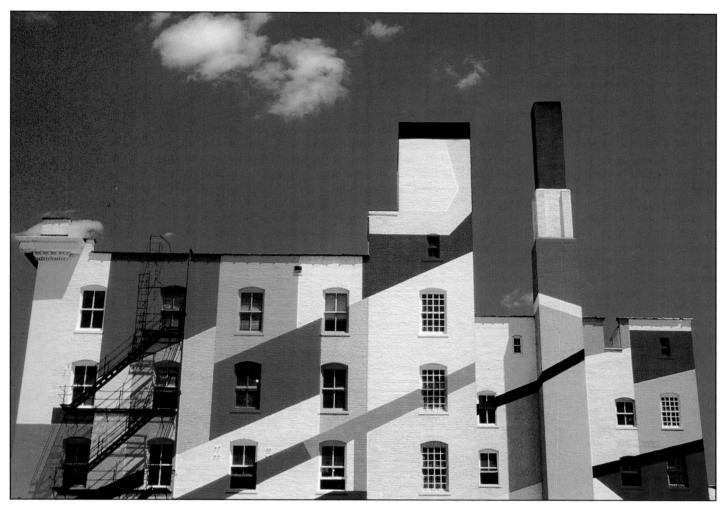

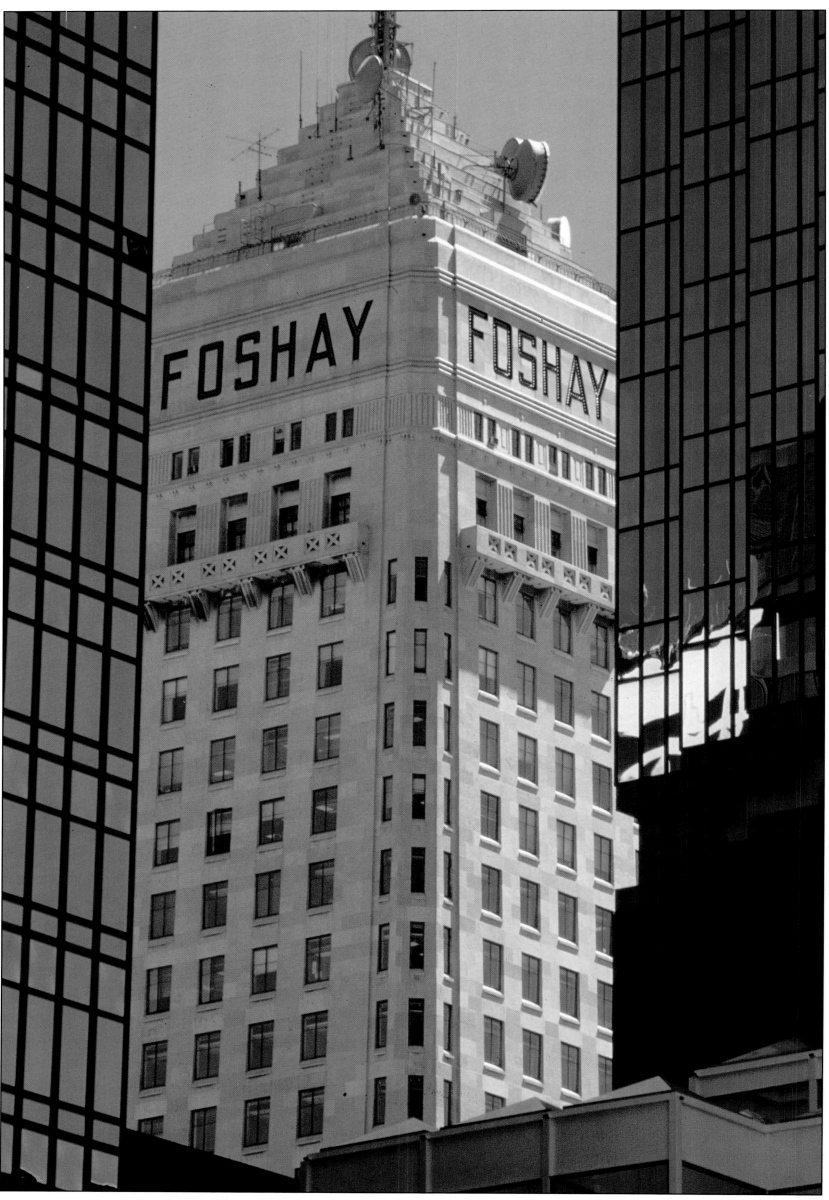

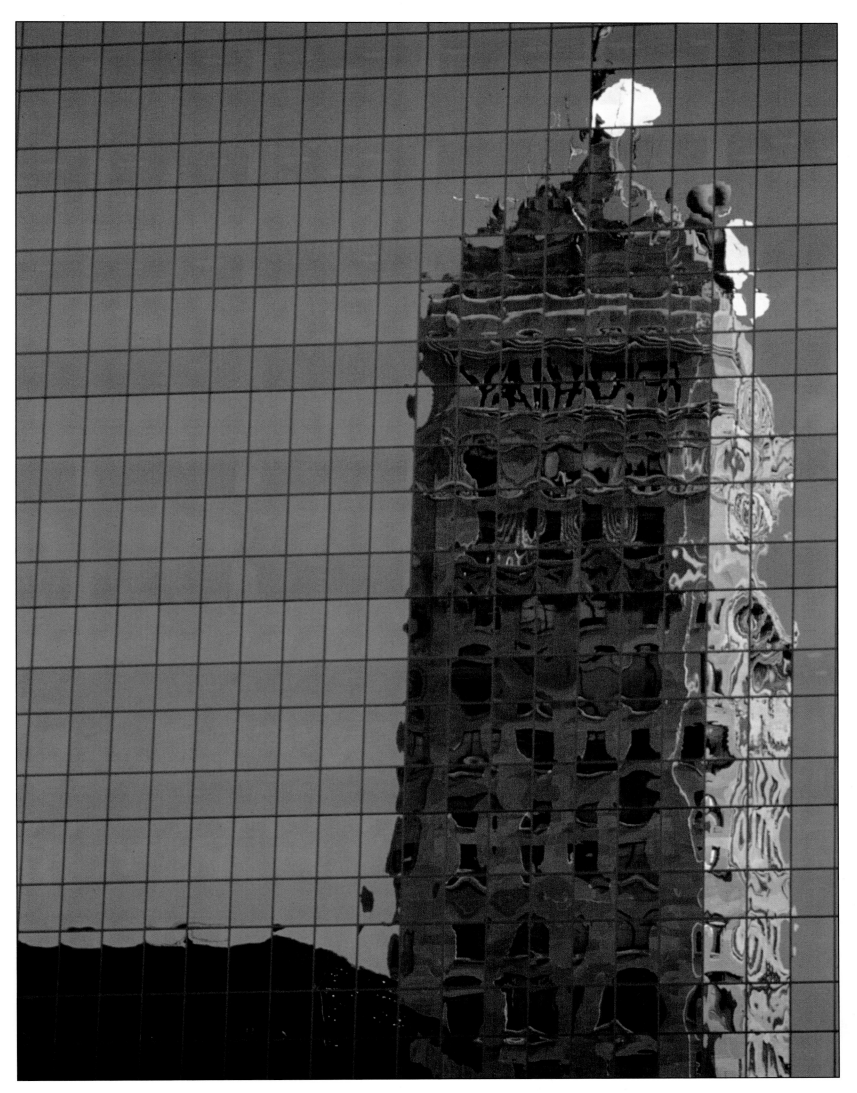

Foshay Tower (these pages) was built in 1929 as the headquarters of a utility empire, which went out of business soon after the building's dedication. The tower once dominated the Minneapolis skyline, but due to the tide of progress new structures on the skyline (overleaf) now dominate Foshay's monument to the Roaring Twenties.

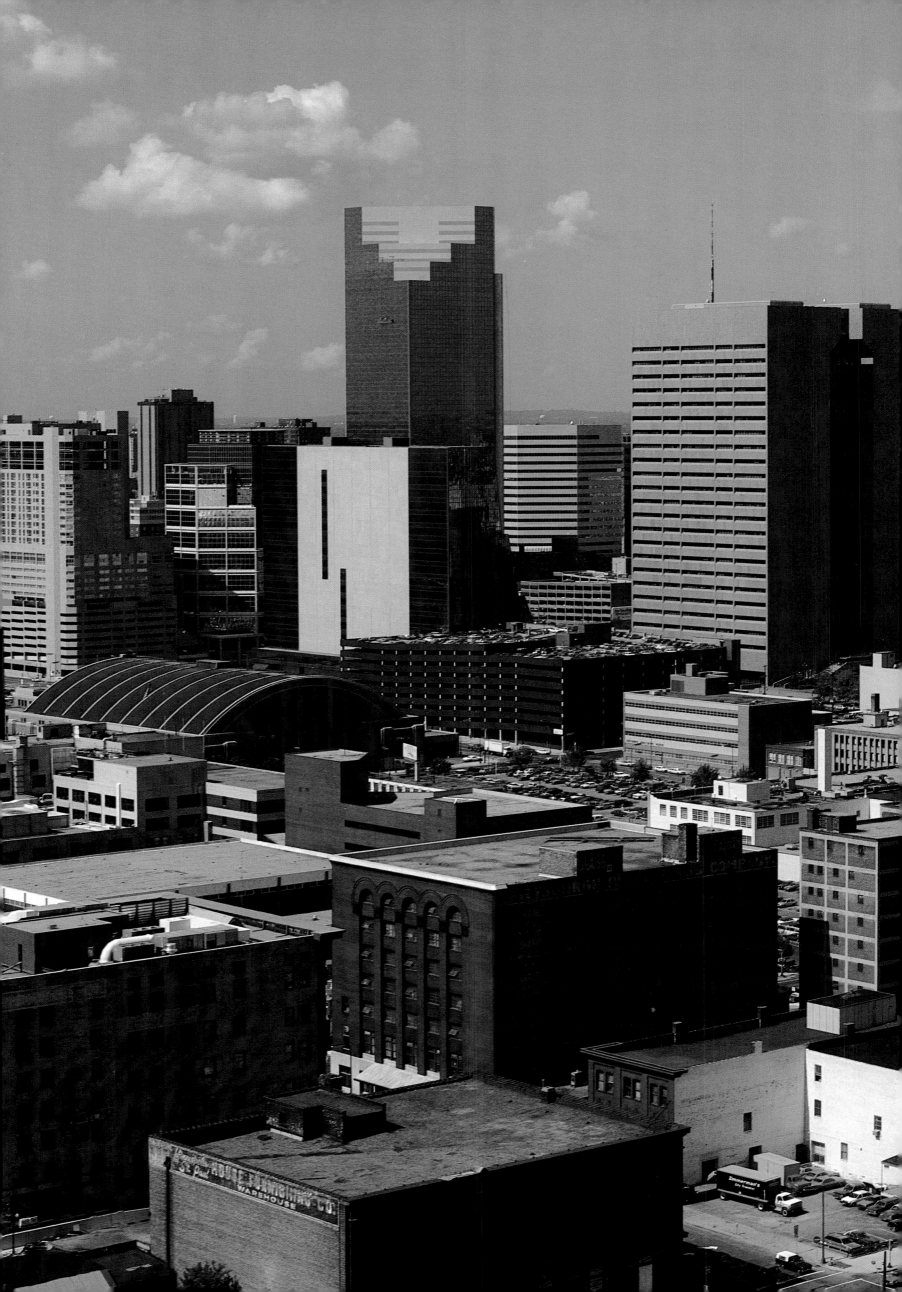

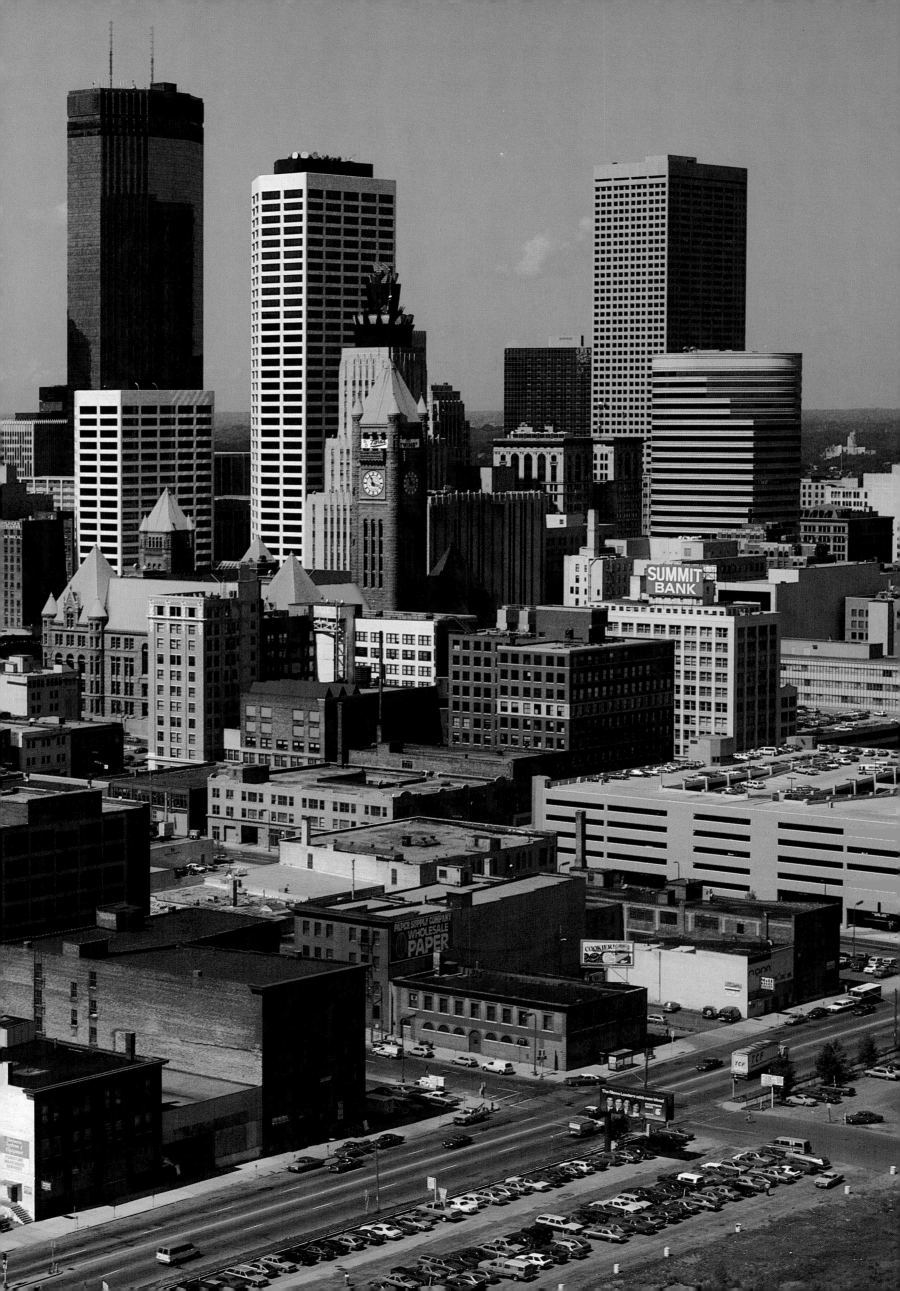

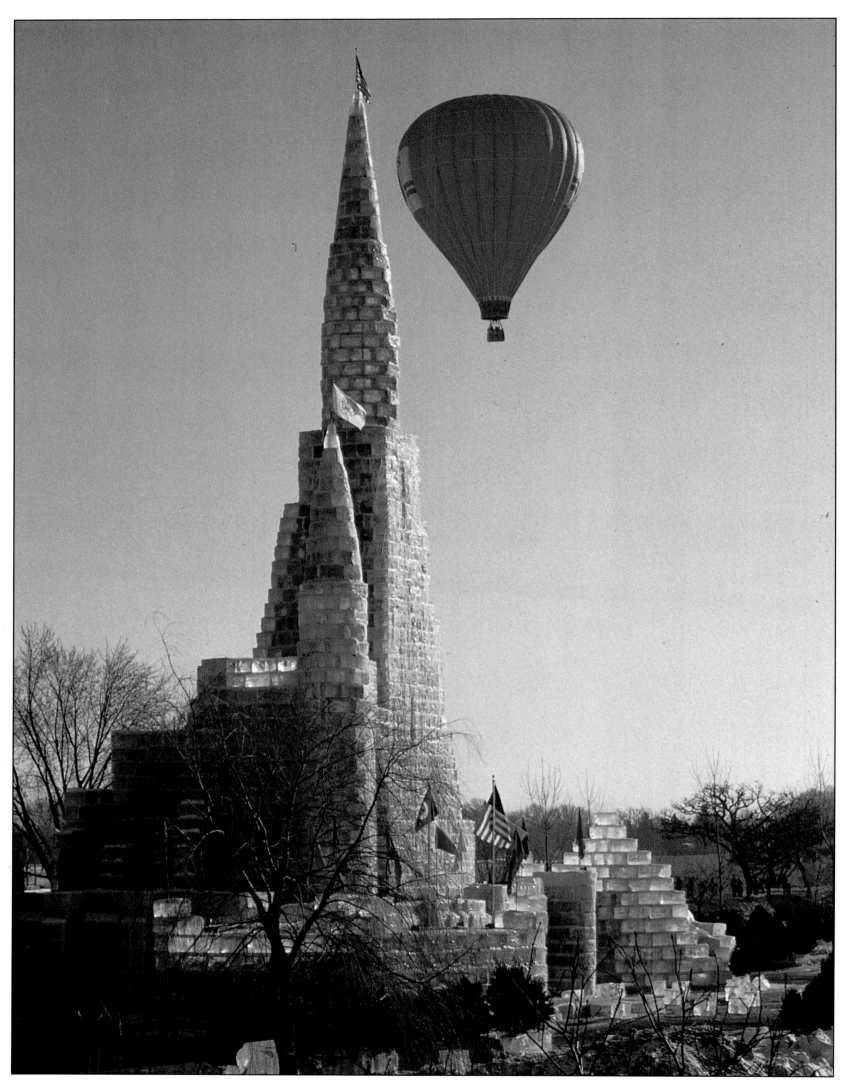

Back in 1886, the St. Paul City Fathers constructed a huge ice palace to show the rest of the country that ice and snow could be enjoyable. This gesture has become a major event and, along with ice palaces, the fun includes hot air balloons (above), car races on frozen lakes (facing page top), sleigh rides (facing page bottom) and a display of fireworks (overleaf).

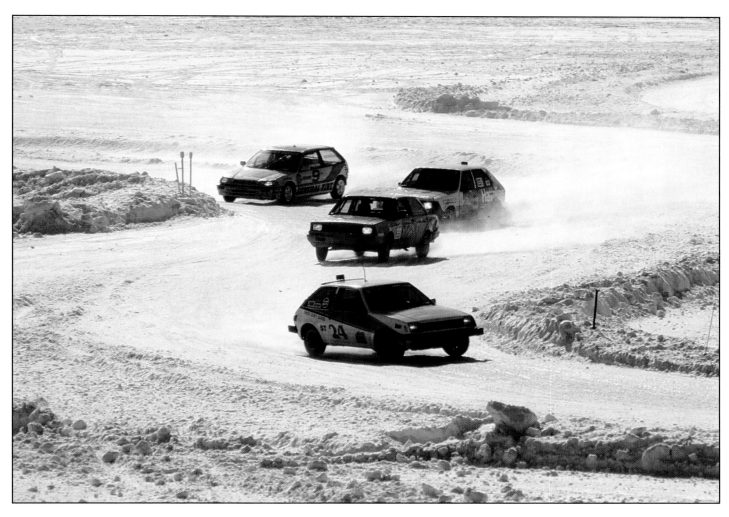

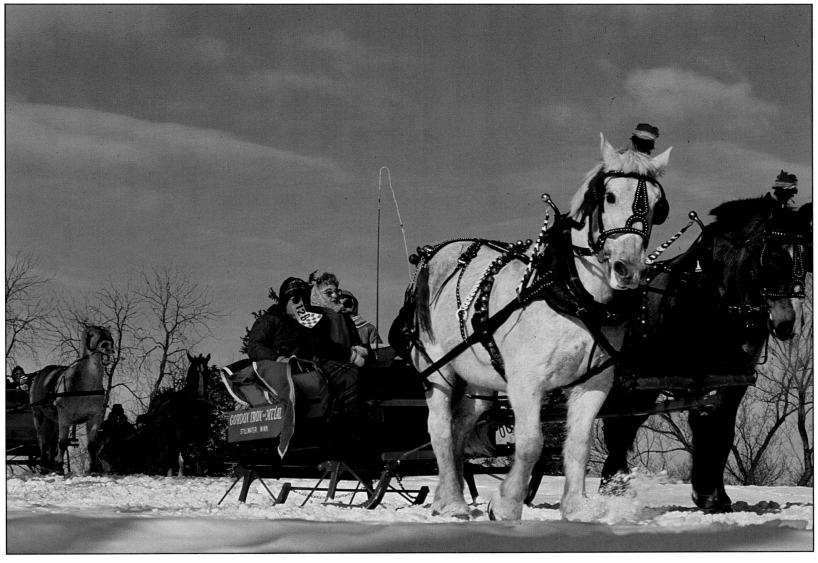

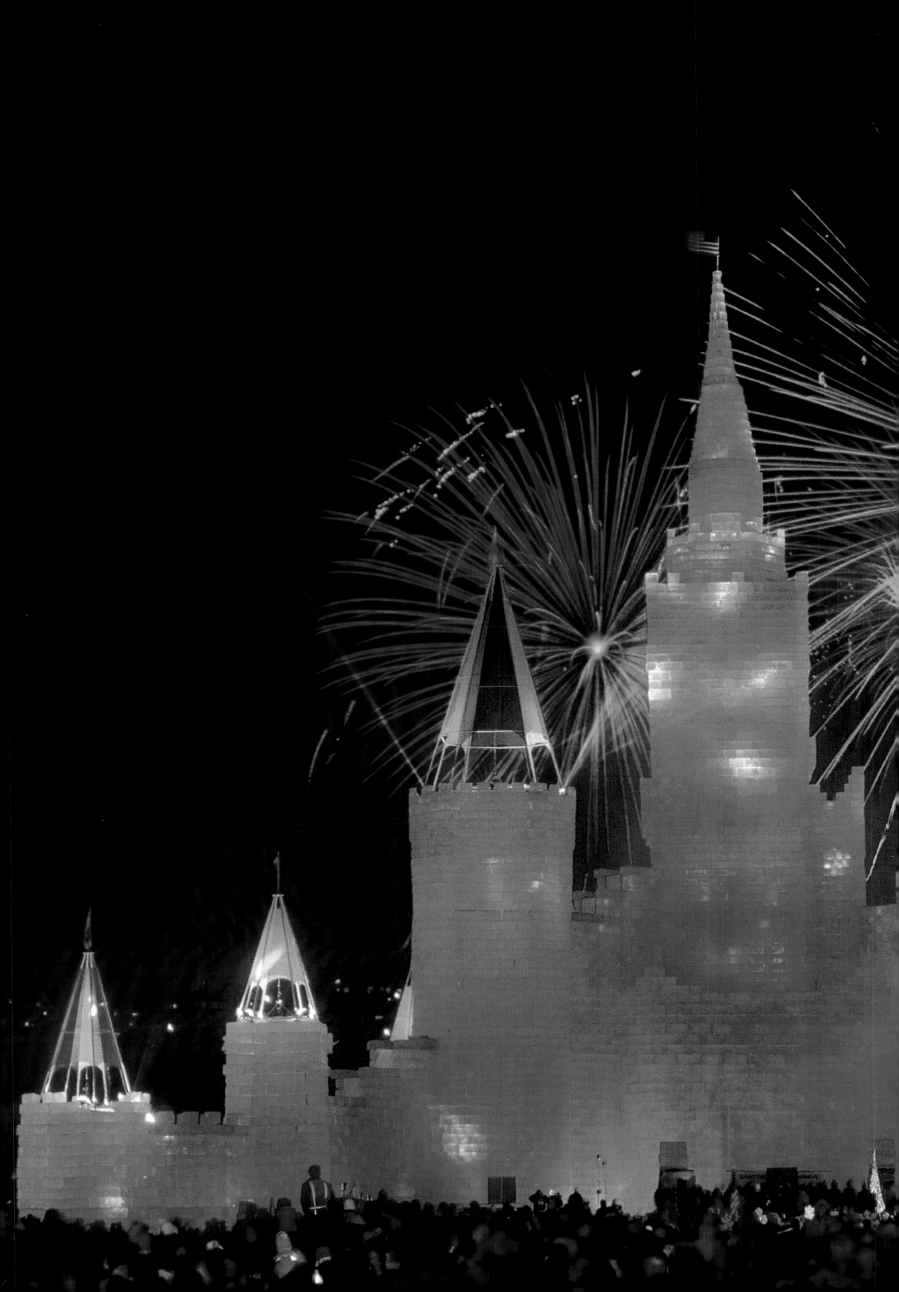

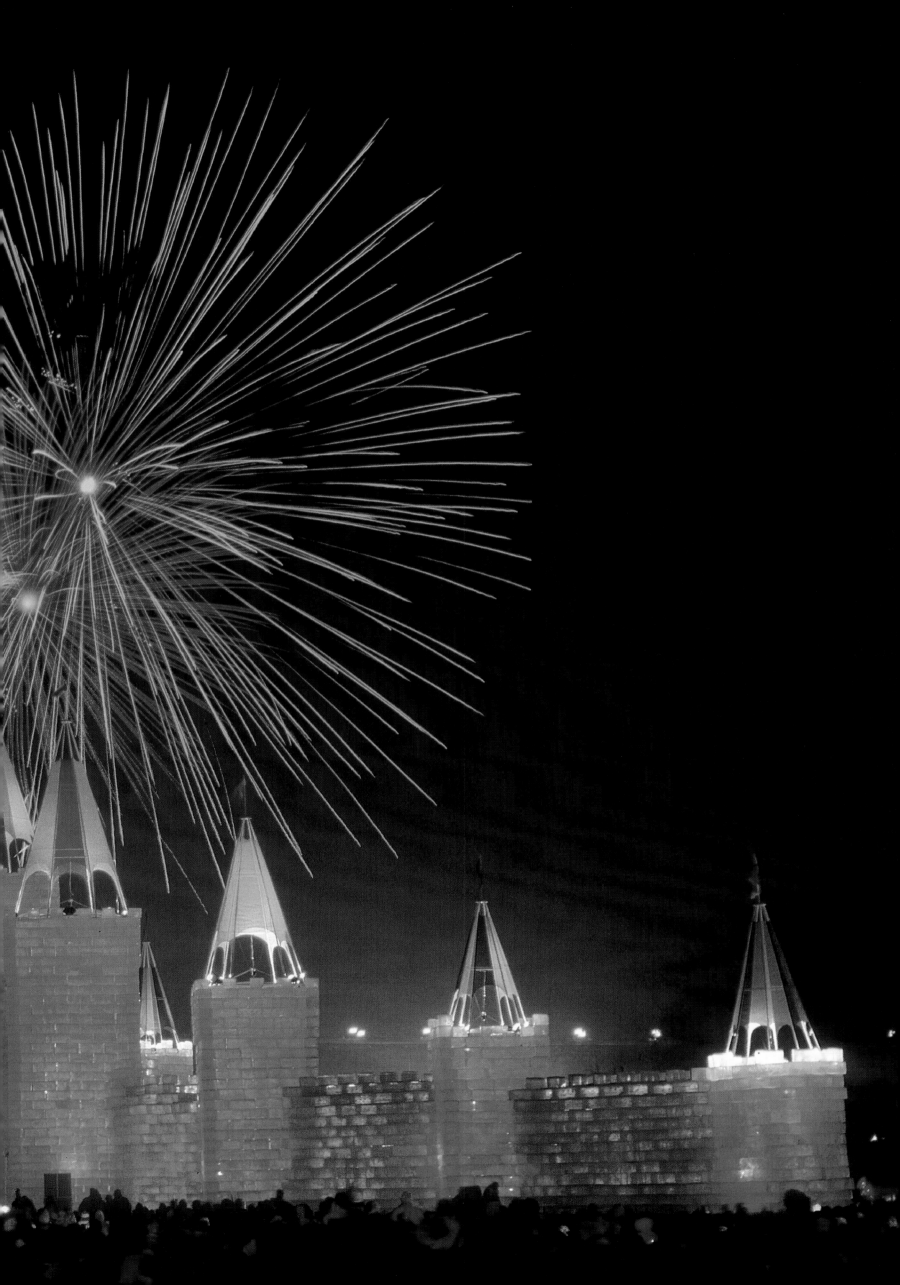

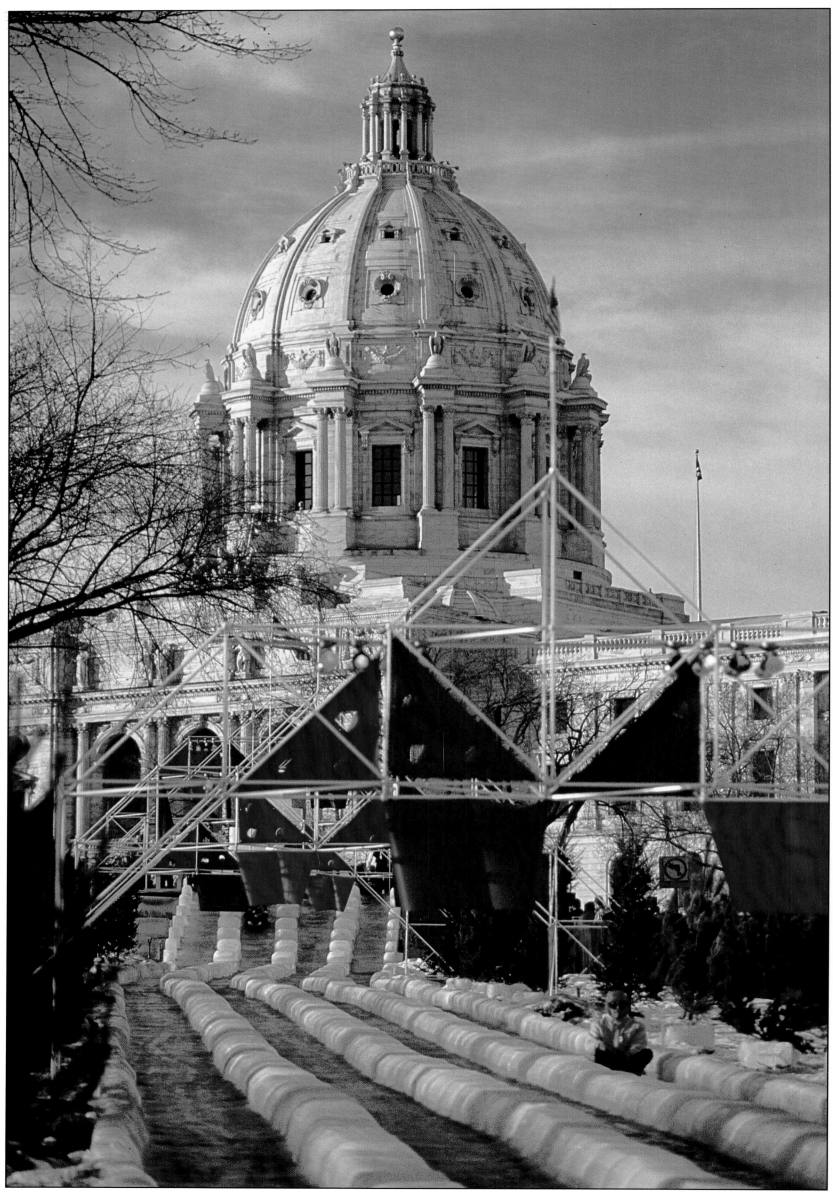

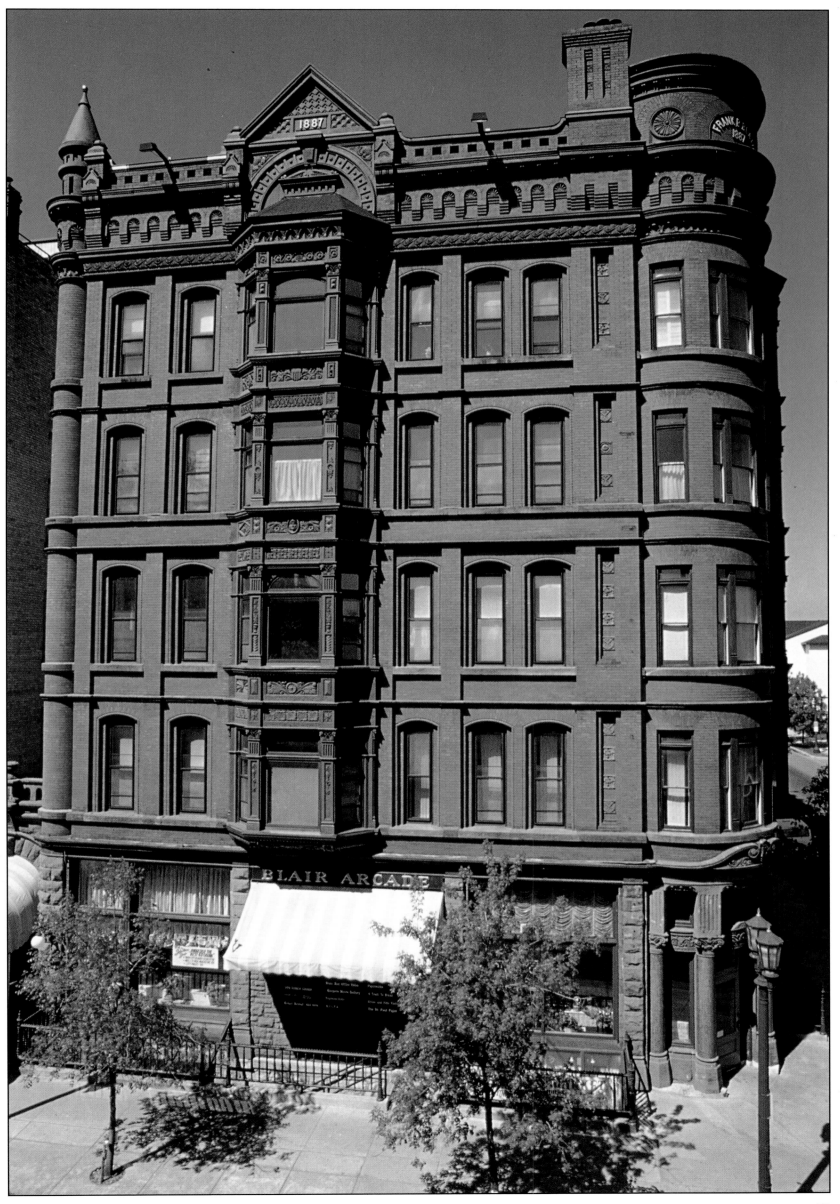

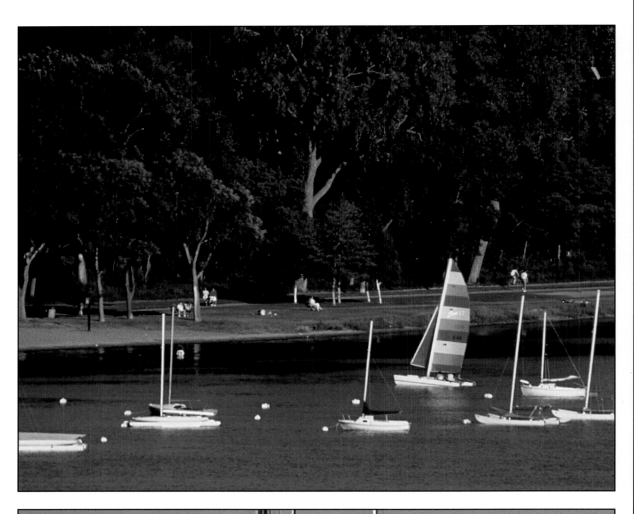

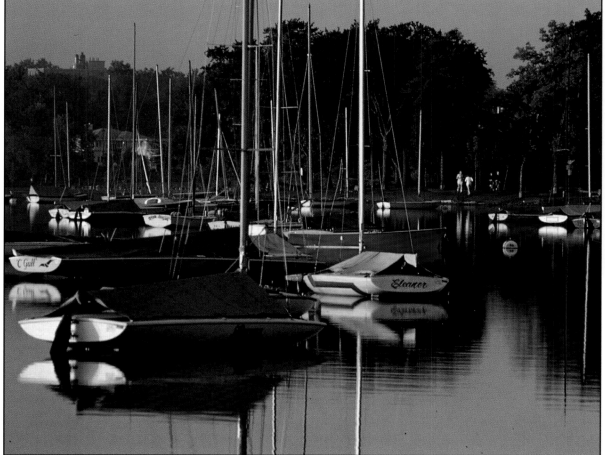

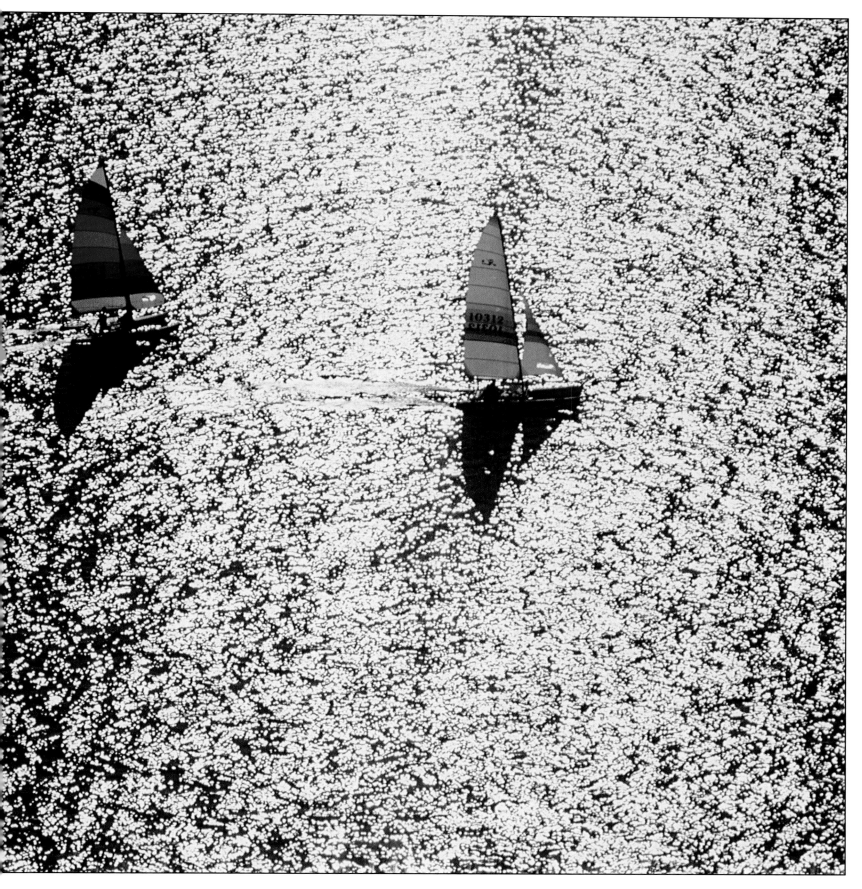

Minneapolis and St. Paul are Mississippi River towns, but within the metropolitan area there are thirty-one lakes covering ten acres or more in area. There are dozens more close by (these pages), including Lake Minnetonka (above), whose Yacht Club has been winning national sailing competitions since 1887. Lake Harriet (left) is as famous for its gardens and bird sanctuary as for its weekend sailboat races, while Lake Calhoun (overleaf), the biggest lake in Minneapolis, is popular with windsurfers. Powerboats are not permitted on any of the Twin Cities' lakes.

There are more than 90 parks in St. Paul, and another 153 in Minneapolis, whose Loring Park (facing page) is named for Charles M. Loring, the man who planned most of them during the 1880s. St. Paul's Prospect Park (above), is the site of an old, but now abandoned, water tower perched on a hilltop.

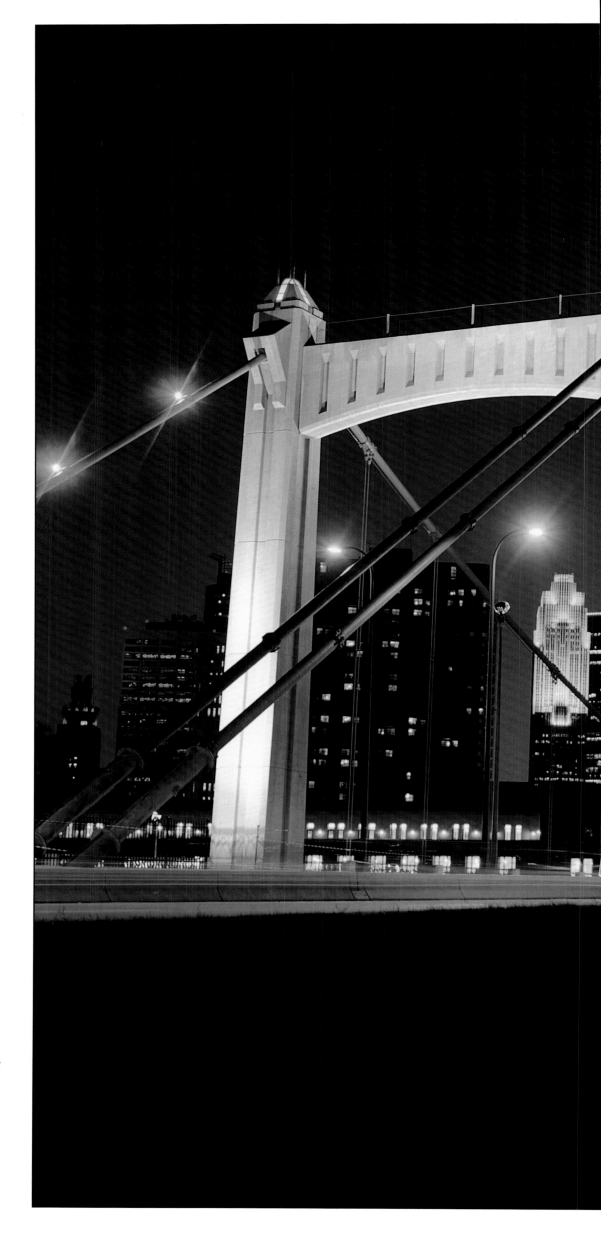

The Hennepin Avenue Suspension Bridge (right) leading to Nicollet Island is a recent reconstruction of the first bridge ever built over the Mississippi River. The original, built in 1855, was heralded as "… a highway to the wilderness, over which Civilization will bear her lighted torches into the evening land of the West."

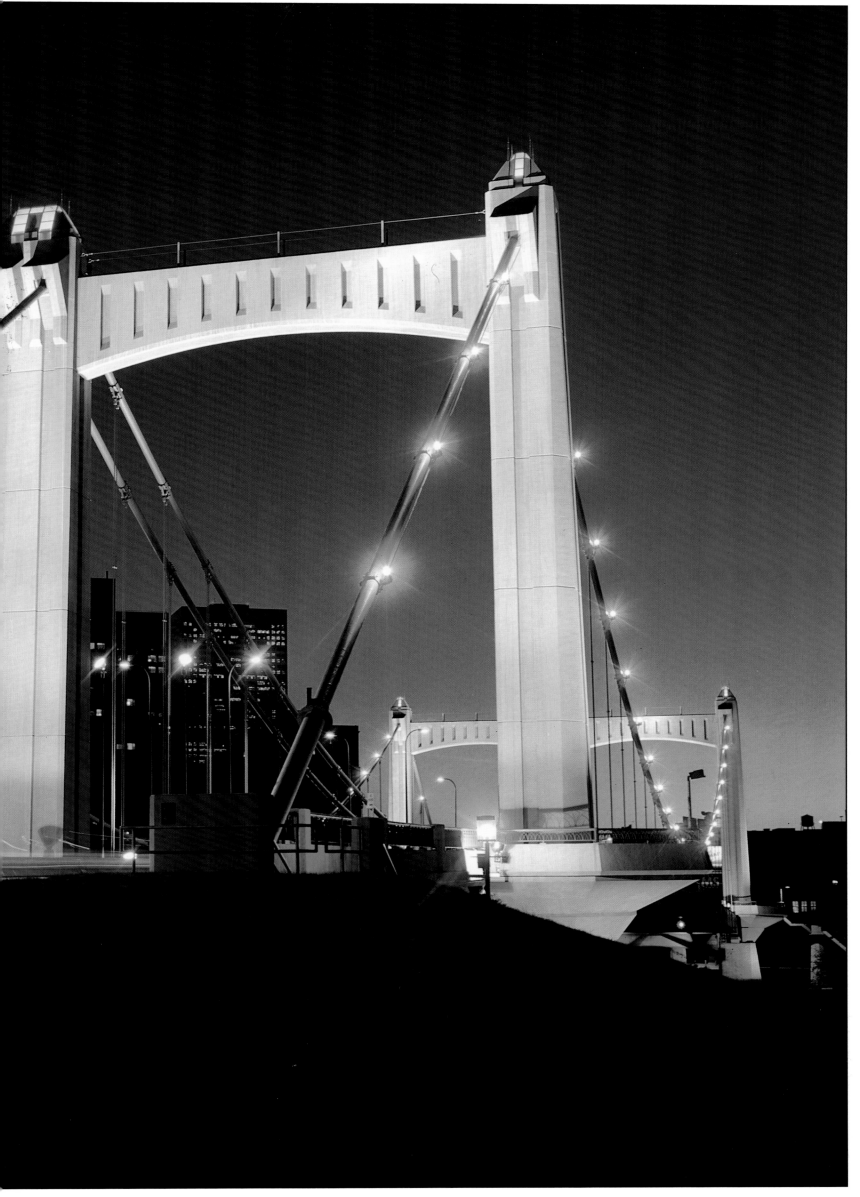

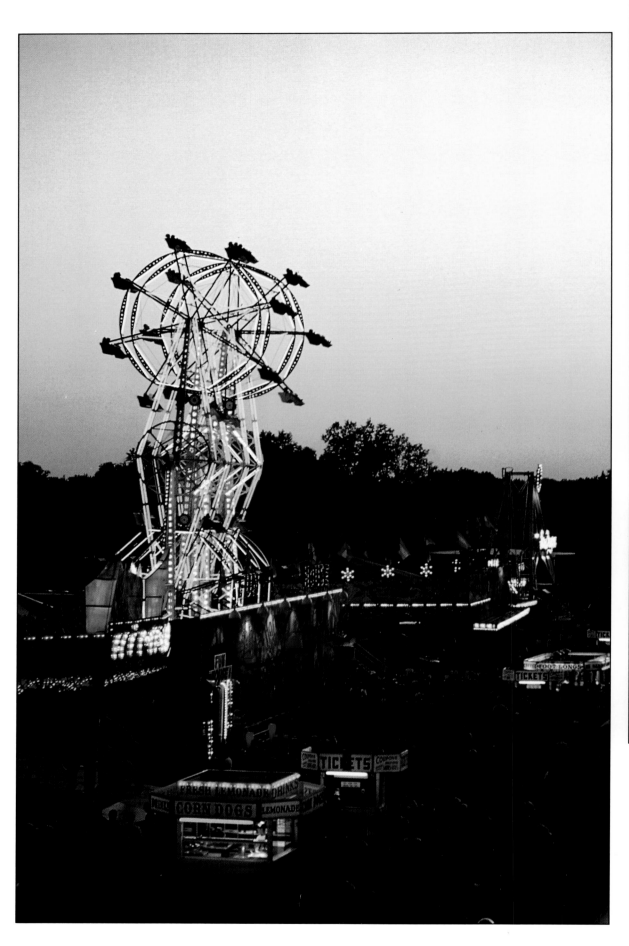

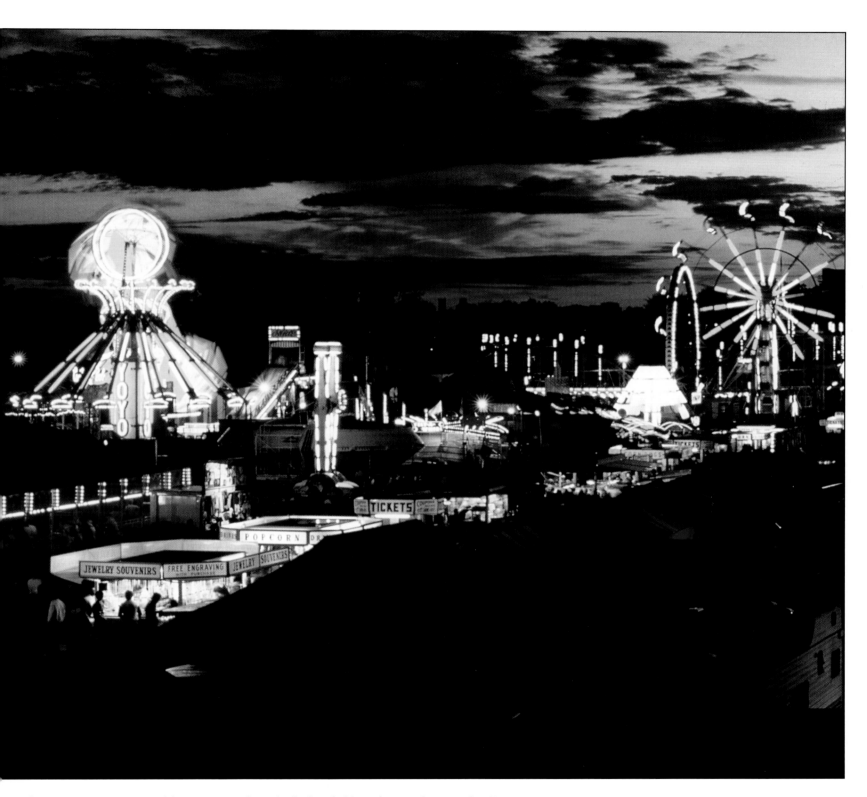

The Minnesota State Fair (these pages and overleaf), first held on the parade ground at Fort Snelling more than a century ago, has grown into one of America's biggest state fairs. The event, held in St. Paul on the twelve days leading up to Labor Day, celebrates the state's agricultural heritage at what is often considered the most beautiful time of the Minnesota year.

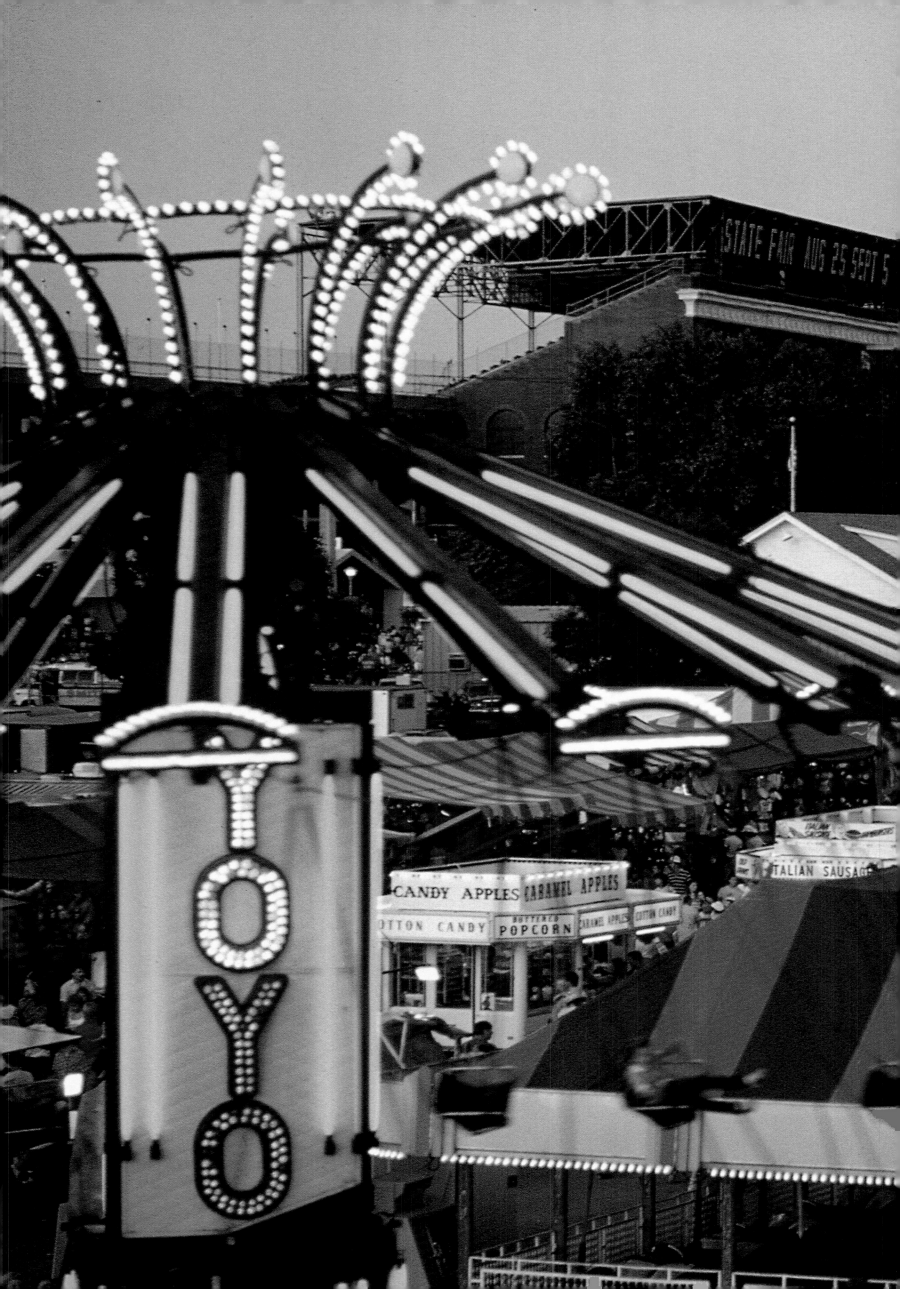

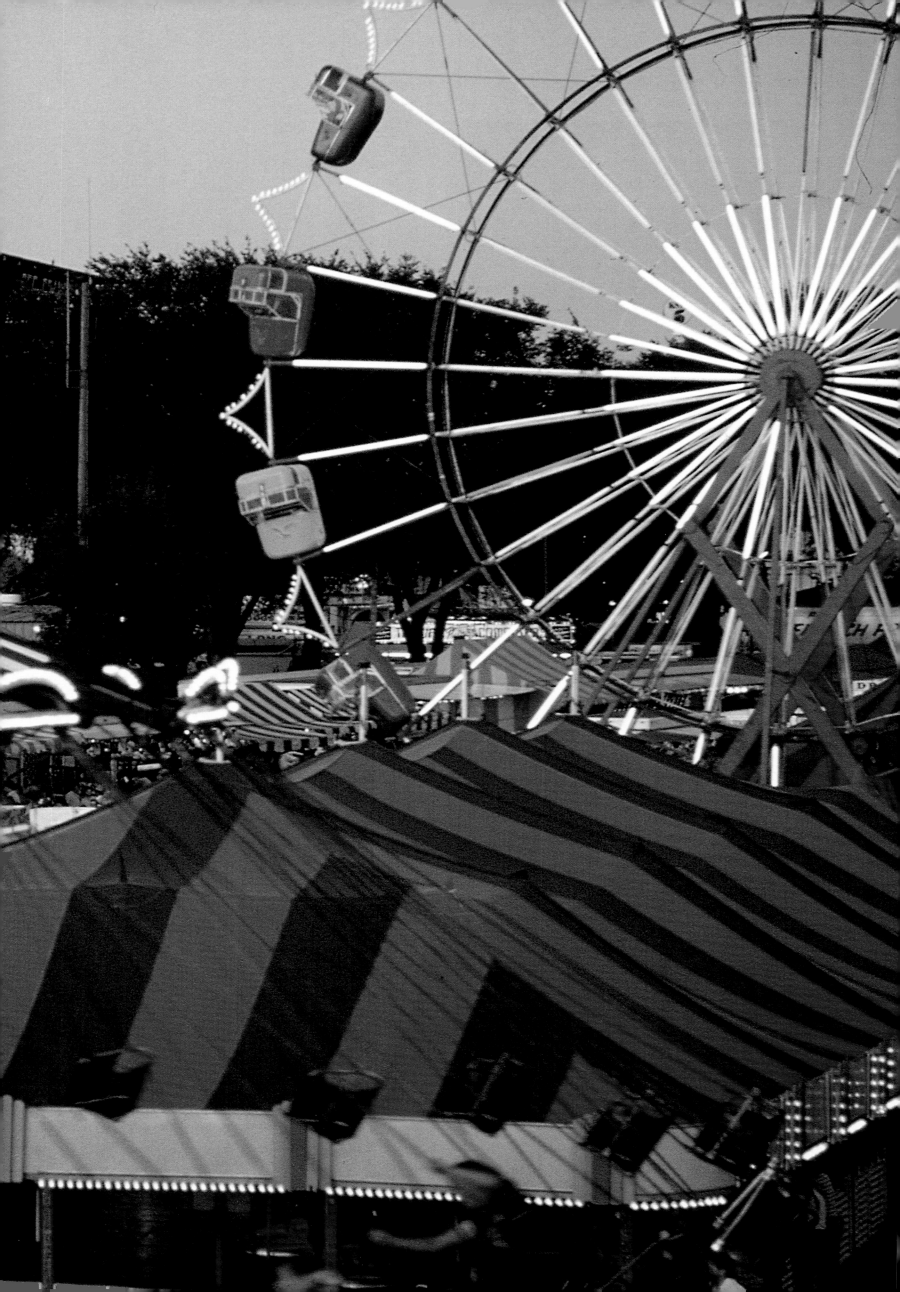

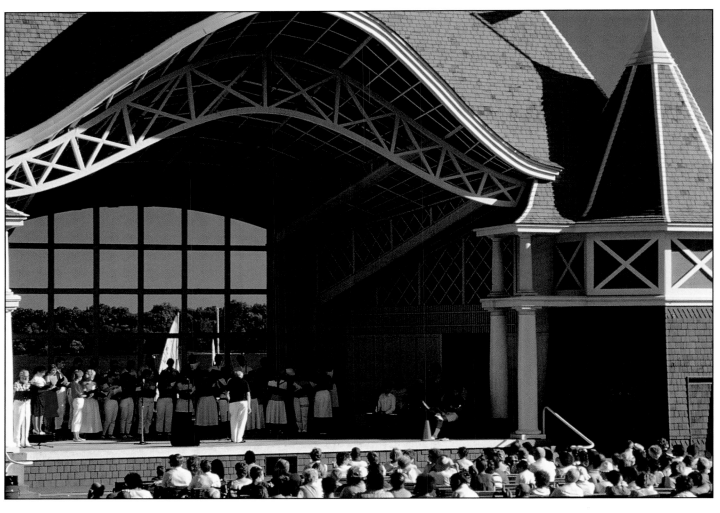

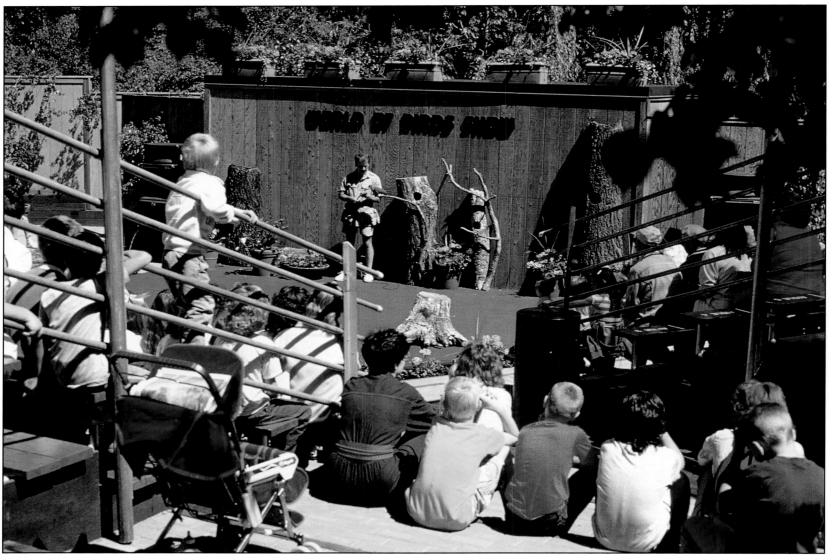

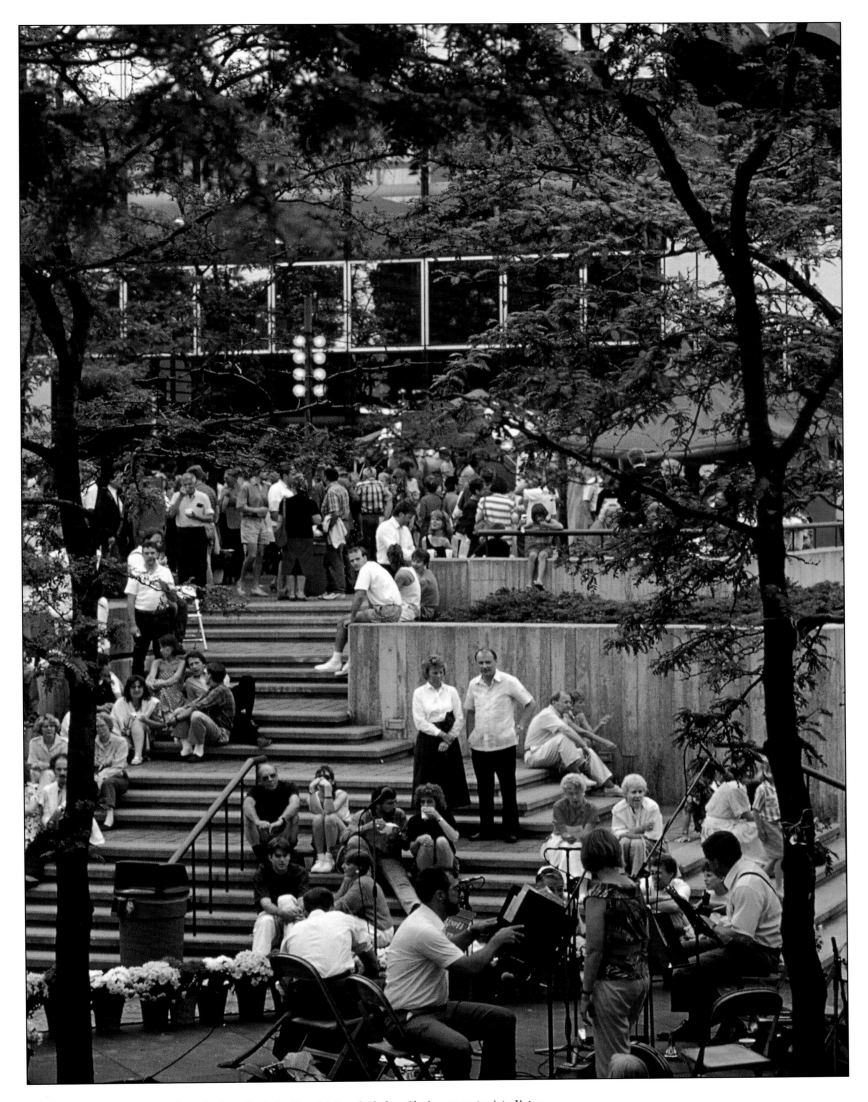

All summer long, Twin Citians flock to the Lake Harriet Band Shelter (facing page top) to listen to nightly concerts. In contrast are the fascinating daytime sounds at the Minnesota Zoo, where you never know what you'll hear at the bird show (facing page bottom). But possibly the best sounds of all are heard at Sommerfest (above), when the Minnesota Orchestra performs outdoors at Peavey Plaza.

The Twin Cities offer a wide range of cultural attractions. The Minneapolis Institute of Arts (above) houses more than 70,000 works of art covering 25,000 years of history. St. Paul's beautiful Ordway Music Theater seats 1,800 in its Main Hall (above right) for programs ranging from opera to pop, and there is rarely an empty seat. The World Theater (right), in St. Paul, is the home of Garrison Keillor's Public Radio performances.

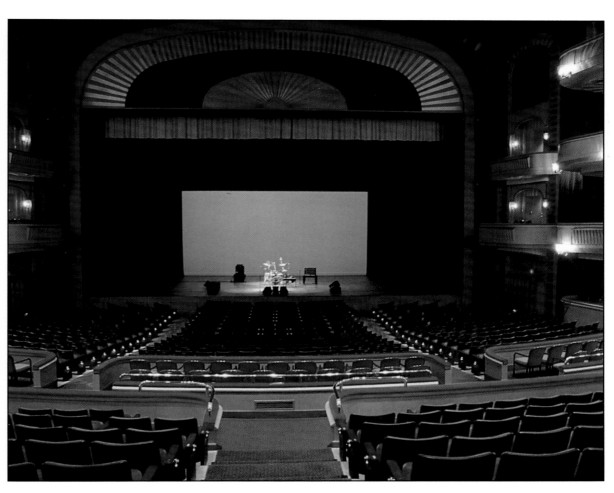

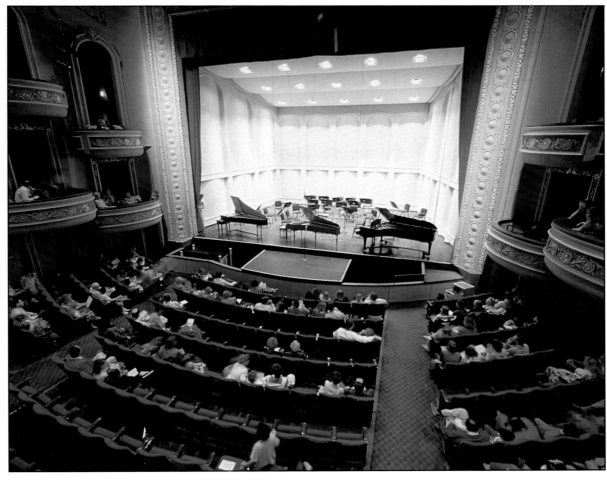

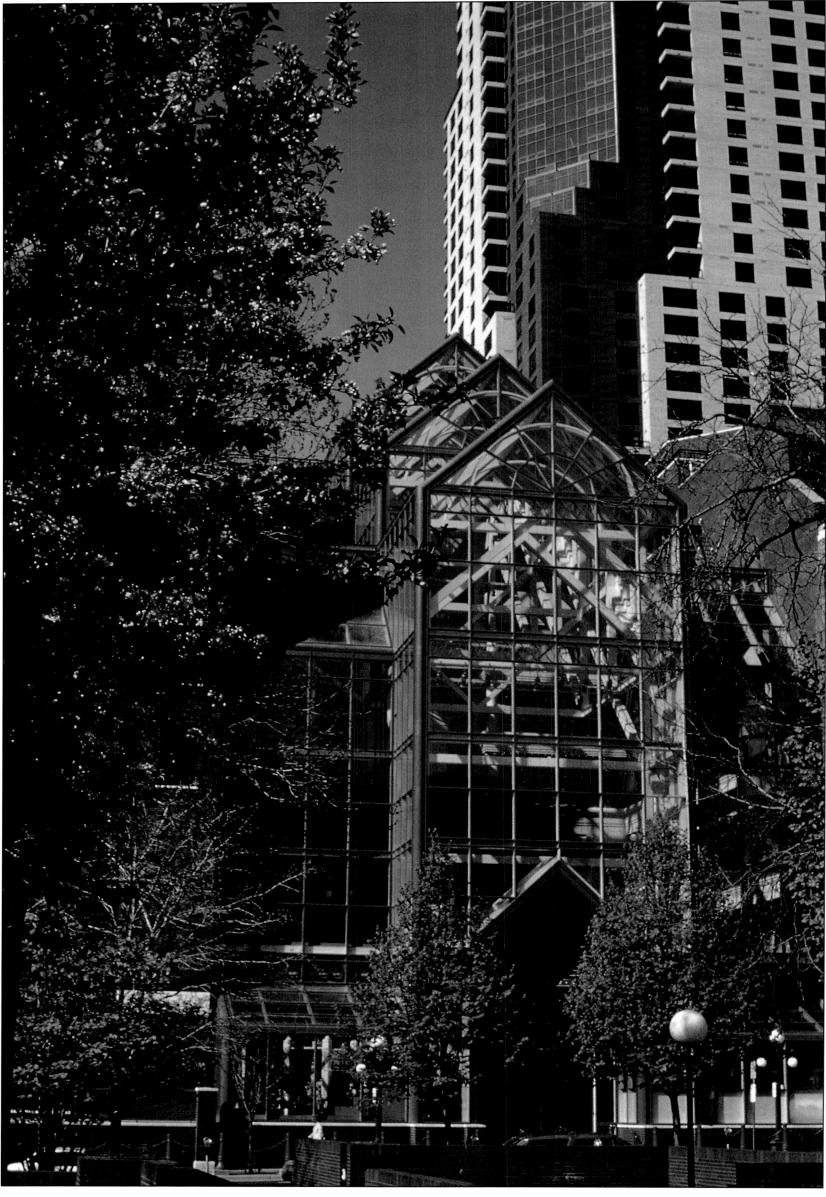

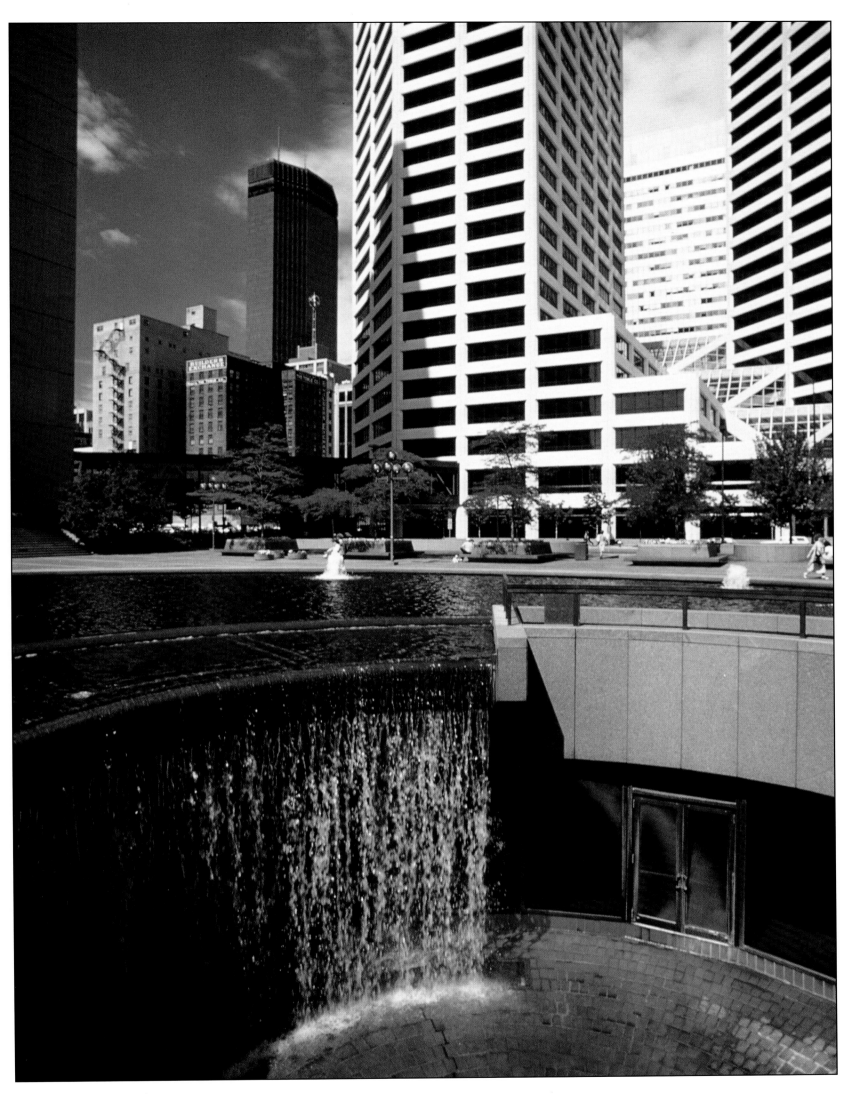

The glass facade of Galtier Plaza (facing page) is symbolic of the surge of new development in St. Paul. In Minneapolis, modern progress is represented in the Pillsbury Center (above), home of one of the city's oldest enterprises. The Center contains an impressive eight-story prismatic atrium.

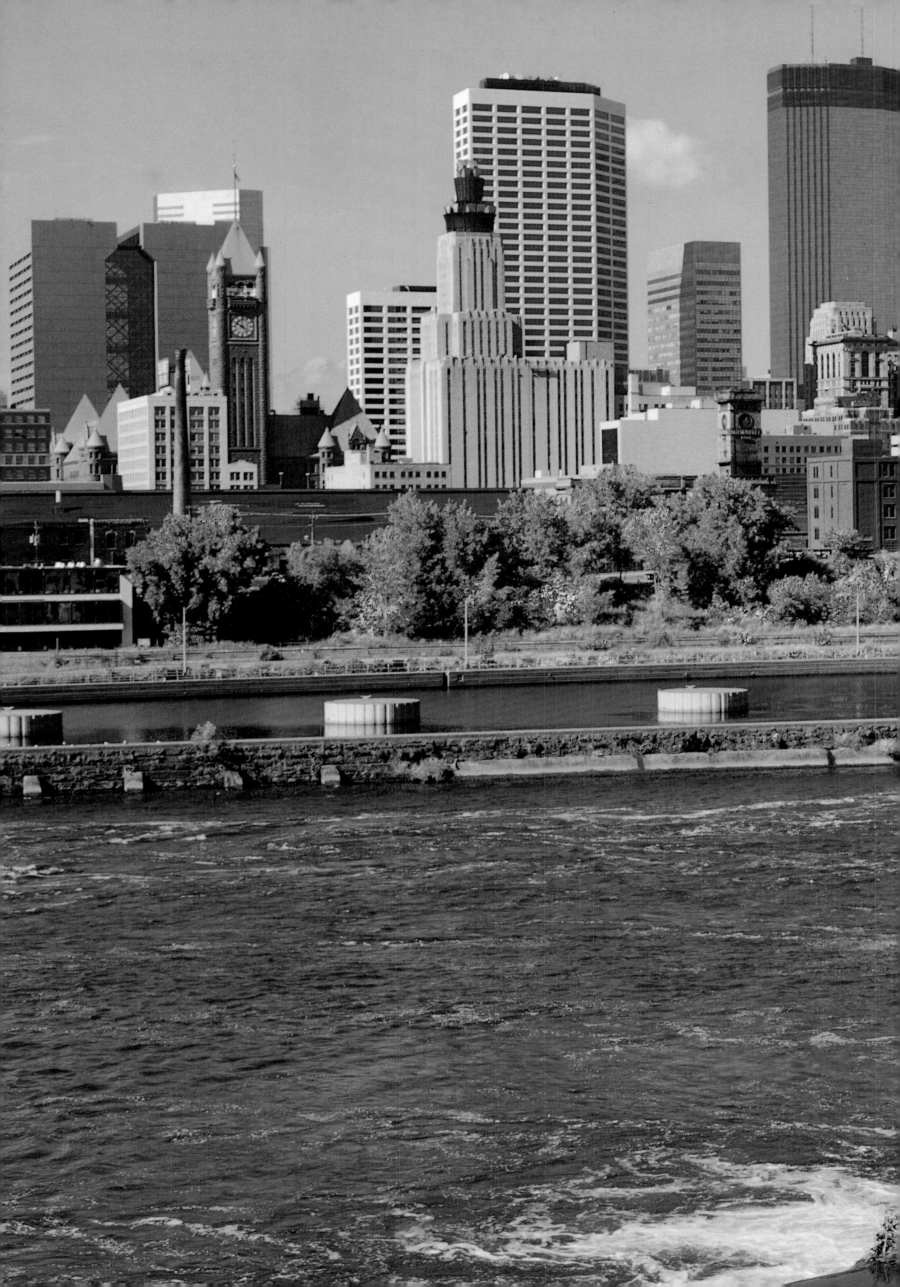

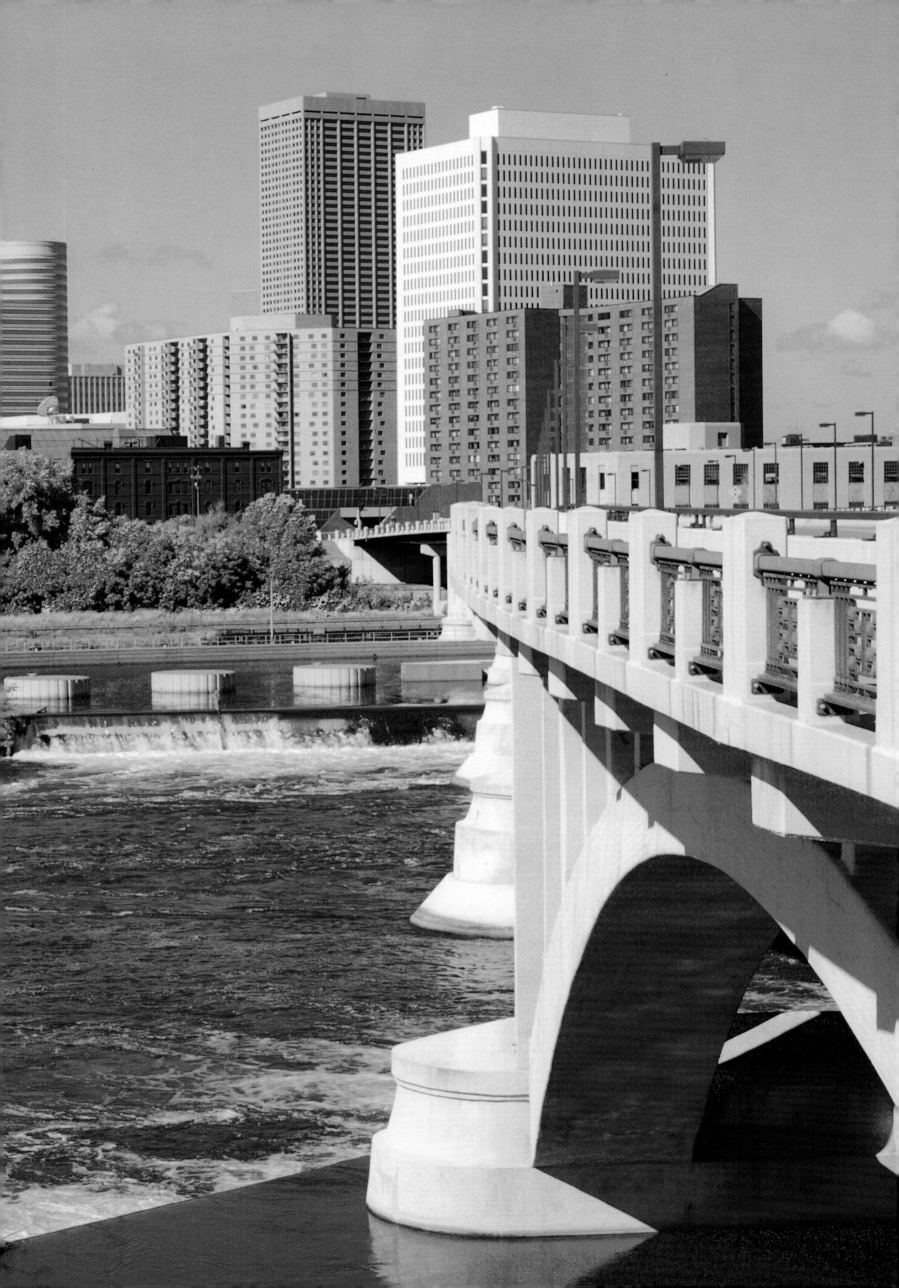

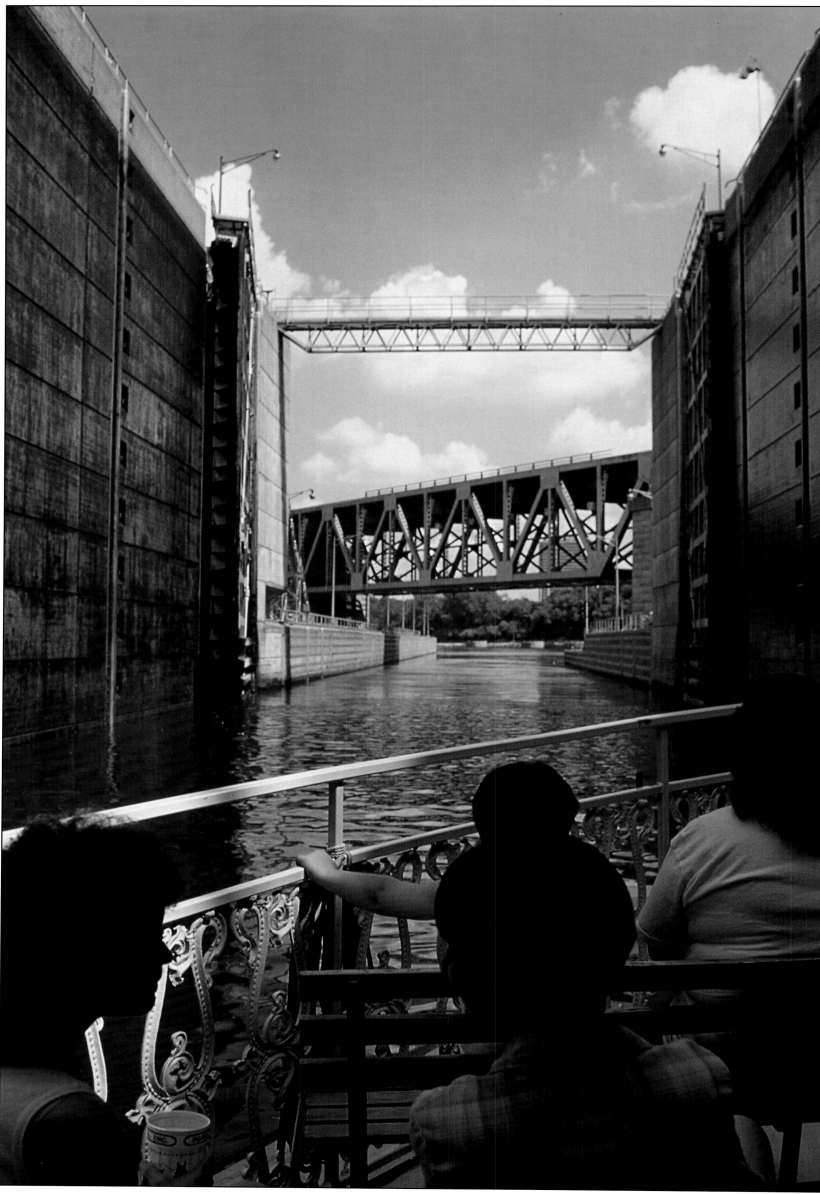

The Third Avenue Bridge (previous pages) crosses the upper lock of St. Anthony Falls, offering a spectacular view of the Minneapolis skyline. For views from the water, a boat trip goes through the locks (facing page) and past Nicollet Island downriver from Boom Island Landing (above).

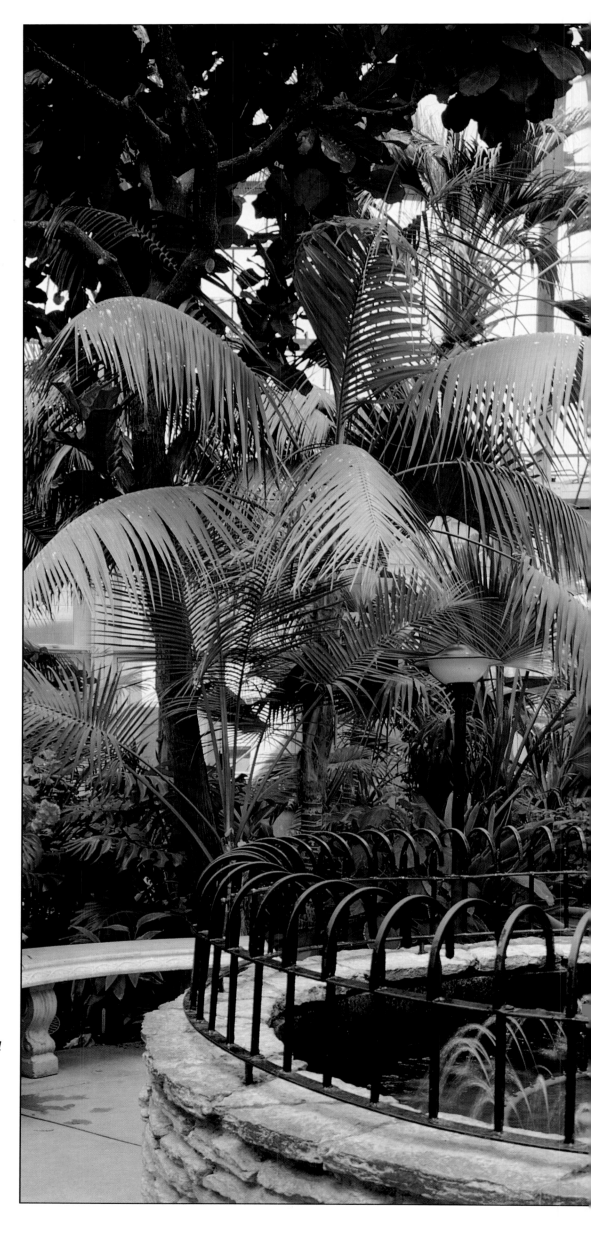

The Como Park Conservatory (right) in St. Paul is one of the most popular spots in the Twin Cities for weddings. The park also has formal gardens, a Japanese garden, and one of the best golf courses in the city.

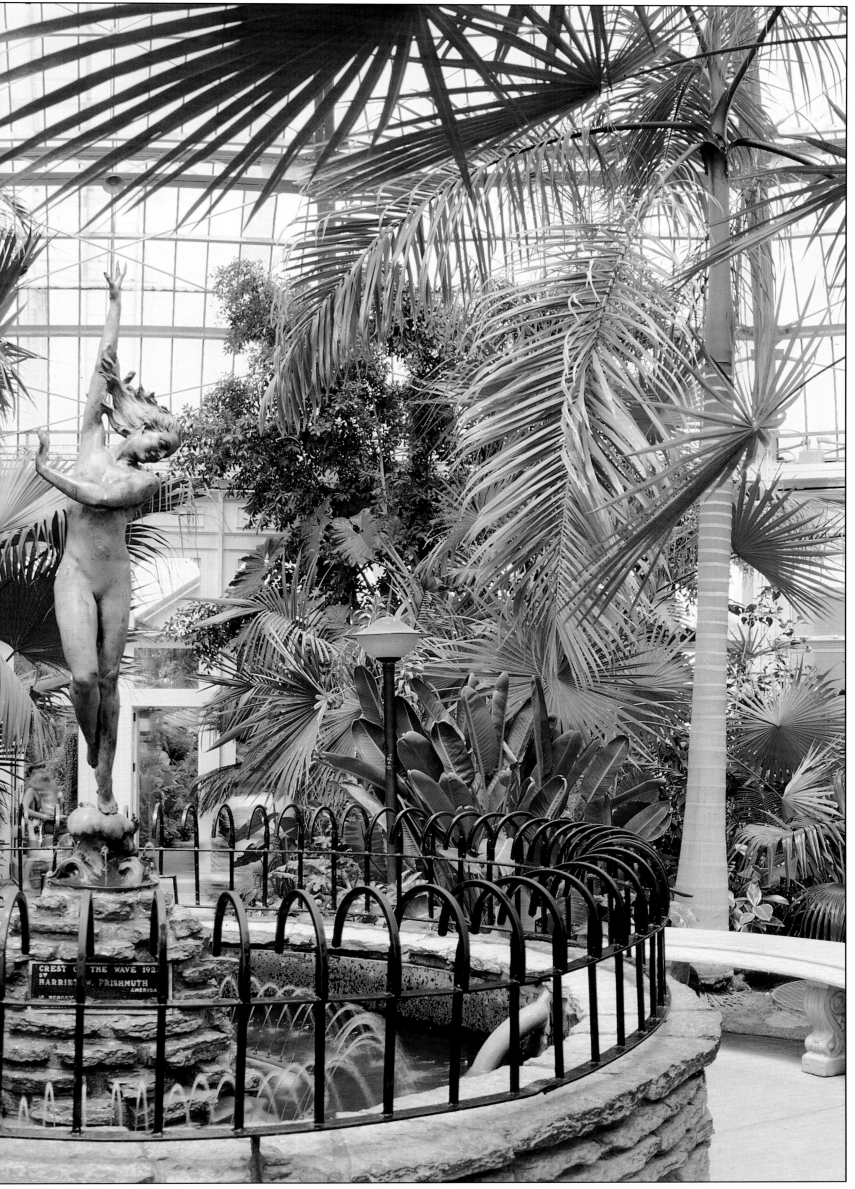

CREST OF THE WAVE 192
BY
HARRIET W. FRISHMUTH
AMERICA

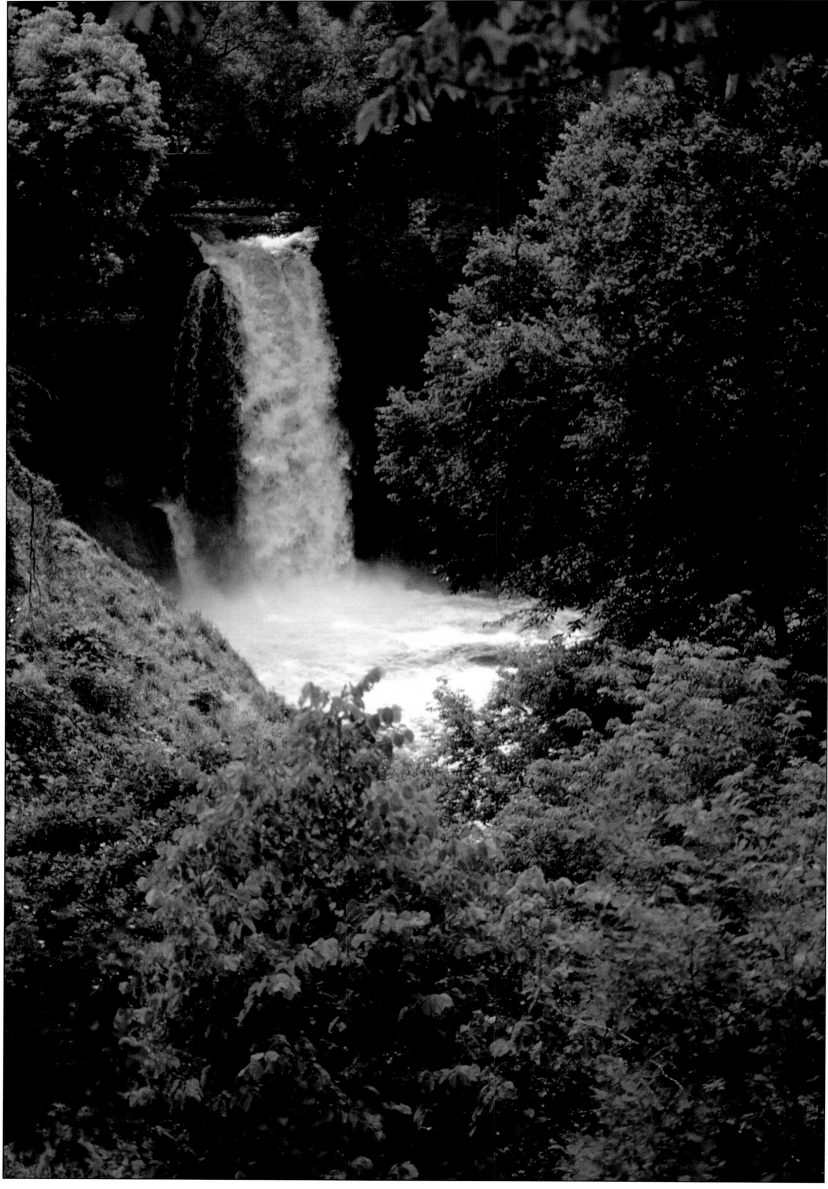

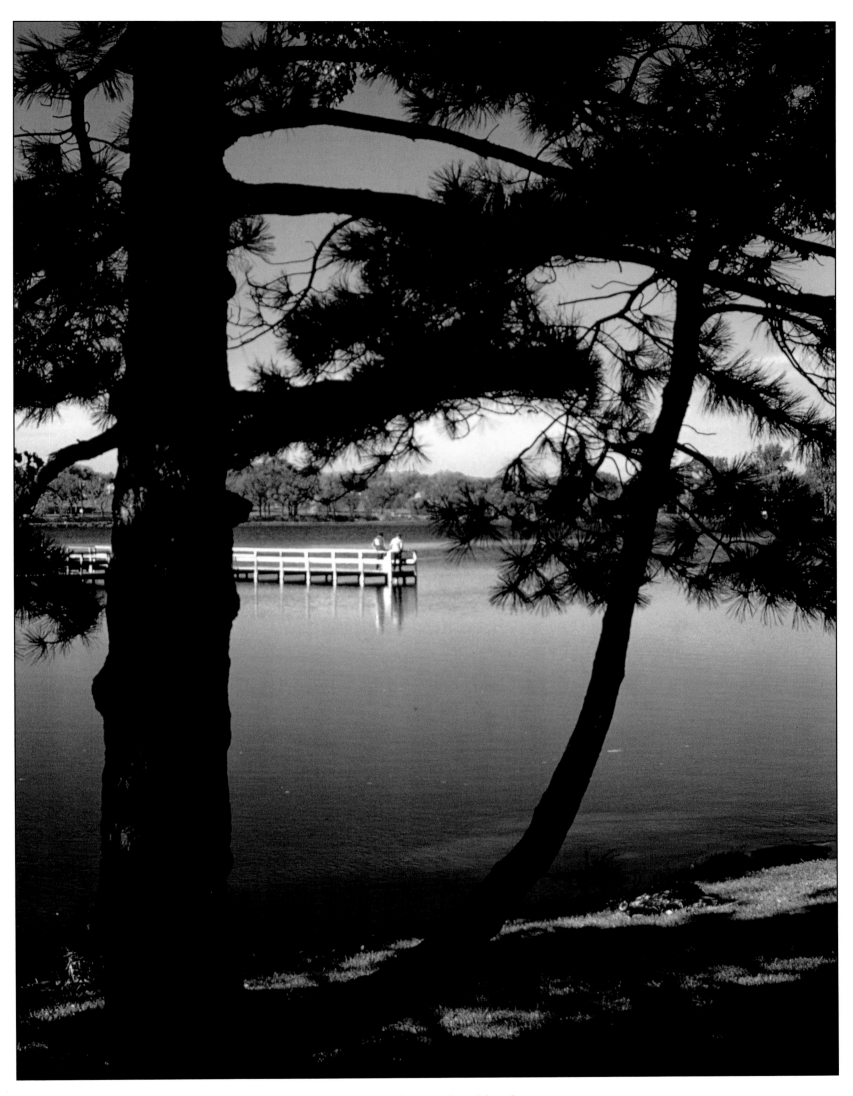

Minnehaha Falls (facing page) was the setting for Longfellow's Song of Hiawatha, *although the poet never saw the waterfall itself. His saga described Gitche Gumee, "the Big-Sea-Water," inspired by Lake Superior. The nearest lake to the Falls is Hiawatha Lake (above), but even more inspiring, had Longfellow seen it, is Lake Minnetonka (overleaf), with its 250 miles of wooded shoreline.*

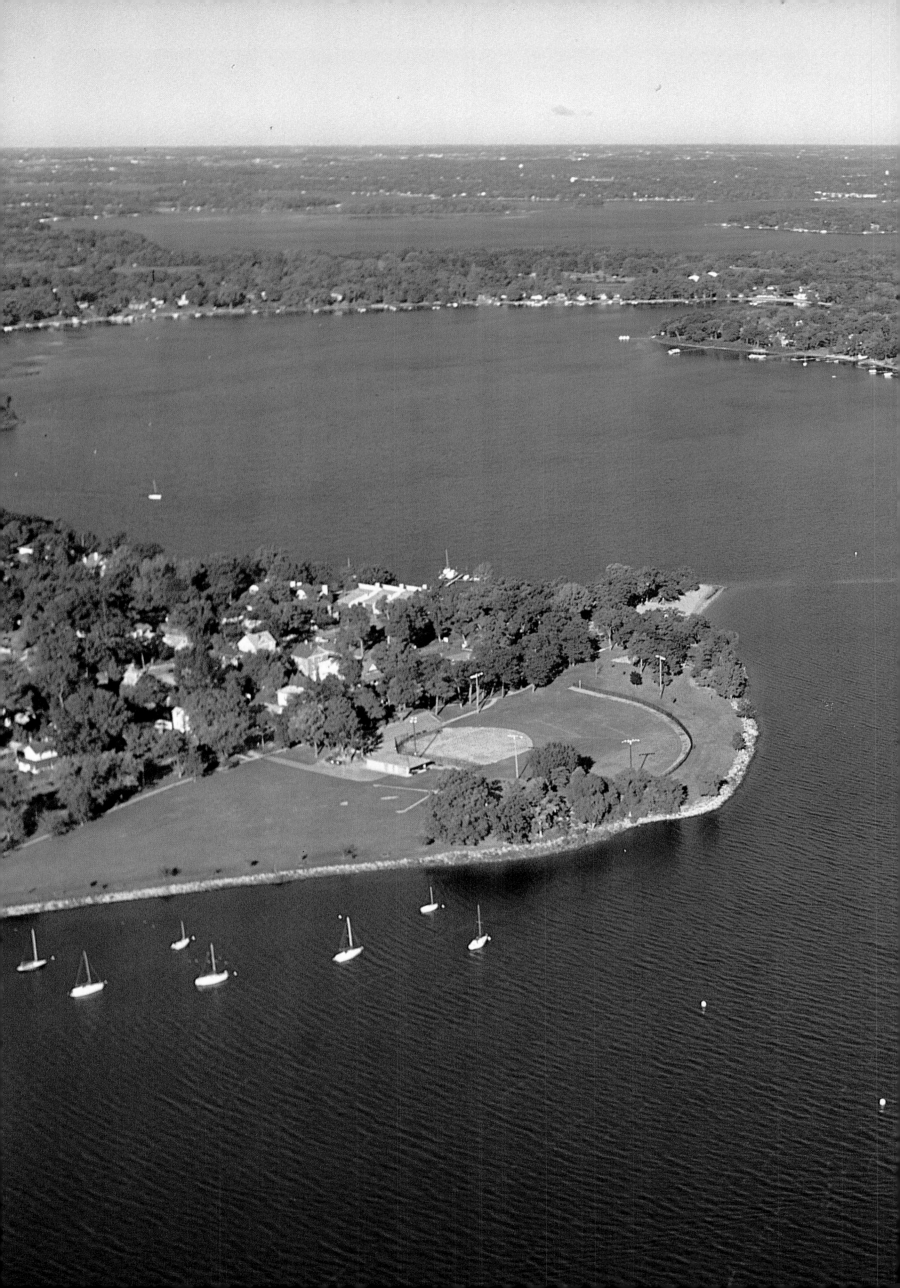

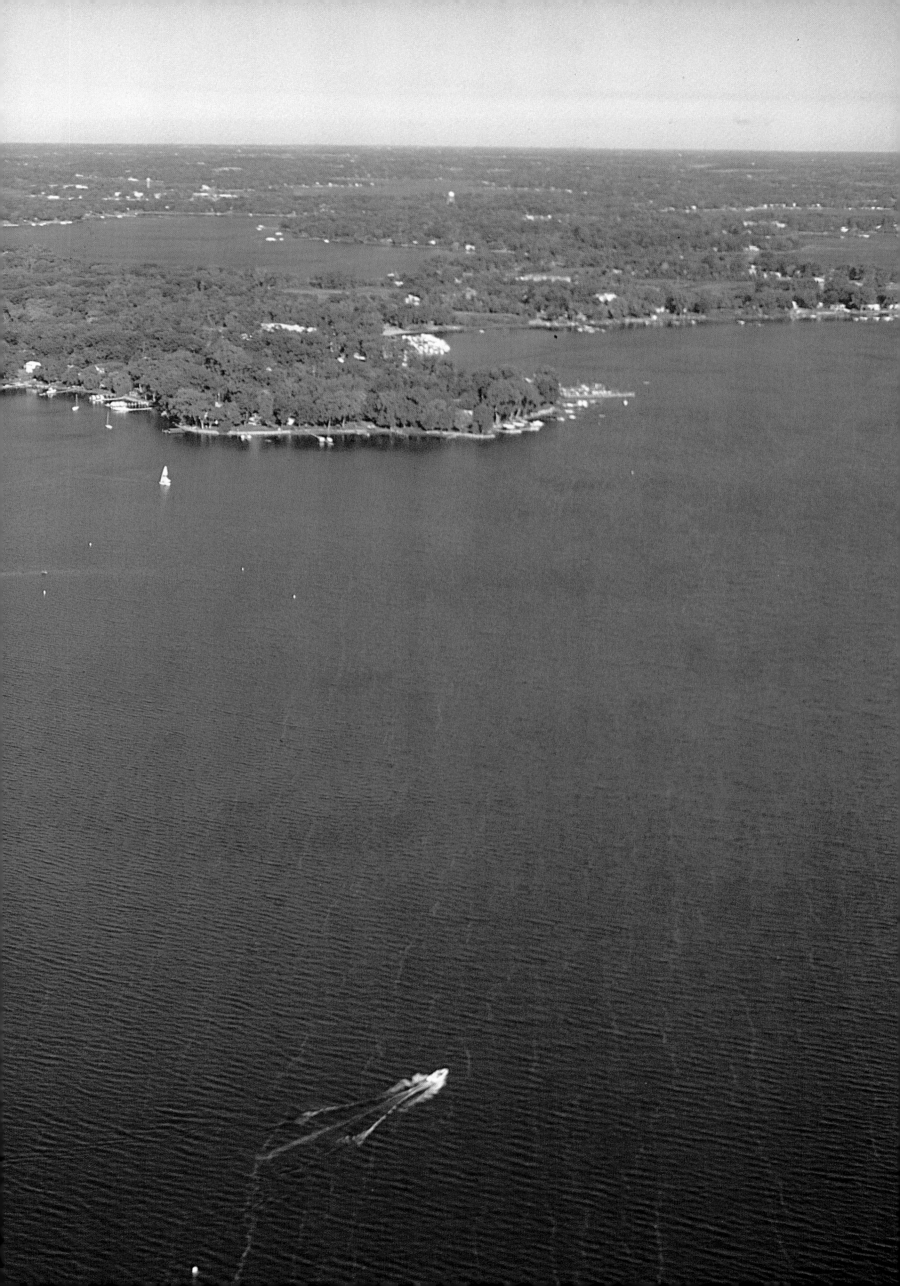

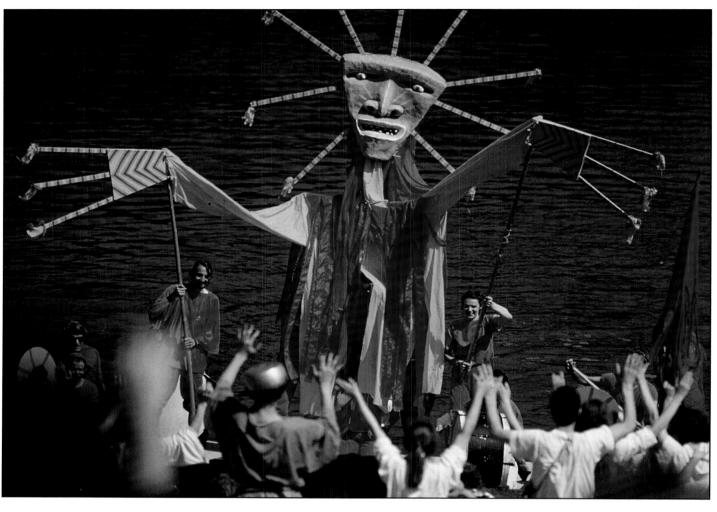

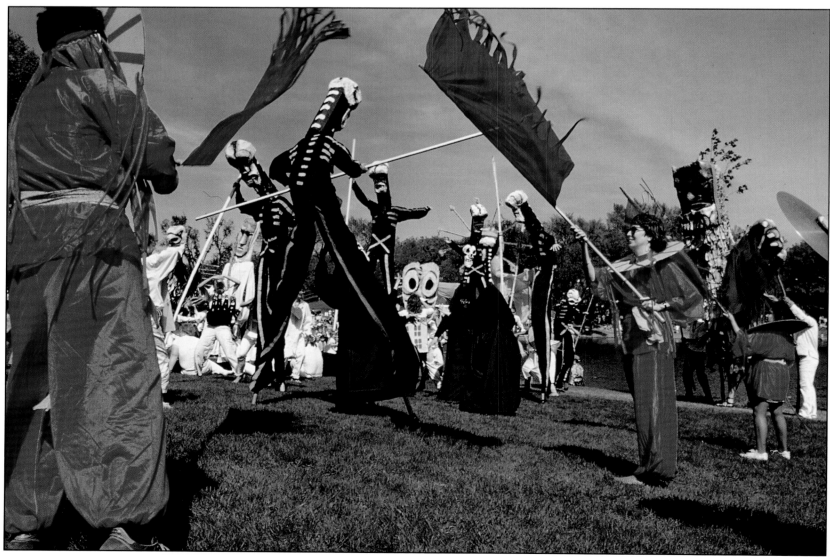

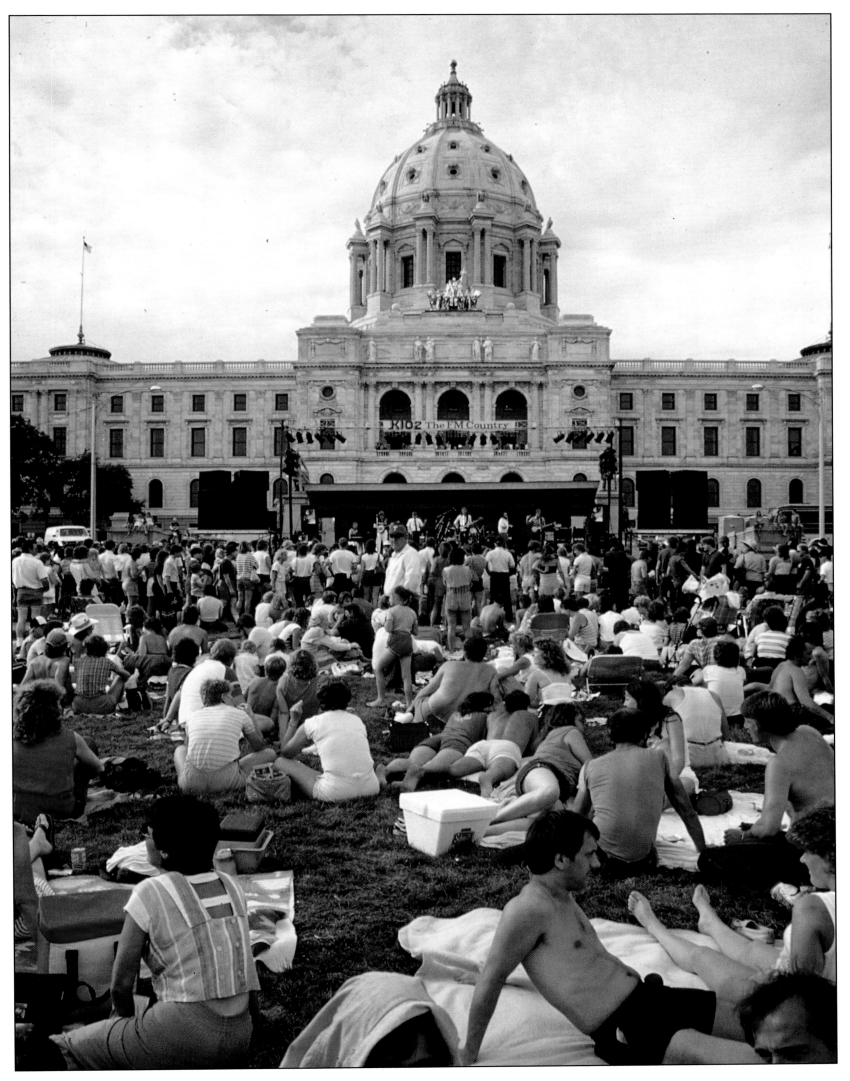

May Day in St. Paul is an occasion to celebrate the ethnic diversity of the Twin Cities. The Native American tradition emerges in such places as Powderhorn Park (facing page) and, although the Festival of Nations is held at the Civic Center, the spring sun brings crowds (above) to the Capitol grounds, too.

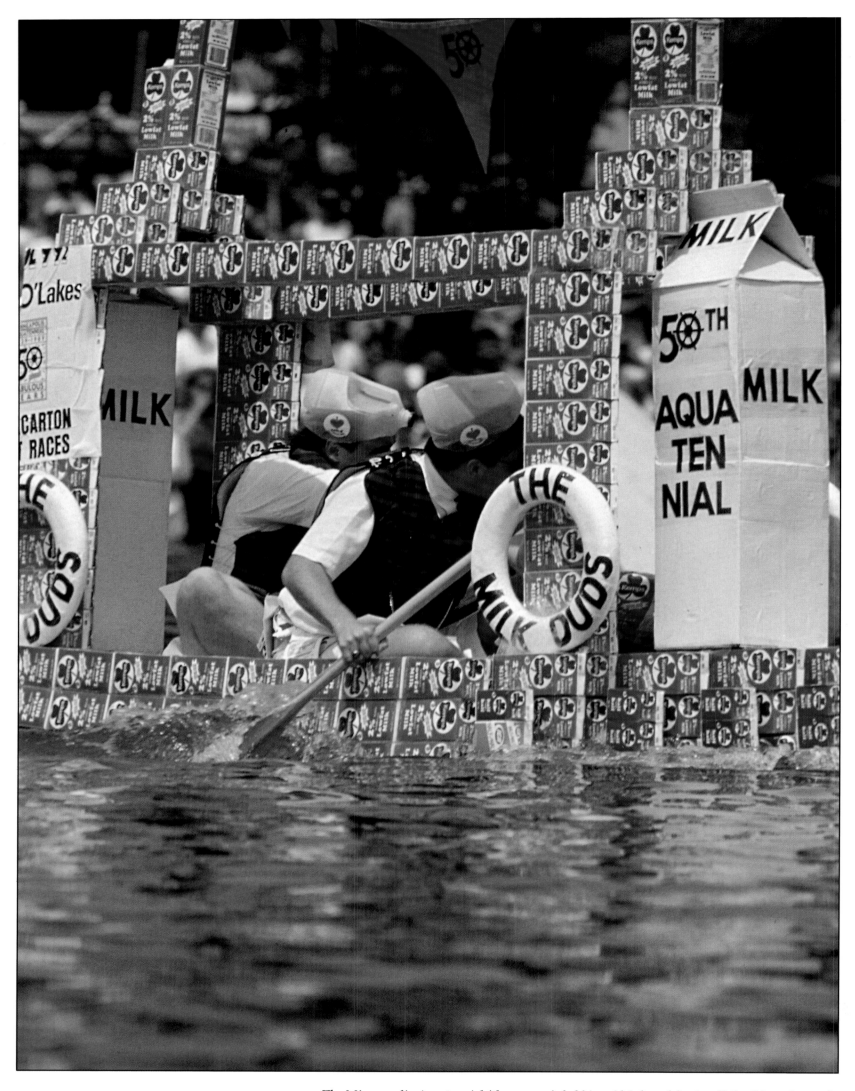

The Minneapolis Aquatennial (these pages), held in mid-July, celebrates all the things that make the city's lakes such a pleasure. Events include the Sand Castle Sculpture Competition (facing page) on Lake Calhoun, where teams create fantasies in the sand, using only pails of water and sticks for tools.

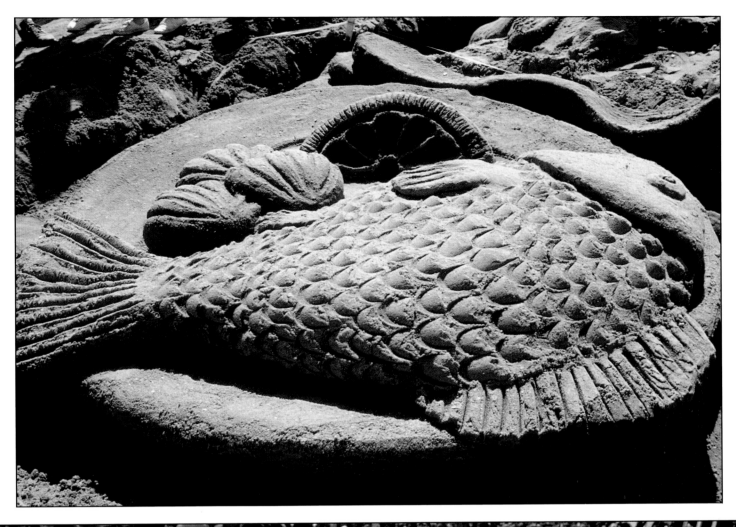

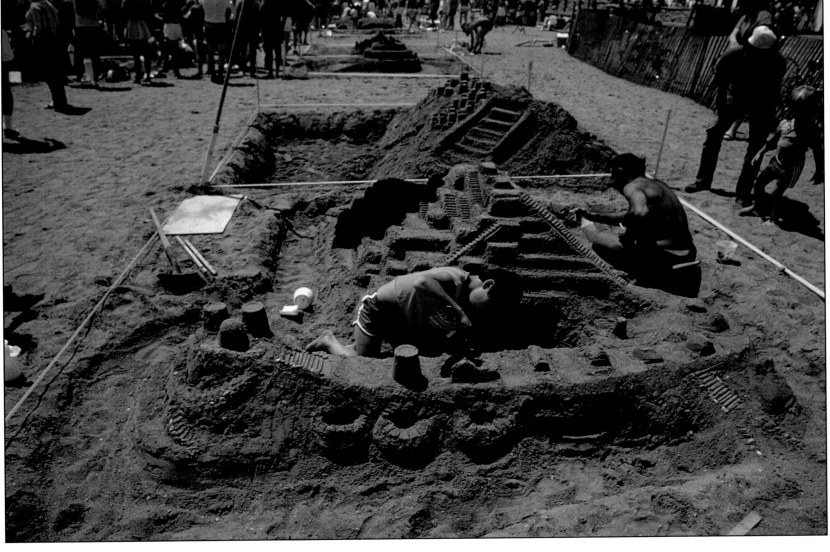

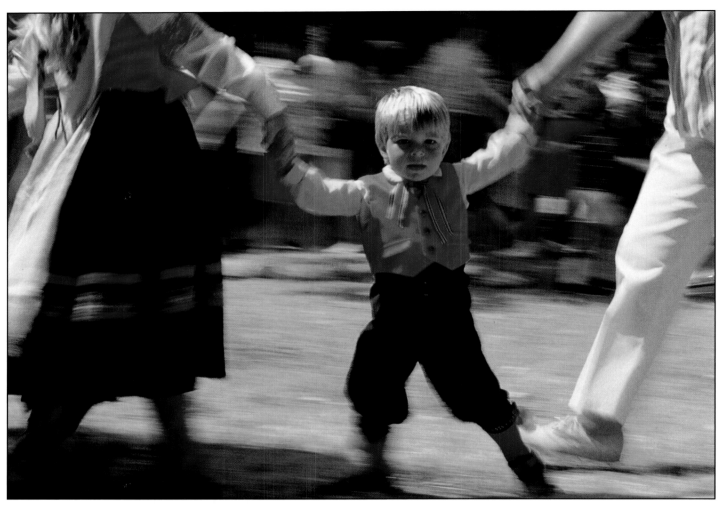

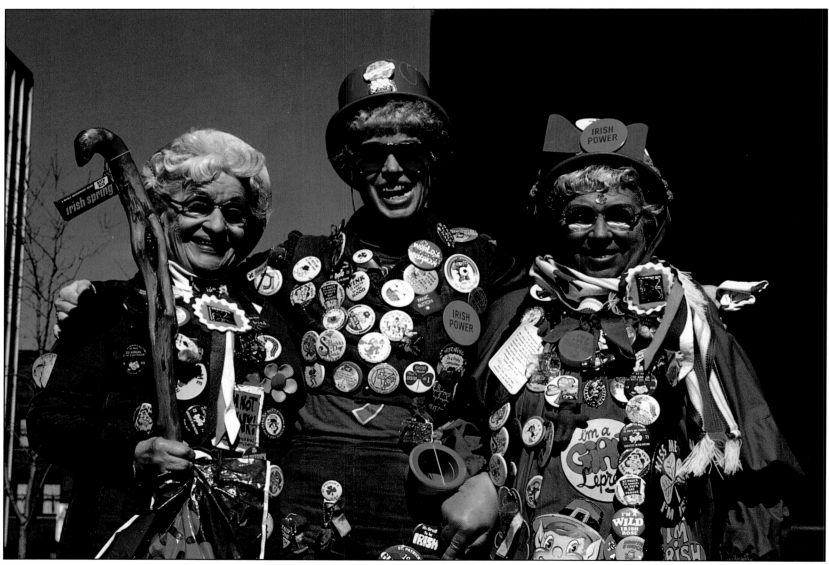

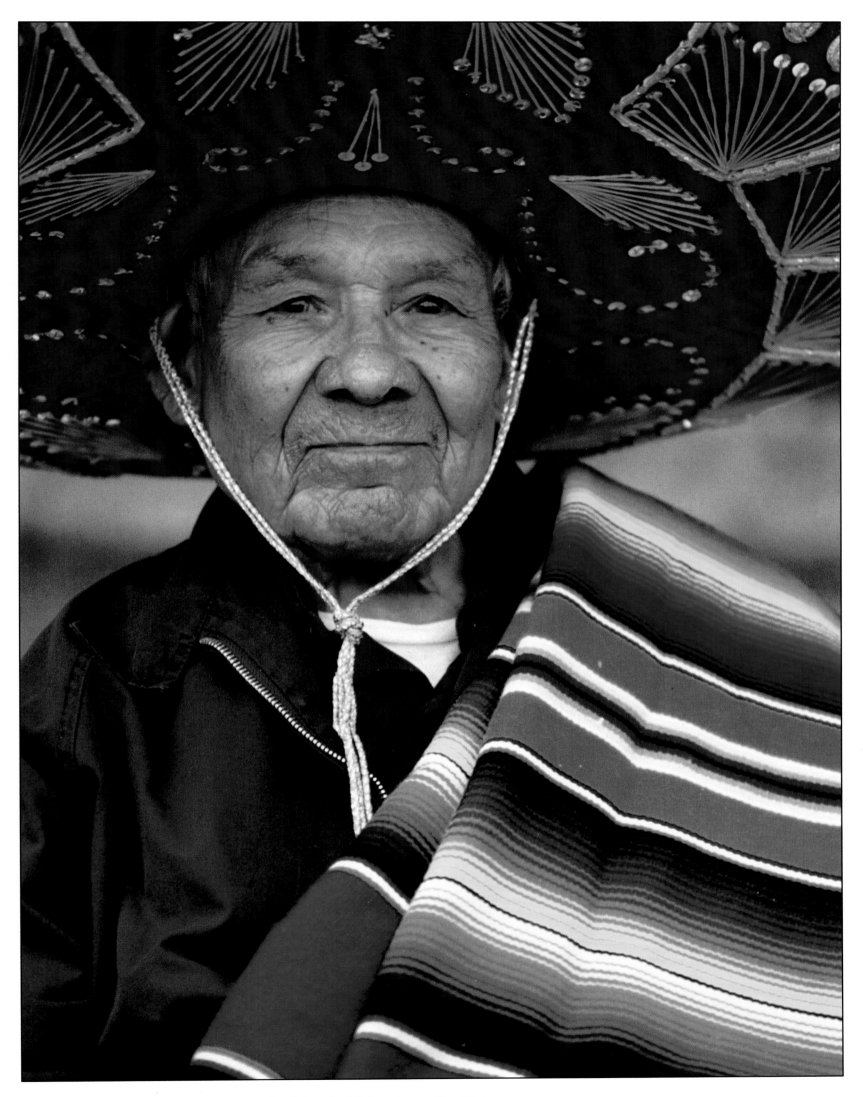

The international diversity of the Twin Cities is celebrated with Svenskarnes Dag (facing page top), a Swedish festival held at Minnehaha Park in June; with St. Patrick's Day parades (facing page bottom) celebrated on March 17, a great day for the Irish; and with Cinco de Mayo (above and overleaf), a traditional Latin American fiesta, in May.

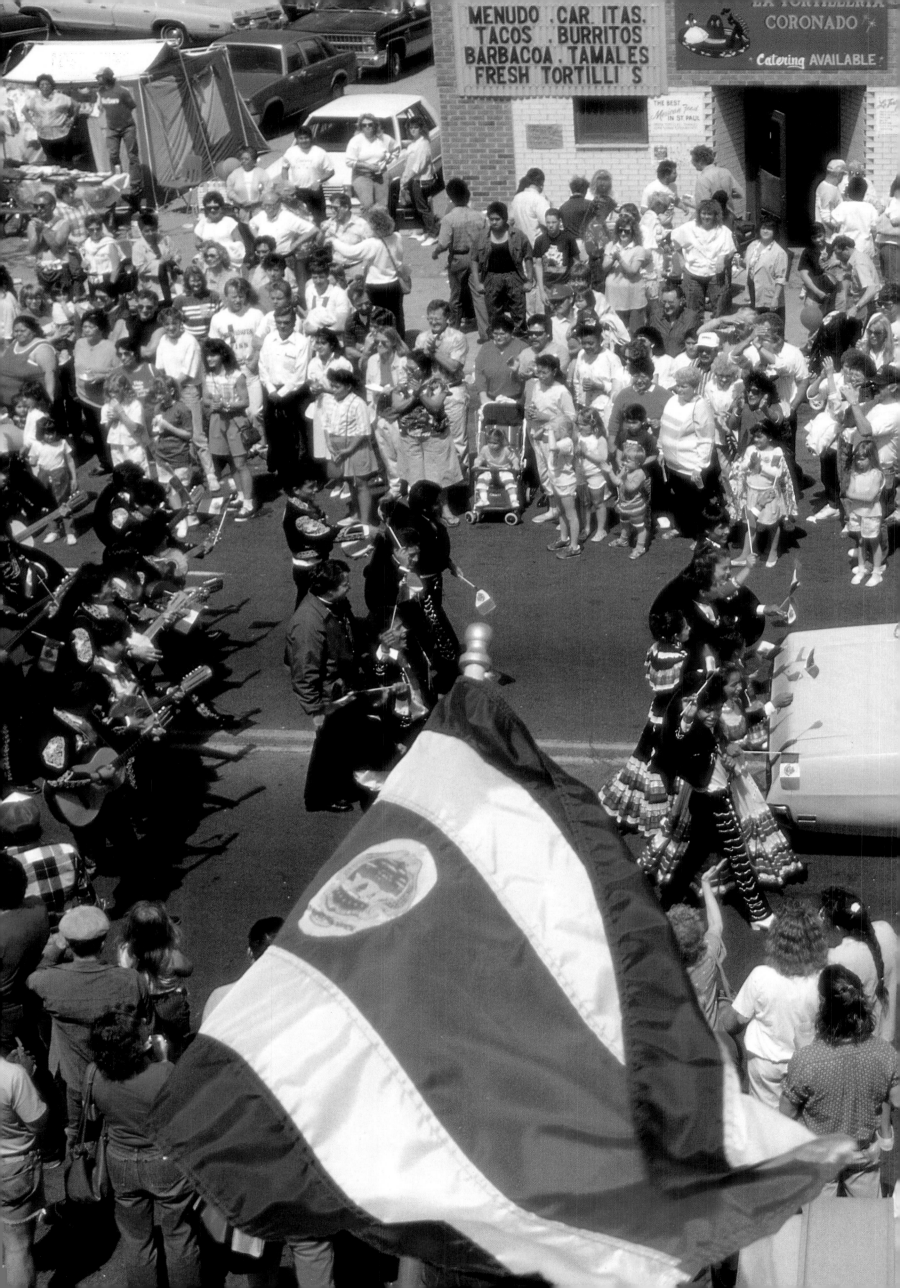

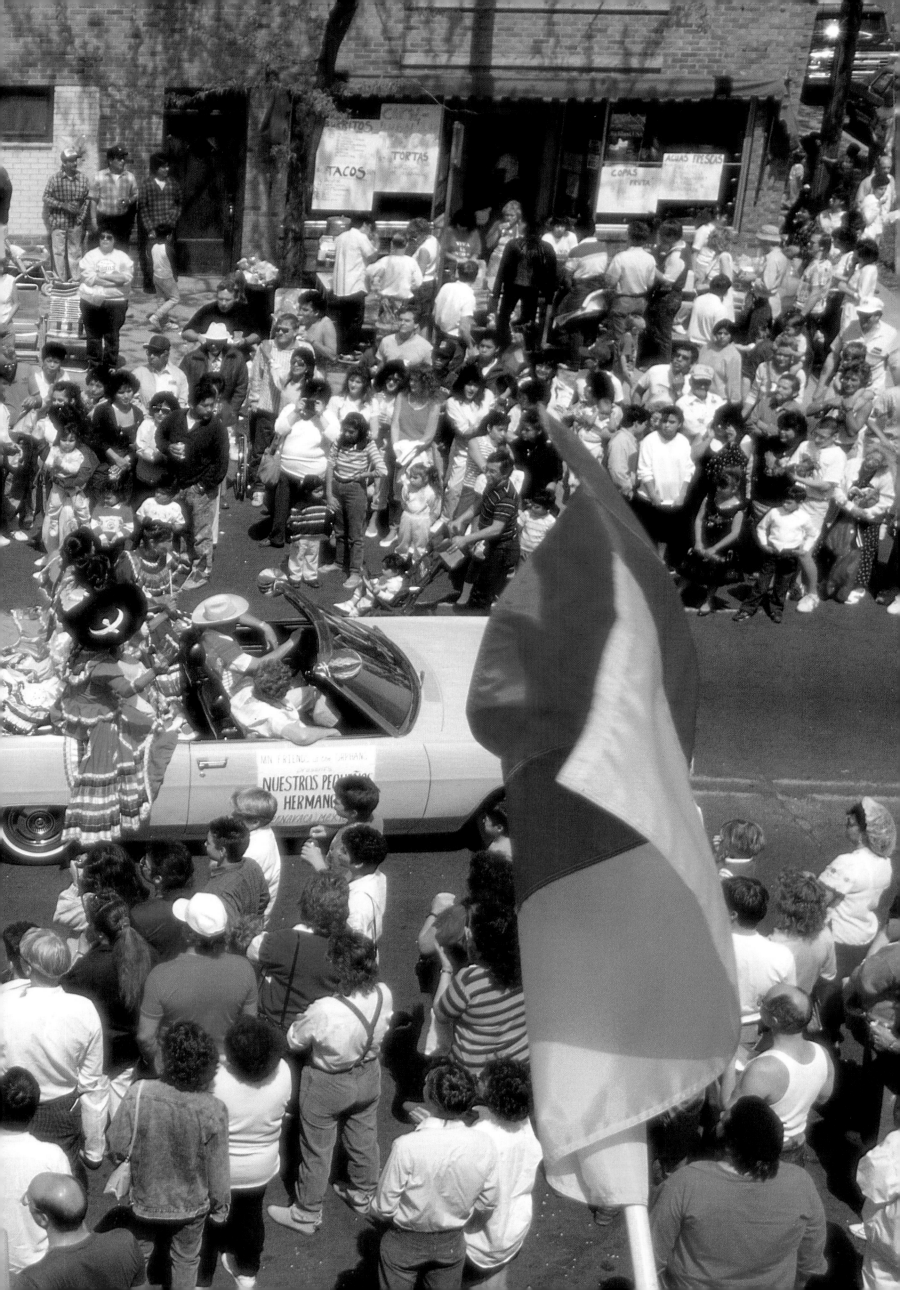

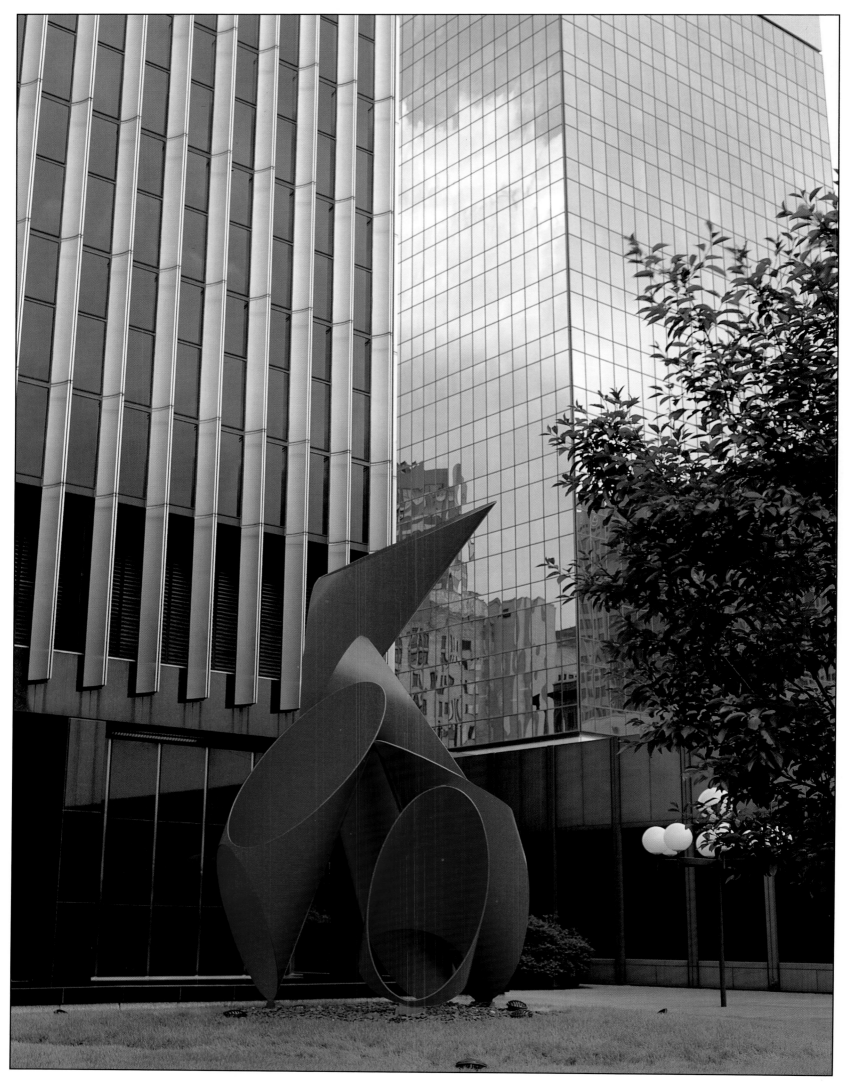

Outdoor sculpture (above) accents such new structures as St. Paul's Ecolab Building at Osborn Plaza. Among the treasures at the Minneapolis Sculpture Garden of the Walker Art Center (overleaf), is the remarkable Spoonbridge and Cherry *(facing page), designed by Claes Oldenburg and Coosje van Bruggen.*

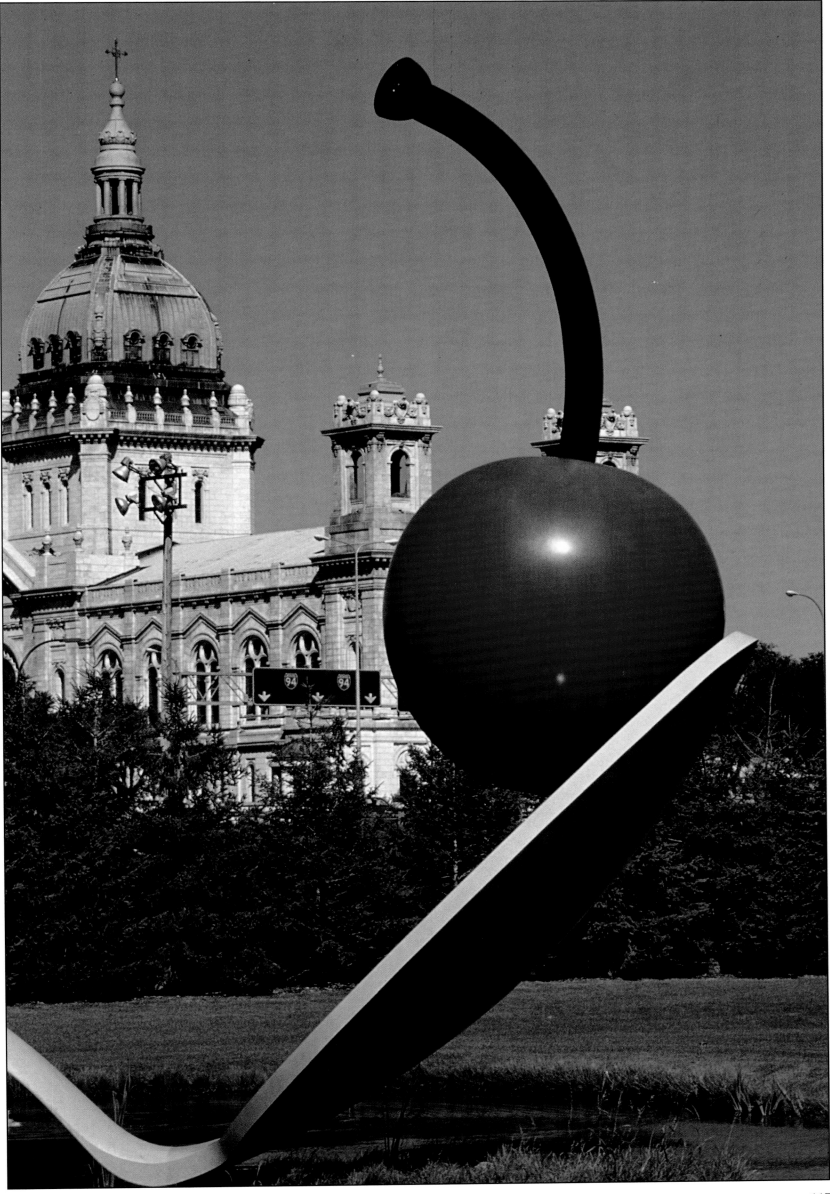

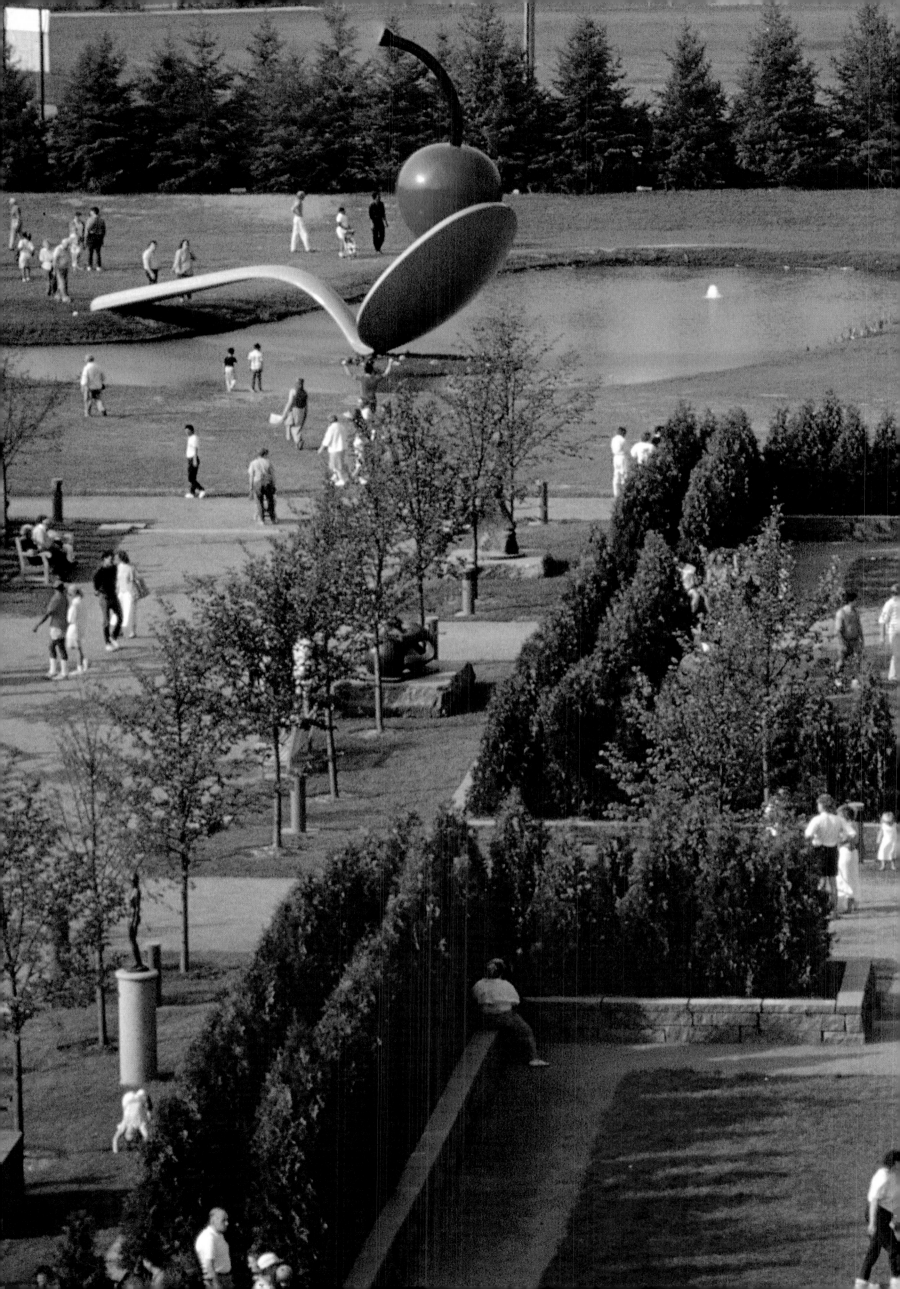

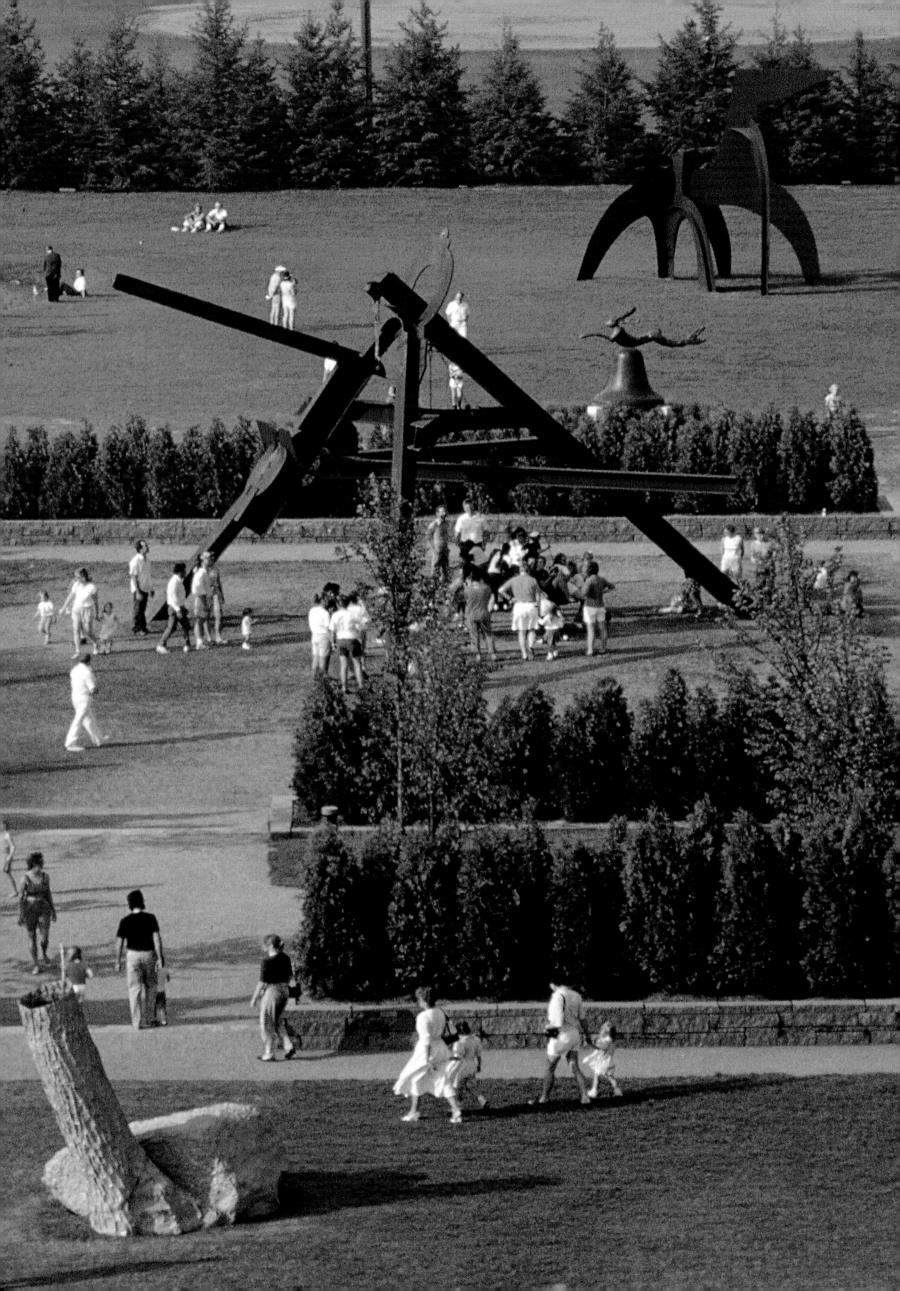

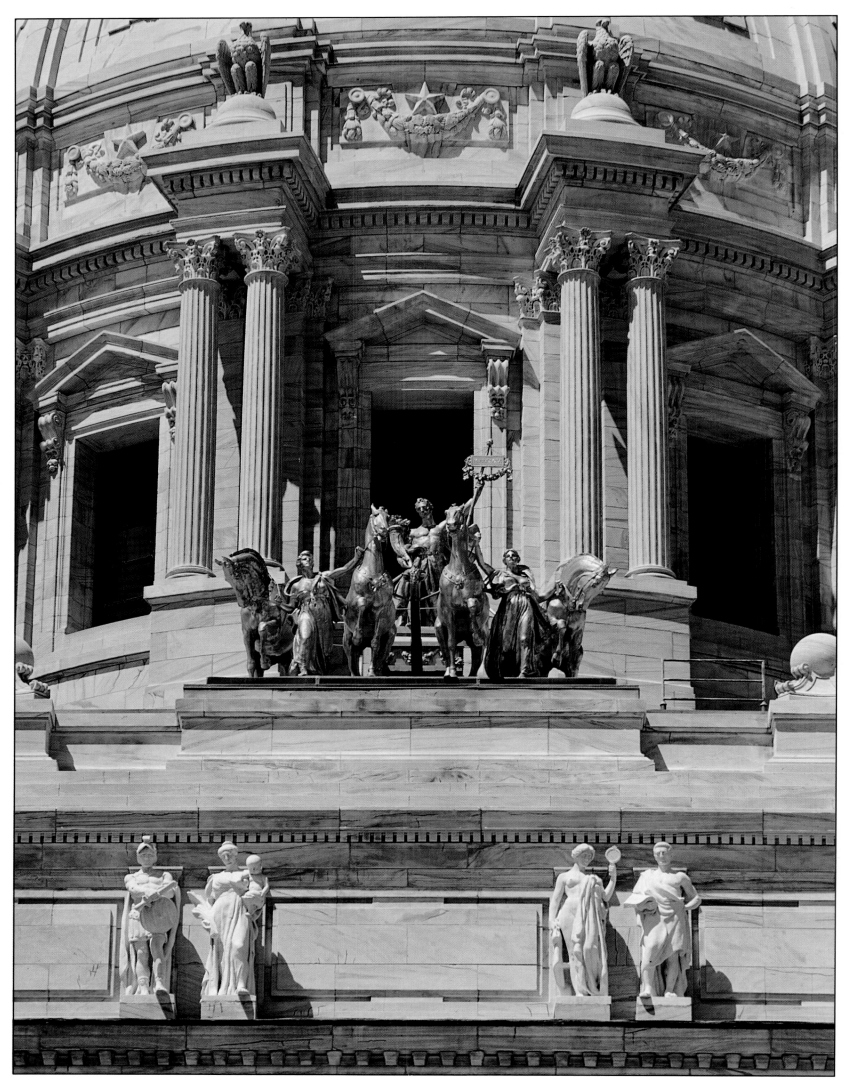

The gilded statue (above) on the facade of the State Capitol is The Progress of State, *the work of Daniel Chester French and Edward Potter. The Rotunda (facing page top) in Cass Gilbert's building is under a dome inspired by Michelangelo's design at St. Peter's in Rome, with murals representing* Civilization of the Northwest *by Edward Simmons. The glass star (facing page bottom) in the floor lights the basement.*

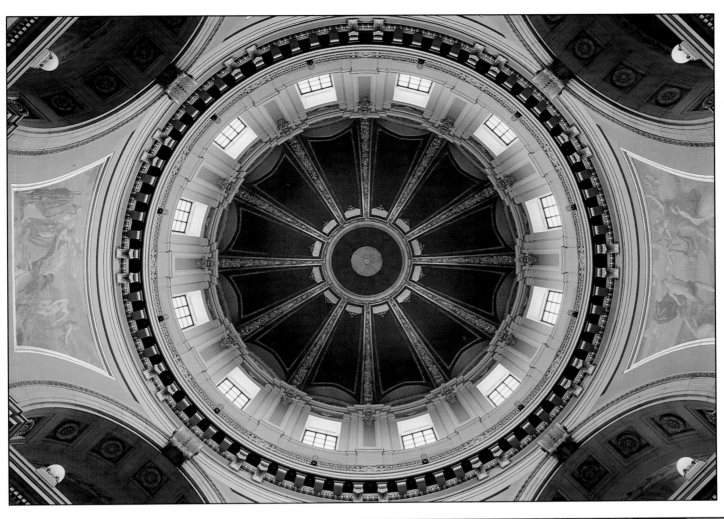

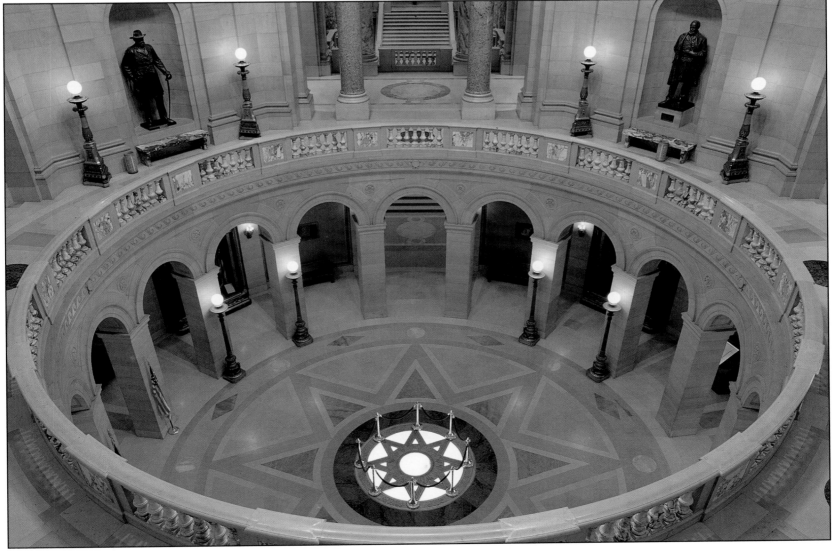

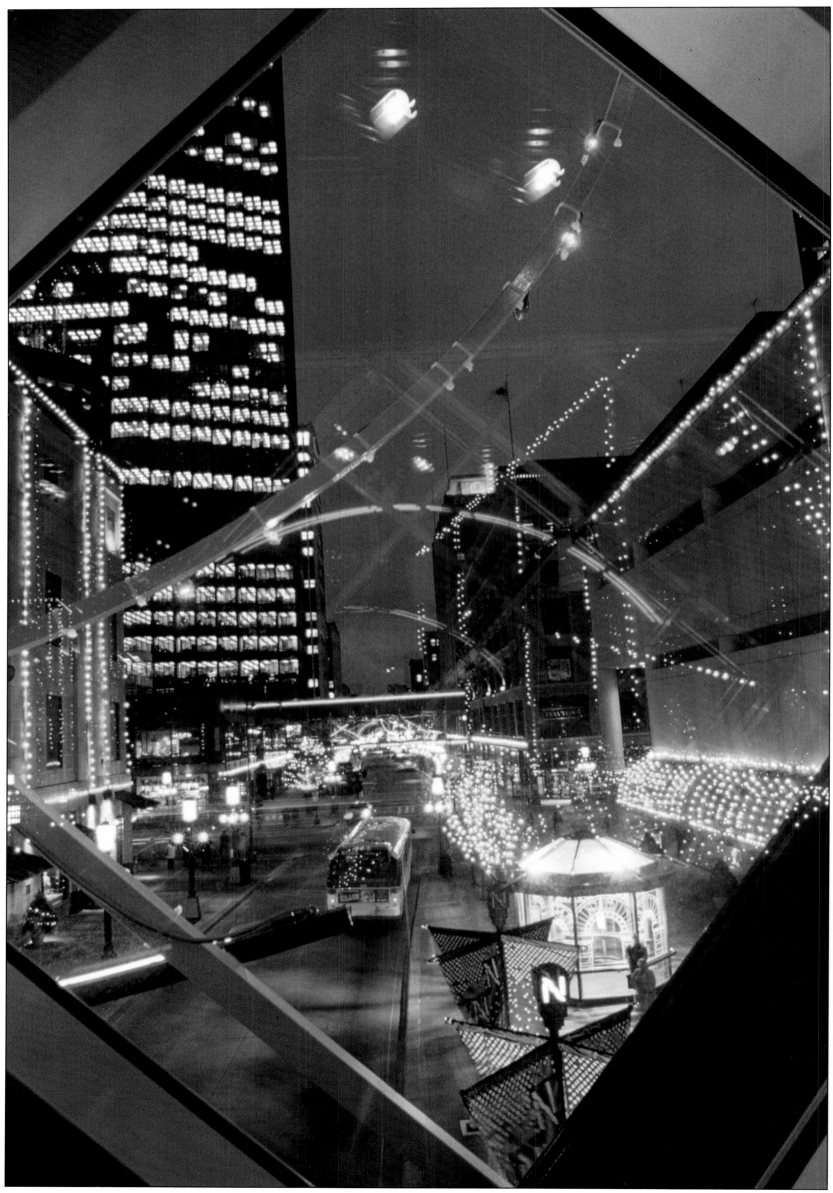

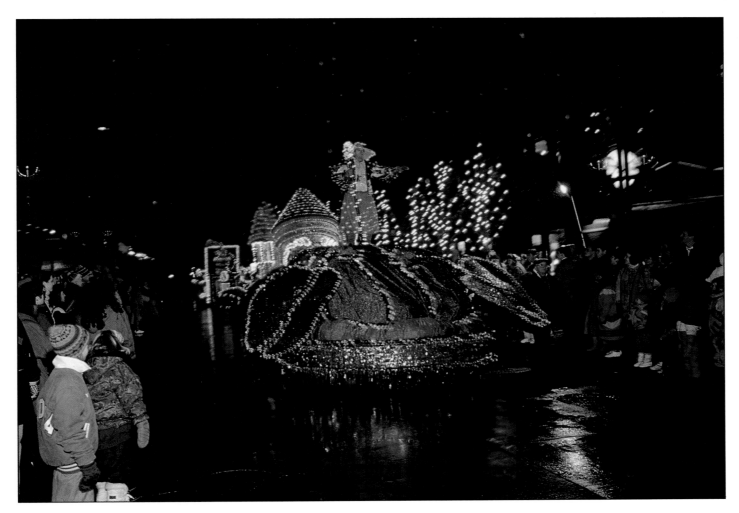

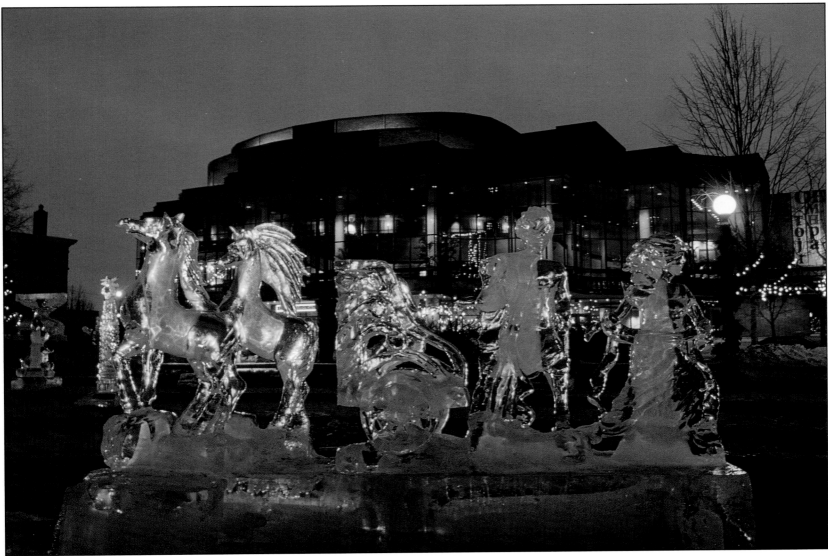

The term "winter wonderland" might have been coined in honor of the Twin Cities, especially at Christmas. Nicollet Mall (facing page) looks its best from the Skyway at that time of year, and the fun continues outdoors for the Holidazzle Parade (top). The dazzle continues into January with the St. Paul Winter Carnival (above), one of the biggest Twin Cities events of the year.

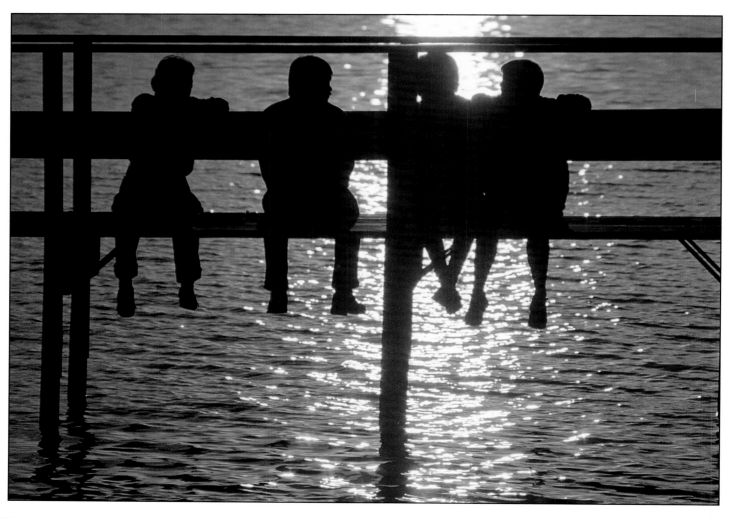

The setting sun (these pages and overleaf) adds glorious touches of red and gold to the lakes and parks of Minneapolis and St. Paul, creating a multicolored extravaganza over the Land of the Sky Blue Waters. Last page: Peavey Plaza, considered one of the special joys of downtown Minneapolis.

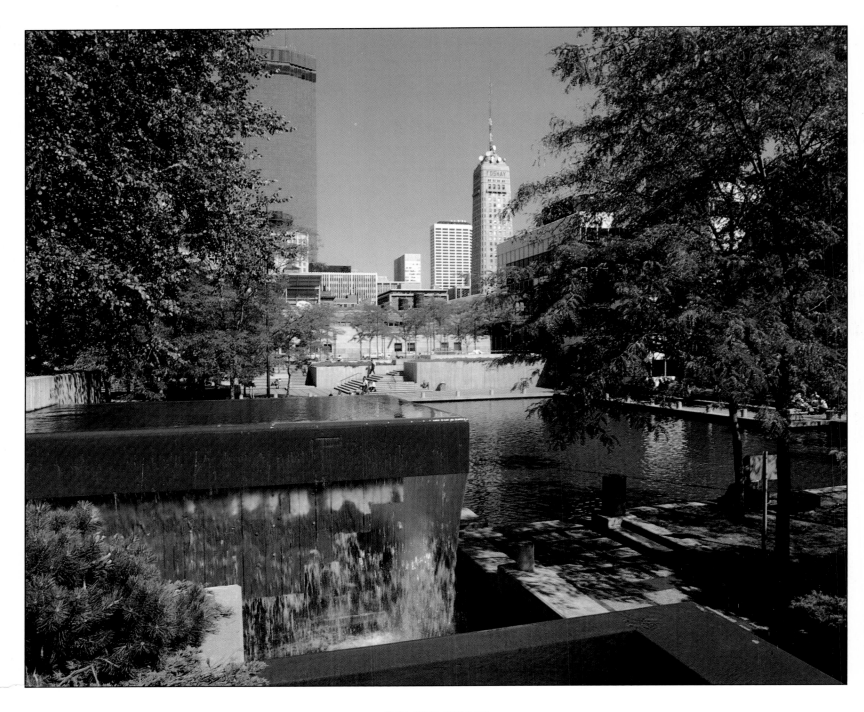

INDEX